FOCUS
ON
FLOWERS

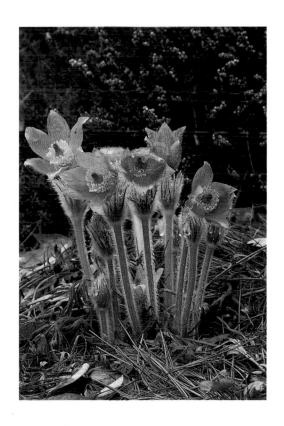

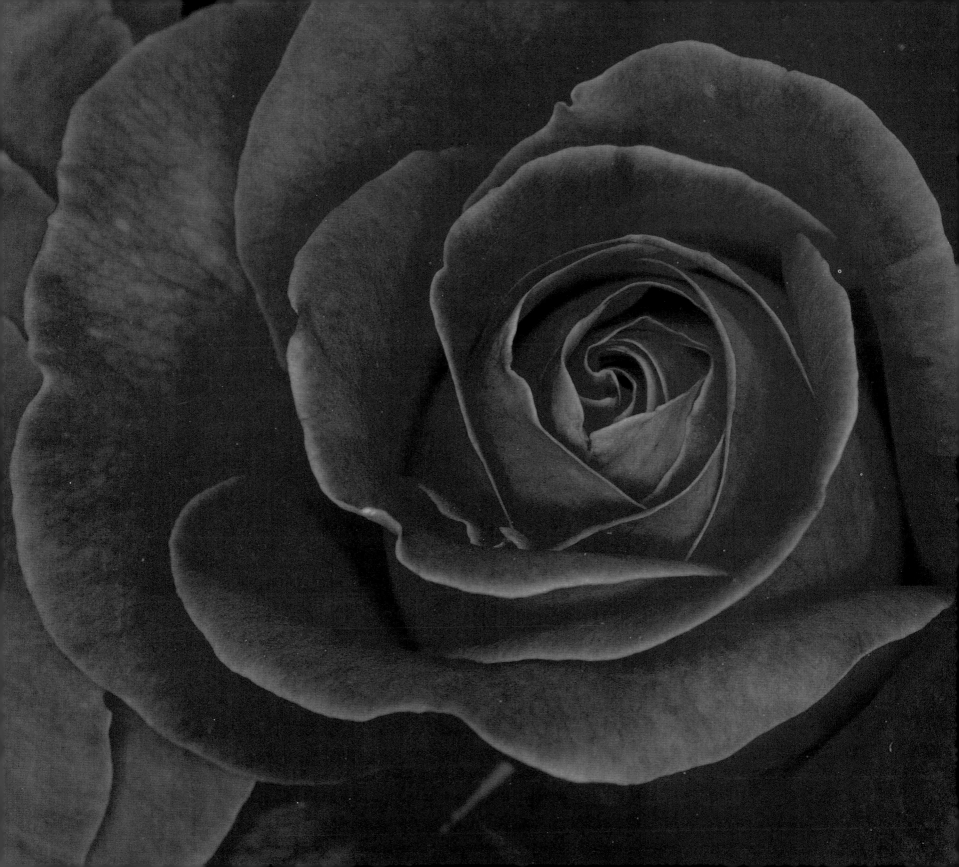

Text by ALLEN ROKACH
and ANNE MILLMAN
Photographs by ALLEN ROKACH

FOCUS ON FLOWERS

Discovering and
Photographing Beauty
in Gardens and
Wild Places

Abbeville Press
Publishers New York

EDITOR: Susan Costello
ASSISTANT EDITOR: Josh Abrams
DESIGNER: Nai Chang
PRODUCTION MANAGER: Dana Colc

Library of Congress Cataloging-in-Publication Data

Rokach, Allen.
 Focus on flowers : discovering and photographing beauty in gardens and wild places / photographs by Allen Rokach ; text by Allen Rokach and Anne Millman.
 p. cm.
 ISBN 1-55859-066-8
 1. Photography of plants.
 2. Flowers. I. Millman, Anne.
 II. Title.
 TR724.R65 1990
 778.9′34—dc20 89-18073
 CIP

Permission to reproduce quotations has been obtained from the following sources:

Pages 6, 13: Copyright © 1981 Arizona Board of Regents, Center for Creative Photography; pages 6, 64: From "Seizing the Light: Photography's First Fifty Years" by Erla Zwingle. Copyright © 1989 by National Geographic Society; pages 6, 96: Copyright © 1989 by Sonja Bullaty; pages 6, 110: Courtesy of the Trustees of The Ansel Adams Publishing Rights Trust. All rights reserved; pages 7, 120: From *More Joy of Photography*. Copyright © 1981 by Eastman Kodak Co; pages 7, 142: From GEORGIA O'KEEFFE: ONE HUNDRED FLOWERS, edited by Nicholas Callaway. Copyright © 1987 by Callaway Editions, Inc. Reprinted by permission of Alfred A. Knopf, Inc.; pages 7, 154: From A *Sand County Almanac: And Sketches Here and There* by Aldo Leopold. Copyright 1949, 1977 by Oxford University Press, Inc. Reprinted by permission. Special commemorative edition.

ACKNOWLEDGMENTS

A book, such as this one, is the product of a lengthy labor. Its production owes much to many, from inception to publication. We wish to thank those whose help was most instrumental in getting the job done.

The project would never have begun without the encouragement of Mary Suffudy, a fine editor and long-time supporter. The assistance given by Joe DeNicola—our student and dear friend—and his graphics staff, Christine Jensen and Norma Novotny, especially his talented wife Billi and his designer Richie Roginski, were invaluable in preparing our presentation materials, as was Lisa Delgado of Delgado Design. Carolyn Lyons, Marcia Stevens, and Muriel Weinerman—colleagues, co-workers, and assistants at The New York Botanical Garden—helped enormously in selecting and editing photographs. And thanks to Sidney Stern and Kay Wheeler for volunteering their time to help organize the photo stock.

There were people whose assistance made it possible to take many of the photographs. In particular, we thank the French Government Tourist Office, Fred Roberts, the director of Longwood Gardens, Mme. de Ganay of the Château de Courrances, Mme. Vogue of Vaux le Vicomte, Mme. Lindsey of Giverny, and M. Caravallo of Château de Villandry.

Our thanks to Robert Cavallo, who helped in our negotiations with Abbeville.

Naturally, we are grateful to those who worked so closely with us at Abbeville Press, especially our editor, Susan Costello, our designer Nai Chang, and Josh Abrams, who took a personal interest in the project.

Finally, we must thank Noah and Ilana Millman, for their incomparable patience and understanding during a period of semi-neglect, and for their unflappable availability during moments of extreme pressure. We love you both.

LEFT: *Soft light on these rhododendrons in a Delaware woodland helps convey subtle color and a feeling of serenity.*

JACKET, FRONT: *Water lilies are among the magnificent flowers that can be found in gardens and in wild places. Understanding what makes them photogenic helps capture their beauty on film.*

JACKET, BACK: *This environmental portrait integrates the misty coast of Maine with the seaside roses in the foreground.*

PAGE 1: *These small Japanese anemones are among the earliest spring blooms in the T. H. Everett Rock Garden at The New York Botanical Garden. A very low perspective was taken to show these beauties pushing through the earth in the dewy morning.*

PAGES 2–3: *An extreme close-up of the tightly curled petals of this rose evokes the mystery inherent in the unfolding of every flower.*

CONTENTS

Preface by Carl
Totemeier 9

Introduction 10

1 Beautiful or
Photogenic 12

*"I see my finished platinum print
[in the viewfinder] in all its
desired qualities, before my
exposure."*
EDWARD WESTON, 1922

Seeing the way the camera
sees 14
 Framing 16
 Composing 18
 Foreground and
 background 20
 Analyzing light 22

Seeing the way the film sees 26
 Color 28
 Grain and contrast 32

Previsualization 34
 Aesthetics 36
 Documentation 38
 Editorial view 40

2 Visual Tools 42

*"The camera should be an
extension of your eye, nothing
more."*
ERNST HAAS, 1971

Cameras 44

Lenses 46
 Normal lens 48
 Wide-angle lenses 50
 Telephoto lenses 52
 Macro lenses 54

Accessories 58
 Filters 60
 Electronic flash 62

3 Light Is
Everything 64

*"I seized the light—I have
arrested its flight!"*
LOUIS-JACQUE-MAUDE DAGUERRE,
1839

Intensity 66
 Strong daylight 68
 Diffused light 70
 Rain, mist, and snow 72

Color 74
 Direct light 76
 Reflected light 78

Direction 82
 Backlight 84
 Sidelight 86
 Frontlight 87

Mixed light 90
 Light and shade 92
 Fill-in flash 94

4 Exposure in the
Elements 96

"Aim for the natural."
SONJA BULLATY, 1983

The light meter 98
 Camera settings 100
 Bracketing 102

Making decisions 104
 Uniform color and light 106
 Contrasting colors and
 light 108

5 Style and Focus 110

*"I believe we have obtained a
fairly final expression of
mechanical technique. . . . and I
think our next step should be the
relation of this technique to a
more thorough and inclusive
aesthetic expression."*
ANSEL ADAMS, 1924

Techniques and aesthetics 112
 Focusing 114
 Motion 115
 Achieving maximum
 sharpness 116
 Aesthetics without
 sharpness 118

6 The Creative
 Viewpoint 120

"I love art . . . because it doesn't
have any rules."
 HARRY CALLAHAN, 1981

Framing 122
 The subject in the
 setting 124
 Choosing the right lens 126
 Format 128
 Positive and negative
 space 130

Design and pattern 132
 Lines and shapes 134
 Surface texture 136
 Abstractions 137
 Depth 138
 Color 139

7 Beyond What Meets
 the Eye 142

"A flower is relatively small. . . .
Still in a way—nobody sees a
flower—so I said to myself—I'll
paint it big. . . ."
 GEORGIA O'KEEFFE, 1939

Close-ups 144
 Moderate close-ups 146
 Extreme close-ups 148
 Adding light 152

8 Photographing in the
 Wild 154

"The chance to find a pasque-
flower is a right inalienable as
free speech."
 ALDO LEOPOLD, 1948

Environments 156
 Forests 158
 Meadows 162
 Deserts 164
 Mountains 166
 Wetlands 168
 Coastal areas 172

9 Pleasures of Garden
 Photography 174

"A garden is a lovesome thing."
 THOMAS EDWARD BROWN,
 1830–1897

Understanding garden design 176
 Seasons 178
 Paths 180
 Trees 182
 Walls, hedges, and fences 184
 Gardens and
 architecture 186
 Ornamental structures 187

Specialty gardens 188
 Rock gardens 190
 Perennial gardens 191
 Water gardens 194
 Natural gardens 196
 Food gardens 197
 Sculpture gardens 198
 Topiary 200
 Conservatories and
 greenhouses 202
 Flower shows and markets 204
 Window boxes 206

10 Great Flower
 and Garden
 Photographs 208

"Photography can never grow up
if it imitates some other medium.
It has to walk alone; it has to be
itself."
 BERENICE ABBOTT, 1951

Appendix 220

 Fill-in flash 220
 Flash test 221
 Color correction chart 222
 Glossary 222
 Technical information 224
 Index 227

The backlight on these cactus flowers in the desert house
of The New York Botanical Garden creates the illusion of a
natural setting. In addition, the dark shadows behind the
flowers camouflage an ugly radiator.

PREFACE

Gardens and scenes from nature spread before us a rich panorama of colors, textures, and forms. Since they will never appear the same on any two occasions, the camera provides us with a means of capturing their fleeting images on film.

The variations that accompany the seasons provide us with a good example of this phenomenon. Spring brings new life with its delicately expanding buds and tender new shoots and flowers bursting forth in drifts of color. Summer is the season of cool green shade with the promise of respite from the heat. Autumn arrives with clear blue skies that provide the perfect background for the rich hues of the turning leaves and bright fall chrysanthemums. Although winter is often considered to be bleak and uninteresting, it exposes the skeleton of a garden, revealing its contrasting forms and textures. Winter's ice and snow create a crystalline wonderland to enhance details hidden by summer foliage.

Flowers and gardens also appear differently to the lens of a camera depending on the time of day. Morning's cool, soft light gives emphasis to greens and blues, while the strong, harsh light of midday pales the brightest of flowers by comparison. Evening light casts a warm glow in contrast with lengthening shadows.

Through photography it is also possible to relive the refreshing coolness of a forest's shade or to imagine the heat rising in waves from a field of lavender grown in a hot, arid climate. One can almost smell the fragrance wafting on the warm breeze.

These changing moods can only be captured through the medium of photography, and there is no one better qualified than Allen Rokach to preserve these fleeting images. While Allen's photographs have appeared in many exhibitions and are held in many collections, both private and corporate, it is as the Director of Photography for The New York Botanical Garden, a position that he has held for 13 years, that I am familiar with his work. In this position, he has been called upon, often with but a moment's notice, to photograph subjects as diverse as a miniature daffodil in the T. H. Everett Rock Garden or the giant trees of the tropical rain forest of the Amazon.

Through his many assignments, Allen has demonstrated a dimension of photography beyond its ability to capture a moment in time. On many occasions his photographs of The New York Botanical Gardens have enabled those of us who work with these gardens every day to discover a new perspective or pocket of beauty. As he has so often stated, the camera forces one to look more closely and carefully at all that surrounds us.

Through his photographs we have discovered how to derive greater pleasure from gardens and nature than would have otherwise been possible. In Allen's vision, the camera becomes an instrument for increasing one's appreciation of beauty, learning how to find it in unexpected places, and knowing how to intensify its impact on viewers. You will find examples of all these elements in *Focus on Flowers.*

CARL TOTEMEIER
Vice President for
Horticulture
The New York Botanical
Garden.

INTRODUCTION

Fourteen years ago, a series of lucky coincidences brought me to The New York Botanical Garden. I arrived with some knowledge about earth science, a subject I had just given up teaching at a nearby college. I had also an abiding love of nature and the outdoors. And I had acquired a fledgling understanding of photography, a hobby I was striving to turn into a profession.

My New York City upbringing was lacking in an exposure to flowers and gardens. In Brooklyn, where I was born and grew up, the only greenery I recall was some unkempt hedges around the dusty yards down the block. Even in my own home, I don't remember ever seeing a bouquet of flowers. My parents were immigrants from eastern Europe eking out a living and weren't concerned with the "foolish" amenities of decorating or beautifying their apartment.

It wasn't until I was twelve that I experienced the excitement of seeing flowers and vegetables grow. My family moved from our apartment in Flatbush into a two-family house in the Borough Park section of Brooklyn. While the house had a typical concrete backyard, there were also two tiny postage-stamp plots of earth, devoid of life except for three scrawny rosebushes. Miraculously, I thought these plants brought forth the most incredible flowers on the face of the earth. At least that is my recollection.

Exhilarated by this success, my mother was determined to add a small vegetable garden. Seeds were bought, planted rather haphazardly and, to my amazement, radishes, carrots, lettuce, and tomatoes grew. There is no doubt in my mind that seeing those vegetables flourish and witnessing those incredible flowers emerge from such unpromising rosebushes greatly influenced my life. I began to have the curiosity and the ambition to understand the natural world.

Ironically, my job at The New York Botanical Garden was not intended for flower photography. I was a member of the public relations department, but it became apparent that there were few exciting photographs on file of the grounds and specialized gardens. As a result, I was asked to create a stock of photographs that displayed the best of the garden in all seasons.

Some of my garden photographs were published, and I began receiving requests for photographs of flowers and plants from magazines, advertising agencies, pharmaceutical companies, banks, and others who thought that the garden had an enormous stock of flower photographs to lend. Since the file was not extensive, I began a personal project to build my own file of flower images.

I quickly realized, as most photographers learn, that it was not easy to photograph flowers or plants. In fact, the photos I initially shot looked like floral mug shots. I began to experiment, trying to discover how to capture—and even enhance—the flowers' beauty, and also seeking to establish a personal photographic style. I was determined to develop the technical skills necessary to serve my new found perception.

In the years since that naive beginning, I have become a nature photographer with a specialty in flowers and gardens and an instructor of photography as well. All along, I was painfully aware of the steps in my own growth and development. And as I reached each new level of discovery and mastery, I had a strong desire to share my knowledge and understanding with other photographers.

This book, then, is but an outgrowth of that same impulse to share and instruct. I have no secrets as a professional photographer. There are no hidden techniques or tricks that I must keep to myself to maintain my expertise. There is, in fact a deep wish to bring to others the

same pleasure and accomplishment that I derive from my work.

After all these years, I am still amazed at how much beauty is contained in objects as small as flowers. The mission of this book is to help photographers capture this incredible beauty. Although flowers are one of the most popular photographic subjects, it is sad that most photographs of them are unsuccessful. The most common reason for such disappointing results, I have learned over the years, is that the photographer has chosen a subject that may be physically beautiful but is not *photogenic*.

The concept of a photogenic subject is important to all photography, but it is crucial to the photography of flowers and gardens. Saying something is photogenic means that it will translate into an outstanding image on film. In flower photography, this requires looking beyond the surface to a deeper appreciation of what flowers represent. Indeed, the flower does not need to be at its prime—or particularly noticeable to the inexperienced eye—and yet it can be quite photogenic.

Because flowers can be so breathtaking, an effective photograph must have a startling impact. The photograph must catch and hold the eye and force the viewer to look at the flower in a new way. The photographer's approach needs to be as individualistic as the subjects themselves. The emphasis should be on involving the viewer emotionally and on portraying subjects so they surpass the viewer's expectations. Each photograph must convey an element of surprise, either through dramatic or subtle effects, through color, form, or arrangement, or through the sensitive use of available light, or the bold use of artificial light. With a clear and a determined vision, a photographer can penetrate the flower's facade and reveal its inner beauty.

To distinguish between a subject that is photogenic and one that is beautiful requires thought, technique, and practice. It requires that we confront our creativity in a solitary act. We must previsualize the resulting image, that is, imagine the photograph before taking the picture. Having a clear vision beforehand is particularly necessary for success in reinterpreting how a flower looks.

Only after achieving such a personal aesthetic can the photographer utilize technical skills to produce an image. It's important to experiment, to learn how to make decisions, and to be prepared to compromise. To ensure that our mental picture becomes the image we visualize, we must be able to control all the technical decisions (shutter speed, f-stop, focus, lens selection, film type, etc.) before releasing the shutter.

Students often ask me how a certain effect was achieved: "How did you make that flower glow?" Or, "how did that tulip become so red?" Or, "why is that photo so appealing with nearly everything in the frame out of focus?" The technical answers to these questions are not as complex as they may seem. But they involve an understanding of a variety of factors, the patience to see how those factors interact, and the commitment to produce outstanding photography. The rest is a matter of experience, which is largely learned and relearned from one's mistakes.

But these technical matters are only relevant after one develops a sense of vision. Ernst Haas said it best: "You do not photograph with your brain, but rather with your heart." In this book I hope to teach you how to develop a sensitivity for the photogenic, and how to translate successfully the images you can see in your mind's eye into magnificent photographs.

1
Beautiful
or Photogenic

"I see my finished platinum print [in the viewfinder] in all its desired qualities, before my exposure."

EDWARD WESTON, 1922

SEEING THE WAY

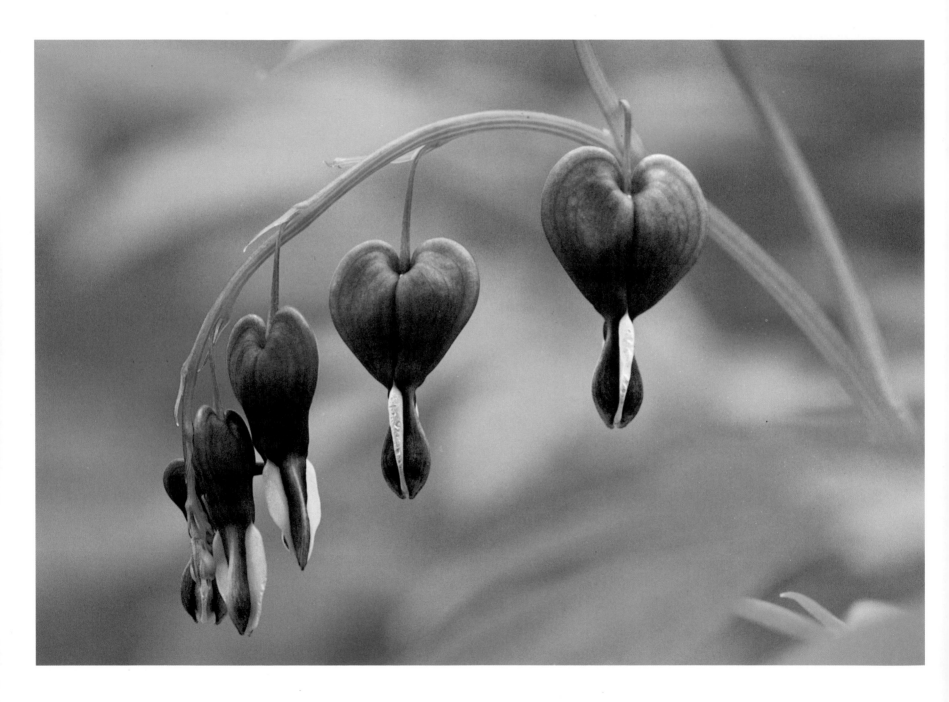

THE CAMERA SEES

In mastering the photographer's craft, one of the most difficult adjustments that must be made is learning how to look at the world through the camera's eye. Our own biological mechanism for vision is a complex composite of eye and brain coordinations and interpretations. Simply stated, our eyes "register" an image based on what is "visible," but our brains filter and skew that image to suit whatever emotional and psychological factors are influencing us. As a result, we actually "see" what we wish to see.

The camera is not nearly as subjective. In fact, its singular objectivity irritates many people. Suppose, for example, that a beautiful woman is standing behind a chain link fence. We can appreciate her beauty without any consciousness of the fence. Our mind has the ability to erase that fence, and we can "see" her—and will remember seeing her—as if the fence did not exist. But if we wanted to take her picture as a keepsake, we would have to contend with the reality of that fence. If we didn't, we would get a photograph of the fence, with a shadowy figure of the woman we admired barely visible behind it.

This may be an extreme example, but it illustrates an important distinction between what is beautiful and what is photogenic. In this case, the woman is certainly beautiful, but under the given circumstances, she is not photogenic. Her image would not be seen by the camera in a way that would represent her attractively.

The reverse is also true, and too often neglected by photographers of flowers. Subjects that may not be considered beautiful may prove most photogenic. For example, a flower well past its prime may not be ideal for a dining room vase, but it may reward the photographer with an unusually evocative image.

That is why it is crucial to develop an objective consciousness about how the camera will see a particular photographic subject. The broad guidelines to help develop such an awareness concern four areas: framing, composing, understanding the relationship between the foreground and the background, and analyzing light.

ABOVE. *A startling image can be made by taking an uncommon perspective, such as this view from the rear of these tiny anemones in an Arizona garden. The soft pink petals are effectively set off by the greens of the stem and sepals.*

OPPOSITE. *The delicate heart-shaped flowers on this drooping branch of a bleeding heart in Westchester stand out against the blurred green of their woodland setting.*

PAGES 12–13. *These delicate blue irises were growing in front of a dingy old radiator in a conservatory at The New York Botanical Garden. To transform the unattractive backdrop into a lovely wash of pale yellow, a telephoto lens was used.*

Framing

The world we look at is a fairly random place. With a camera, we select and isolate a section of that chaos. When we frame a shot, we point at one small parcel of order or inspiration or beauty and say, "Look at this!"

A problem arises, however, because our brain has the capacity to isolate what we *wish to see* from the totality of what our eye objectively perceives. We may admire a perfect rose but be oblivious to the twigs, foliage, people, and structures surrounding it. We may delight in a lush display of woodland azaleas and be unaware of a poorly maintained path in front of it. All too often photographers are disappointed when a photographic image does not live up to a fond recollection. The subject of their "Look at this!" response is lost because of imprecise framing.

Many students have been helped to identify exactly what they intend to include in the frame by completing a simple statement of purpose: "This photograph is about . . ." or "What I want to show is . . ." This exercise forces the photographer to clarify what is important, and, therefore, what should *fill the frame*. The statement should be as specific as possible: "This photograph is about how brilliant the red of this flower looks when the light strikes it from the side," rather than "This photograph is about a flower." The more precise the statement, the better the chance of identifying the exact visual elements to include in the frame. If it is the red color of a flower that is foremost, then the red presence must be overwhelming. In contrast, a small red speck within the frame will convey a diminished experience of color.

Coherent framing, then, means filling the viewfinder with the image that defines our visual statement—and with nothing more. Framing is the visual equivalent of editing, a process that forces us to identify the elements we wish to include and those we wish to leave out. Although this procedure may seem slow and tedious at first, it will vastly increase the odds of keeping subjects photogenic, and maximize the percentage of images that please us.

The following steps will improve effective framing:

1. Move in every available direction, experimenting to see which angles best include what is necessary and exclude what is extraneous.

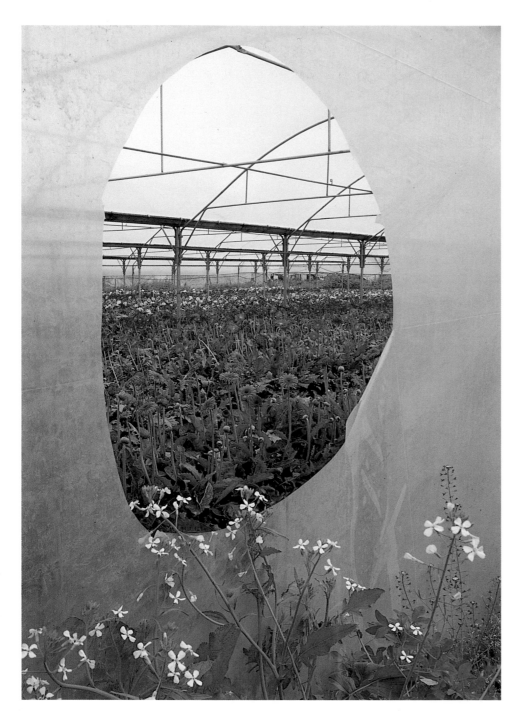

2. Learn how to manipulate camera settings and understand the advantages of one lens over another to frame a subject in the most advantageous and photogenic way.
3. Take the time to see what is in the background, in the foreground, and to the sides—and include these elements only if they enhance the total effect.
4. Before releasing the shutter, look deliberately at everything within the frame—to the very edges and into the corners—to make sure that *only what is necessary to the photograph* is included.

The chapter on composition, "The Creative Viewpoint", explores the subject of framing in greater detail.

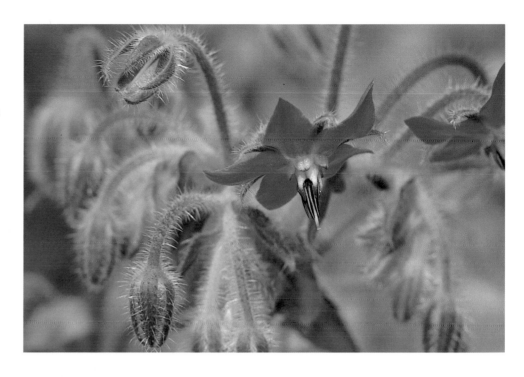

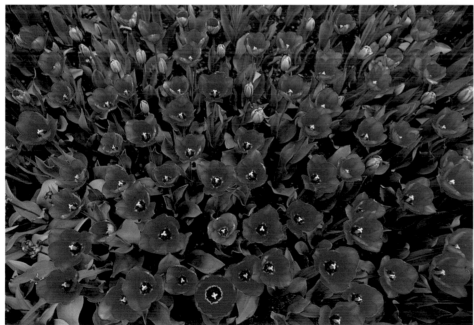

ABOVE. *Much experimentation was needed to discover the right angle for photographing this borage in a private Long Island garden. In previsualizing this image the plan was to feature a single bloom surrounded by buds, with only a suggestion of the many other flowers nearby.*

LEFT. *The frame is completely filled with this downward view on a bed of tulips at The New York Botanical Garden. The dynamic sense of the flowers pushing out in all directions is enhanced with a wide-angle lens.*

OPPOSITE. *A plastic greenhouse in Israel was made photogenic by framing the dahlias within through a ventilation hole in the structure. Both the flowering weeds outside and the framework inside were integrated into the composition.*

Composing

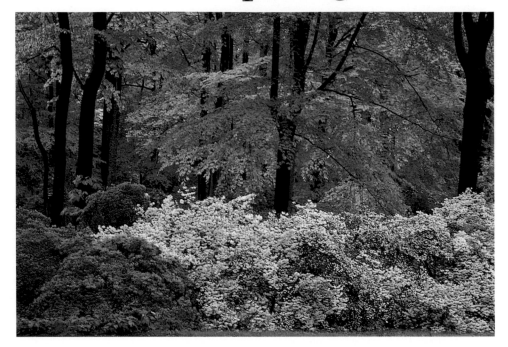

ABOVE. *The classical proportions based on the "rule of thirds" serve as a guideline in this composition of pink-and-white azaleas at Winterthur, Delaware. The broader upper band of green balances the lower one, and the vertical lines formed by the trees add visual interest.*

OPPOSITE. *For this composition of a wheat field in France a flat presentation was chosen to spotlight wild, red poppies and a horizon line broken by a single tree.*

Good composition goes hand in hand with successful framing. Composition refers to the arrangement and organization of elements within the frame based on some principle of order. It is the success of the arrangement or design, rather than the beauty of the individual members, that helps make a subject photogenic, and that distinguishes the way the camera sees from the way our eyes ordinarily see.

What kind of arrangements work? There is certainly room for argument. Flowers have distinct forms and shapes given to them by nature or refined through horticulture. Gardens are the products of human minds imposing order on living and man-made materials. In both cases, there are discernible patterns to be discovered. The perceptive photographer finds these design elements and organizes them within the frame so they become visible and identifiable, although they should not necessarily dominate the image.

Compositions work well if they create distinct graphic lines—horizontal, vertical, diagonal, radiating, S-curves—or form geometric shapes—rectangles, triangles, circles, figure eights—to visually harmonize the elements within the frame. If some such arrangement acts as the organizing principle of what the camera sees, then the chances of having a photogenic subject are greatly improved.

Another consideration in composition is learning how to translate the three dimensions of the visual world into the two-dimensional language of the photographic plane. Our eyes see stereoscopically, but our brains take the visual information from each eye, merge the two images into one, and use the slight discrepancy between the two images to interpret depth. Fortunately, our brains have also learned to associate certain visual cues as representative of depth. It is these secondary visual cues that artists and photographers incorporate to create the illusion of depth in a two-dimensional frame.

Among the most common illusionist techniques in photography are the use of diagonal or converging lines to represent a receding landscape, the use of differentials in size between foreground and background objects, and the juxtaposition of light and dark areas. In cases where the photographer's intent is to create a sense of the third dimension, these techniques may be utilized. Since the camera cannot interpret depth without such cues, the photographer must consciously include them where a perception of depth is important to an appreciation of the image. The chapter on composition, "The Creative Viewpoint," describes these techniques in detail.

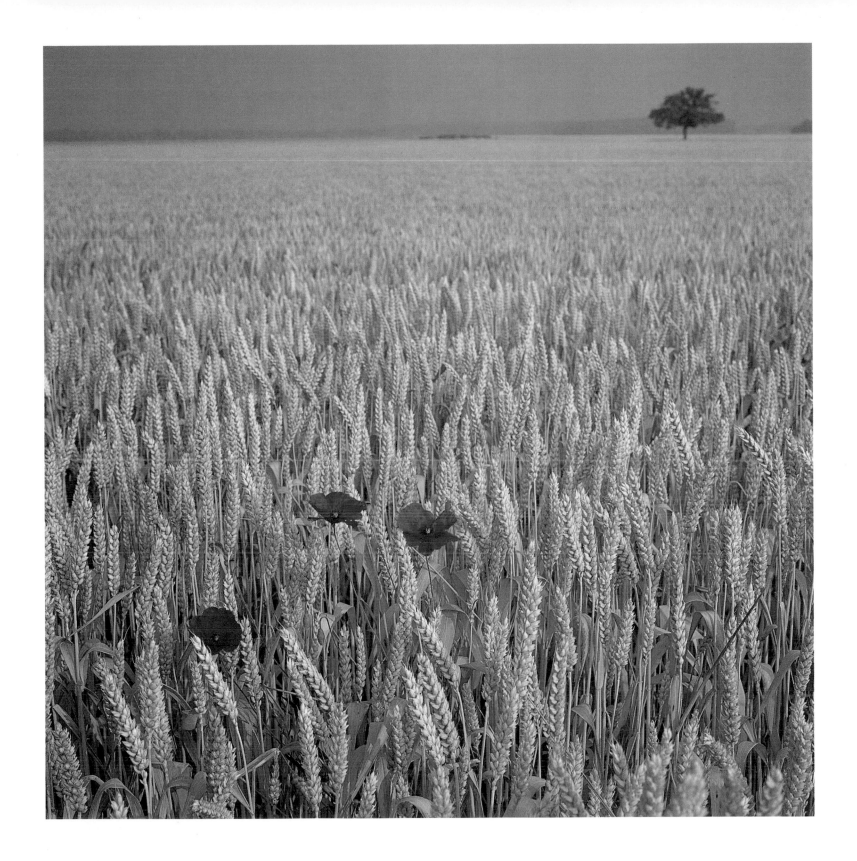

RIGHT. *A telephoto macro lens was selected to isolate this Maine meadow lupine from the foreground grasses and the other field flowers in the background.*

OPPOSITE. *A wide-angle lens makes it possible to incorporate the swans in the foreground and the background in this sharp composition of the water canal at Courrances in France. The converging lines intensify the illusion of depth and echo the classic elements that add to this garden's aura of tranquillity.*

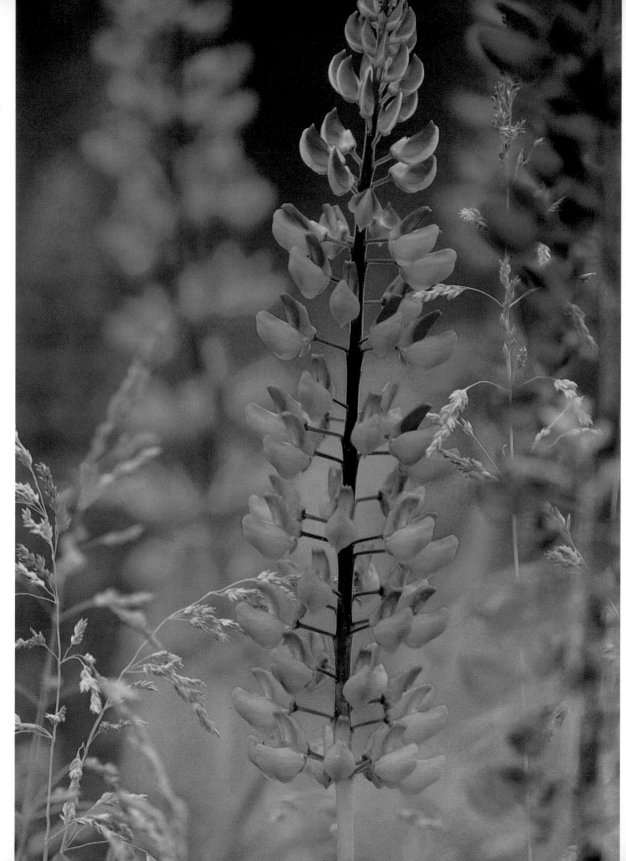

Foreground and background

Unlike our eyes, the camera has the ability to portray reality according to our imagination and wishes. From a given vantage point, our eyes may take in a broad expanse. But from that same point, a camera can yield a variety of images that reflect many ways of seeing. The relationship of foreground subjects to their background is one of the important considerations in these myriad possibilities.

Depending on the choice of lens, the photographer selects the degree to which the background is a visible component of an image. Wide-angle lenses will incorporate more background, while telephoto lenses will limit the extent of the background.

The photographer's perspective influences the orientation of the background to the foreground. One's repertoire is expanded with unusual points of view, such as those from above or below.

Most interesting, however, is the camera's ability to integrate or separate foreground and background, according to the photographer's instructions. This feature, called depth of field, refers to the extent of sharpness from near to far, something the photographer must learn to control purposefully.

Because our eyes see selectively and are guided by emotions, they do not pay equal attention to everything. They ignore distracting twigs, exaggerate the size of a lovely rose, and fail to notice unsightly shadows. A camera is not as generous. It records everything within the frame with ruthless accuracy—even the things we did not notice, or would have eliminated if we had. And it does so with blind obedience to our commands, based on the camera settings we have chosen.

This is why serious photographers train themselves to see the way the camera sees, with similar objectivity about what lies beyond and around the chosen subject. And once the composition has been properly framed, by selecting the most appropriate lens and the most effective perspective, the photographer must instruct the camera very precisely about what should be in focus.

This is a greater challenge than most people realize, and is discussed in the chapter, "Style and Focus." In terms of what is photogenic, the photographer must real-

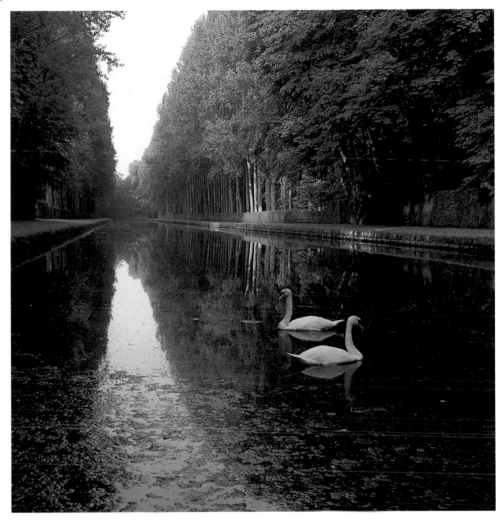

ize that the relative sharpness of various elements in the composition plays a crucial role in enhancing or spoiling the impact of a subject. If the relationship of sharp to unsharp elements is decided thoughtfully, the photographic results will enable the viewer to experience the original impetus for the picture. If sharpness is left to luck or chance or carelessness, the beauty we hoped to capture will be lost.

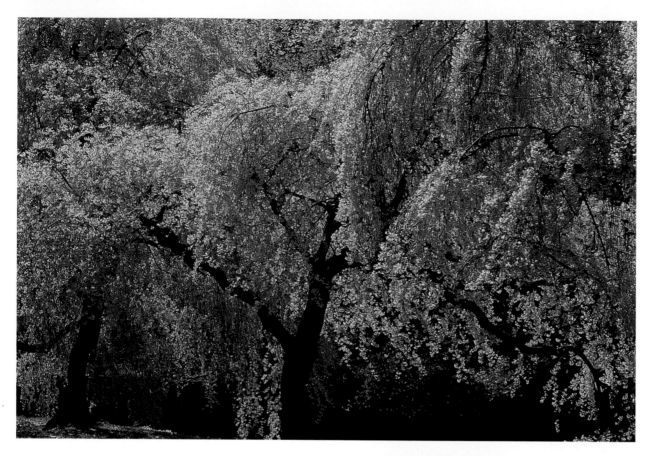

OPPOSITE ABOVE. *The mist enveloping the mulberry and weeping cherry trees at The New York Botanical Garden casts a bluish light that enriches colors and cloaks the scene in a veil of mystery.*

OPPOSITE BELOW. *A shaft of bright late afternoon sunlight pierces the overhanging foliage of a tree and spotlights this morning glory in a private Long Island garden. The strong high sidelight isolates the flower from its dimly lit surroundings and creates a glowing radiance as it passes through its interior.*

ABOVE. *Strong low-angled sidelight intensifies the contrast between the shimmering blossoms and the dark bark on this cherry tree at Branch Brook Park in New Jersey. To saturate color in the delicate flowers, the photograph was underexposed by one f-stop.*

RIGHT. *Backlight on these tulips at The New York Botanical Garden creates a translucent quality which reveals the overlapping shapes of the petals. A low angle of view prevents the backlight from causing flare.*

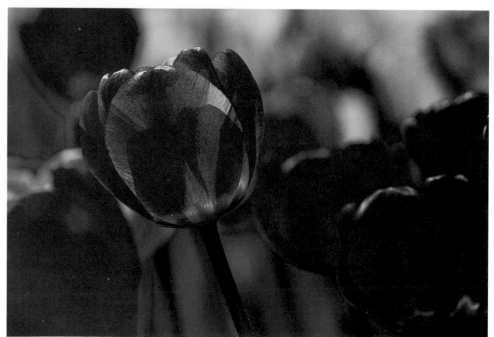

Analyzing light

The word *photography* is derived from the Greek, meaning "writing with light." A good photographer never forgets this. It is the quality of light within the camera's frame which, more than anything else, makes the difference between a marvelous and a mediocre image. Ironically, the most difficult light to work with is the sort many amateurs think is ideal: bright overhead sunlight.

Developing a sensitivity to the qualities of light is crucial to a thorough understanding of what makes a subject truly photogenic. In a studio, photographers can manipulate artificial lights to produce the quality that is exactly right for a given situation. In fact, some studio photographers refuse to risk the uncertainties of natural light and never work outdoors professionally.

Although there are simple and clever ways to alter less than perfect natural light conditions, garden photographers usually depend on the light at hand. Learning how to make the most of each kind of light begins with learning to see light as a distinctive visual component of every picture and is a decisive factor in determining how photogenic a subject may be. In many instances, the very decision to shoot will depend on the nature of the light.

Which of light's qualities are important to notice? The first is intensity, or how strong the light is. Another is the color of the light, which changes according to the time of day, the season, and the reflective surfaces in the surrounding environment. A third key consideration is the direction of outdoor light (usually the sun), which can fall on a subject from innumerable angles.

The point is that there is no right or best light. The influential color photographer Ernst Haas used to say that every light is the best light, if you know how to make the most of its distinctive qualities. Dim light can be dull or effective. Bright light can be dramatic or disturbing. Cool blue light can add mystery; warm orange light can create passion. It all depends. But to take advantage of light in every situation, the photographer must be aware of it, analyze it, and know how to utilize it, for the camera will record the light according to the instructions it is given. And the more keenly the photographer has understood the light, the more accurate those instructions can be.

The chapter, "Light Is Everything," discusses in detail how to make the best use of every kind of light.

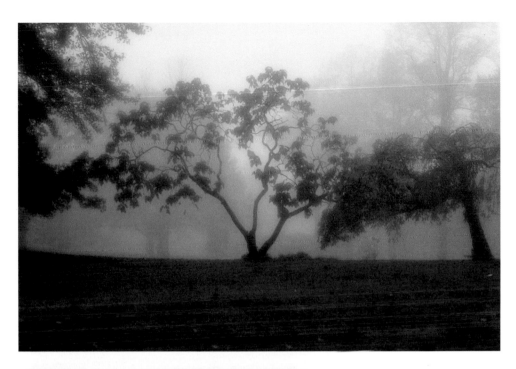

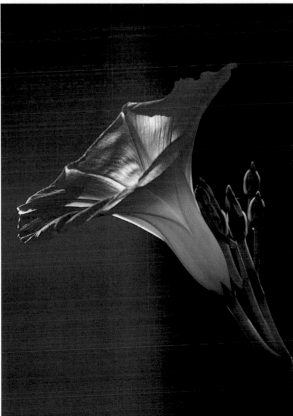

OVERLEAF. *The soft afterglow of sunset turned this cyclamen into a flower of ethereal beauty.*

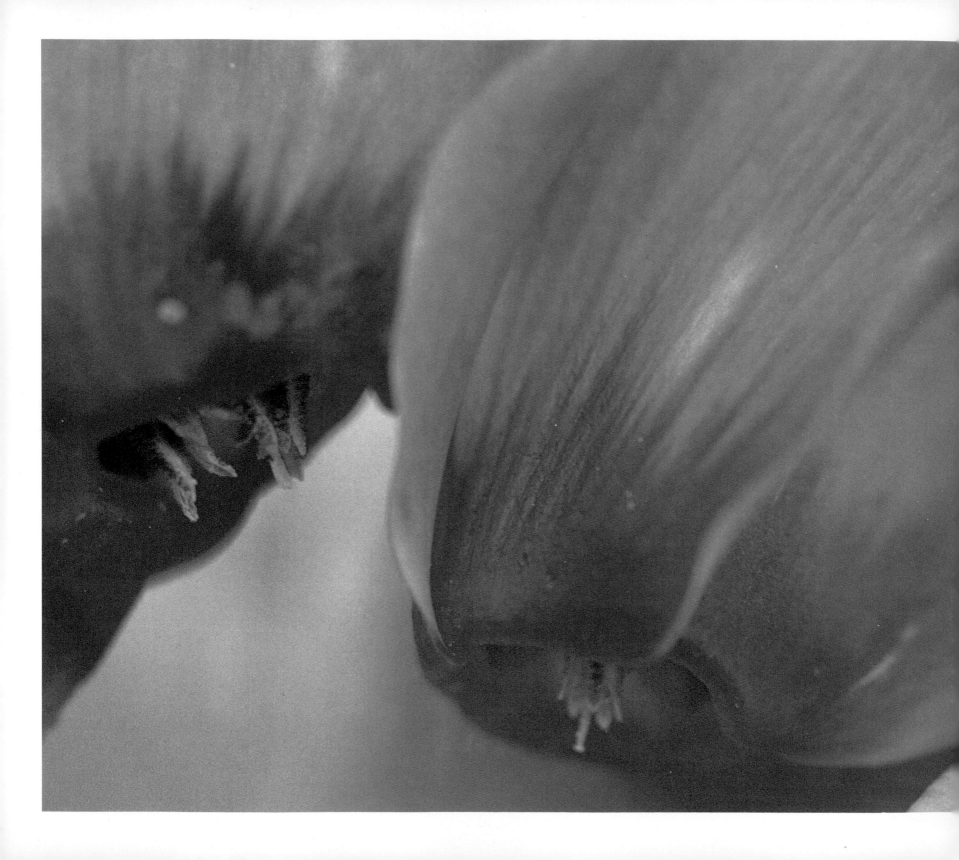

SEEING THE WAY

An appreciation of how *film* translates visual reality is just as important as understanding how a *camera* transforms what the eye sees. While the camera is primarily an optical and mechanical tool, film works on chemical principles.

One of the main distinctions between film and the human eye is that film has the ability to accumulate light. As long as there is some light—any light—available, and as long as the camera's shutter is released so the aperture is kept open, the light will continue to bombard the film. The speed of film, indicated by the ISO number, tells how quickly light will accumulate. But even a slow film can depict a dark cave as if it were in full light, provided an exposure of several minutes is used. This marvelous property of film makes it possible to produce images that reveal much more than the eye could see.

Film differs from human vision in other ways as well. No two films will render a scene with exactly the same color reproduction. Films vary in their tolerance to differences in light intensity, in the size of the grains in their emulsions, and in their sensitivity to specific light sources.

There are dozens of different films on the market, all of them potentially useful in flower and garden photography: black-and-white, color print film, color slide film, film at various speeds, and by different manufacturers. Ideally, the photographer will select the film best suited to the lighting conditions at hand and to the aesthetic effect preferred. That is not to say that there is one perfect film for each situation but to indicate that there will be differences in the photographic results given by different films, and that those variations should be considered when choosing a film.

As it is produced today, film is essentially a strip of celluloid treated with light-sensitive chemical emulsions. The chemical properties of a film vary with its type, its manufacturer, and even its particular batch. Professionals are so concerned with consistency in a film's rendition that they will shoot a test roll before an assignment and will use film only from that particular batch for the entire job.

Going to such lengths may not be necessary for the amateur, but it is important to test any film that will be used with regularity, or any film that one has never used before or which will be used for an important assignment. The primary purpose of such a test is to determine how each type of film, placed in one's own camera, will render a variety of light conditions.

A simple, all-purpose test is described in the appendix. Be sure to keep a record for every photograph so the results can be compared meaningfully. Running a series of tests with different films provides an invaluable lesson and, in the long run, will save an enormous amount of frustration, disappointment, and money.

Fujichrome film was selected to brighten the grayish green grasses surrounding these wild red poppies in the Loire Valley of France, producing a richer combination of color tonalities.

THE FILM SEES

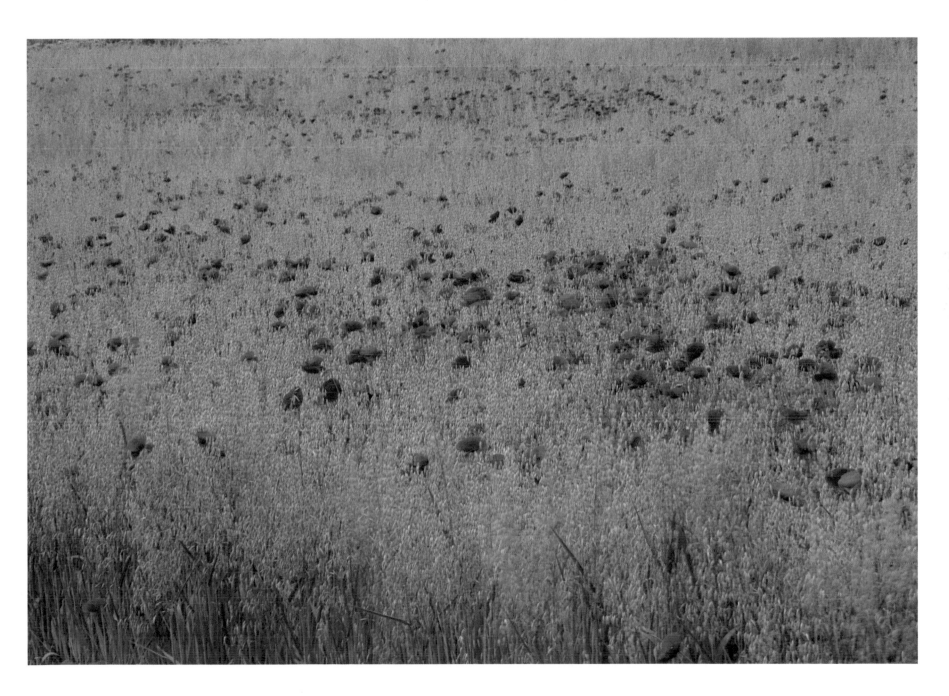

Color

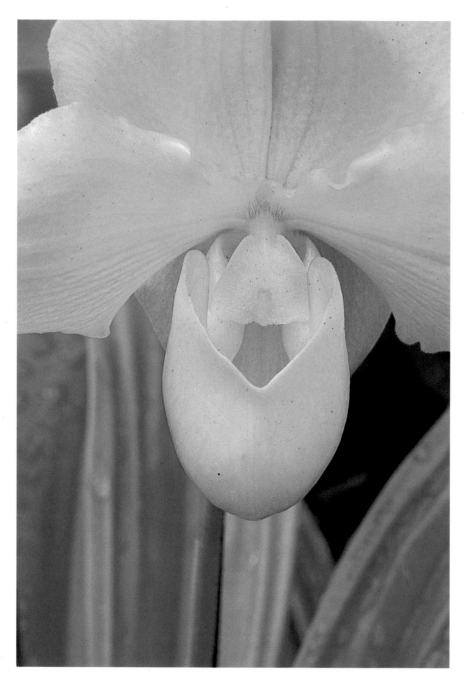

Film does not necessarily record color as our eyes see it. The reproduction of a particular hue is the result of that film's chemical reaction to light. And films by different manufacturers will render colors differently, even though they are of the same type—slide transparencies or prints, for example—and the same film speed. Photography magazines periodically test the various films on the market to compare their color reproduction.

To say that there is a difference between films is not to say which one is best. That becomes a matter of personal choice, but selection of film will matter if color reproduction is important. For example, Kodachrome reproduces blue flowers with a reddish magenta cast. Therefore, if accurate rendition of blue is an important ingredient in your photograph, try using either Fujichrome or Ektachrome or a color correction filter.

Another source of variation in color is exposure. Exposure refers to the amount of light that contacts the film and is based on the size of the aperture and the amount of time the shutter is released. Colors are not just hues, but intensities. A rich, deep color, referred to as a saturated color, is often achieved by some underexposure, while a pale tone or pastel is frequently the result of some overexposure.

Whatever the actual color of the subject the photographer must decide whether the final image will look best at settings other than those suggested by the meter reading. One consideration in that decision depends on an understanding of the film's response to the available light, based on its intensity, direction, and color. It is easier to overexpose using fast films—greater than ISO 400—and to underexpose slow films—ISO 100 or less. In bright desert light, where underexposure may be needed to saturate colors, a slow film would be advantageous, while in the dim light of a forest, a faster film would simplify overexposure. Where light is variable,

Fujichrome film helps bring out the variety of yellow tonalities in this orchid. An overexposure of ½-stop compensates for the relatively dim setting at a New York flower show.

*Kodachrome film adds warmth to the deep reds
of these Dutch tulips, and one stop underexposure
saturates the color further.*

midrange films from ISO 100 to ISO 400 offer greater versatility. Whatever the intensity of light, small adjustments in exposure can make the difference between an ordinary portrayal and one that shimmers with just the right colors.

A careful analysis of available light and an understanding of how the film will render it makes it possible for a photographer to create an image that surpasses, rather than merely records reality, transforming even the most everyday subjects into truly photogenic ones.

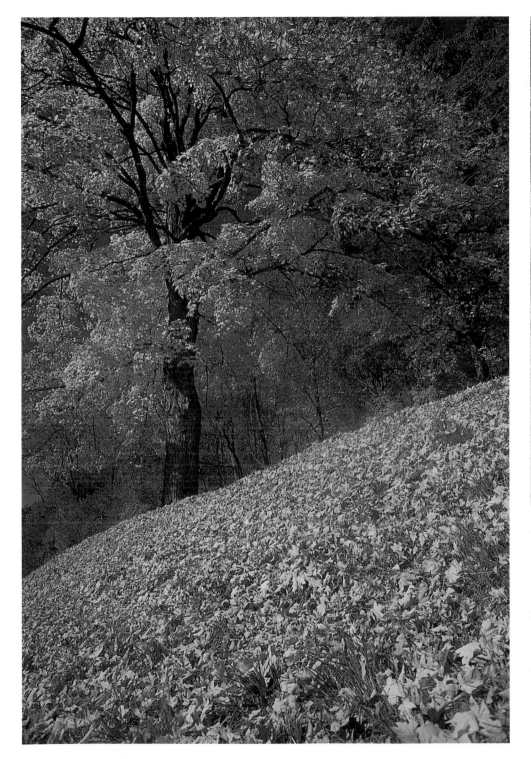

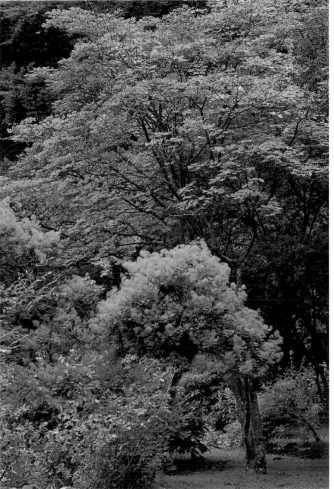

ABOVE. *In this Japanese garden in Courrances, France, a long two-second exposure was needed to provide enough light for detail in the flowering shrubs and trees. Slight movement in the foliage softens the image, while the choice of Kodachrome film enlivens the earthy colors.*

LEFT. *In autumn the brilliant golden tones of the fallen sugar maple leaves in a Westchester wilderness area are enhanced by using Kodachrome film.*

OPPOSITE. *The greens in this Texas field are given a fresh, young vitality by the use of Fujichrome film.*

Grain and contrast

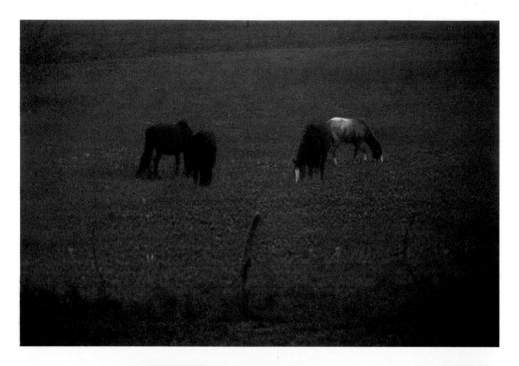

Film has still another property that can be used to the photographer's advantage when knowledgeably applied, namely latitude. Latitude refers to a particular film's ability to discriminate a range of shades between extremes of light and dark. Simply put, this means that some films exaggerate the contrast between tones—they see things in terms of "black and white"—while others are able to distinguish many shades of gray. As in politics, those which make the finer distinctions are more "tolerant," or have greater latitude, than the others.

What causes the difference in latitude are the grains of silver oxide embedded in the film's emulsion. Many fine grains make for greater latitude than fewer and larger grains. In general, slow films of 25, 50, or 64 ISO have greater latitude and finer grain than fast films of 400 ISO and up.

Seeing the way the film sees is equated to deciding on the amount of grain and contrast suitable to the final image. On a bright day, a garden scene may be cast in the extremes of black shadow and harsh white light. Does the photographer wish to exploit the natural high contrast by using a high-contrast film? Or would it be better to soften the extremes of light and shadow? On an overcast day, when light is even and low in contrast, the various shades of green in a grass garden may lose their definition and distinction unless the contrast is increased. On the other hand, the soft pinks of roses can be made still softer by playing to the low-contrast light.

The visibility of grain, called graininess, can be a distracting nuisance when inappropriate, but it can also be wonderfully evocative when purposeful. Photographs taken in snow, rain, or fog often gain an aura of mystery through a grainy appearance. A simple way to achieve this painterly effect is to "push" film by setting the camera's ISO number to a higher than actual level. Be sure

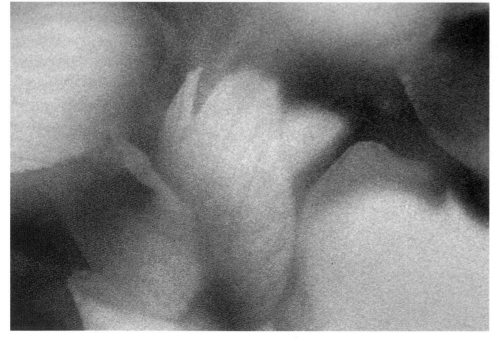

TOP. *Film rated ISO 1600 was "pushed" to ISO 3200 to exaggerate the grain on this Texas scene of horses in a field of bluebonnets.*

LEFT. *An abstract close-up of roses was given visual interest through graininess produced by "pushing" film rated ISO 400 to ISO 1600. A long telephoto lens with a magnifying filter further softens the image.*

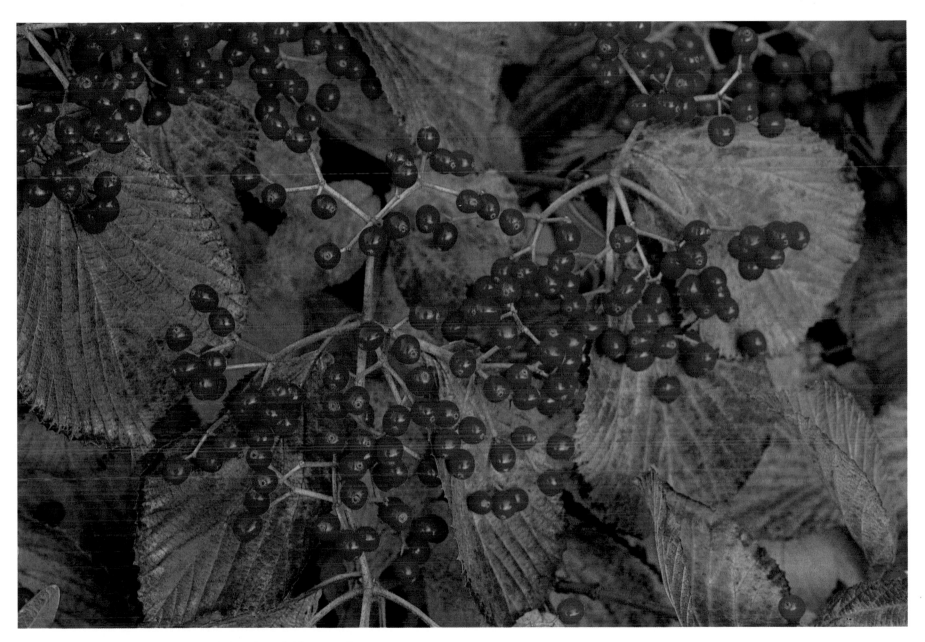

to instruct the processor of the altered film speed. Most films using E-6 processing, such as Ektachrome and Fujichrome, can be pushed to twice and even three times the original speed, each time increasing the grainy quality.

The fine grain of slow film produces the clarity and sharpness in this close-up view of viburnum leaves and berries.

PRE·VISUALIZATION

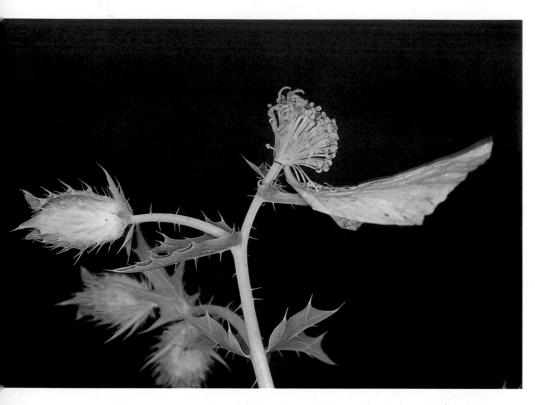

ABOVE. *An understanding of what is photogenic and the ability to previsualize led to this image of a Texas thistle well past its prime. The balletic movement, muted colors, and varied textures are spotlighted against a shadowy field turned black by the use of electronic flash.*

OPPOSITE. *A careful search through a low growing border at The New York Botanical Garden led to the discovery of these drooping peonies. The tight bud of one peony resting against the full head of another evokes a "mother and child" image.*

Edward Weston was the first to articulate the concept of previsualization, an idea that every serious photographer today must eventually absorb and integrate as the basis for every release of the shutter. Previsualization refers to the creation of a clear mental image of the photograph *as it will appear,* based on the photographer's prior analysis of the visual elements of a scene or subject, together with a full understanding of how the film and camera can be manipulated to produce the desired result.

The most important dimension of this powerful idea is that it is the photographer's imagination that guides the photographic process. The equipment constitutes the tools with which the imagined photograph is ultimately created. Every photograph, then, is to some degree a distortion or manipulation of reality in the service of the photographer's inner vision. The implication of this approach is that the photographer must have such an inner vision—and be aware of what it is—if the photographic product is to succeed.

How does one develop inner vision, or the ability to previsualize? Some fortunate few have it naturally. These are the people who know exactly what they want to show in their photographs; they see the image in their mind's eye. For those who fall into this category, the task is simply to master the technicalities of their gear, or to understand the cause and effect relationships of the camera settings, film choices, lighting options, and so forth, and to practice using the equipment until it becomes as automatic as driving a car.

Most photographers, however, are not so clear in their purpose. They respond to something they see, but they are not certain what drew their attention and admiration. And since they have no clearly articulated goal, the chances are that they will not use their equipment to achieve their objective. Imagine being presented with some fine lumber and a set of excellent carpenter's tools but not knowing what to make: a garden bench, a bookcase, a chest of drawers? In the same way that the finished product must first be imagined in carpentry, it must be delineated in photography.

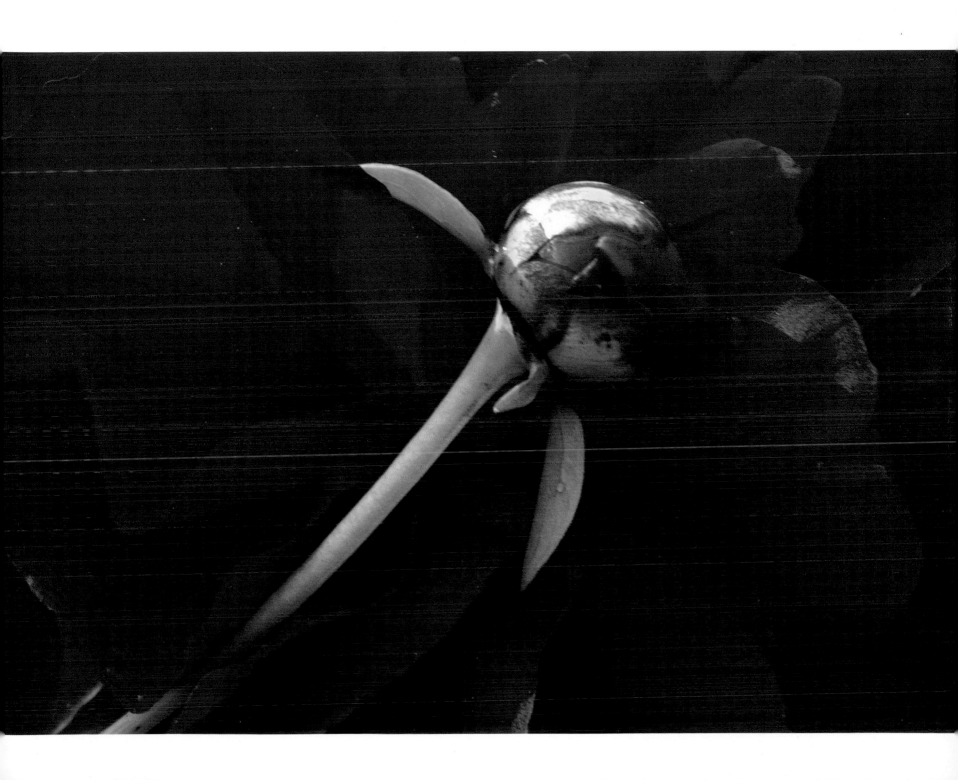

Aesthetics

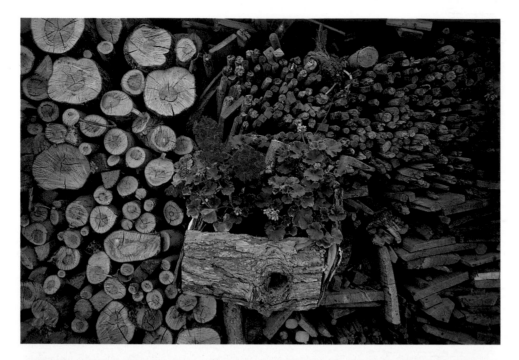

All the elements that have been considered thus far—framing, composing, analyzing light, understanding color, grain and contrast, and the relationship between foreground and background—are important components of the aesthetics of a photograph. Ideally, the photographer exercises complete control over all these matters in the service of a personal vision.

To come even remotely close to achieving perfect control requires the ability to previsualize. Teaching oneself to make a habit of previsualizing takes the utmost in determination and concentration, even for experienced and professional photographers. Despite the messages of clever advertisers, instant and automatic cameras cannot make the aesthetic judgments needed to produce images of outstanding quality. Dedication to that goal begins with a clear mental picture of the photograph as it should appear. Once that is clear, the various decisions about camera settings and options become fairly straightforward in time.

Let's consider the steps involved as if they were on a mental checklist. Imagine the finished photograph. What has been included within the frame? How can that framing best be achieved in terms of the choice of lens and the position of the camera? What provides compositional organization or unity within the frame? Is the background to be included, and, if so, will it be sharp or blurred? Which settings and/or lenses will help achieve the desired effect? How is the available light rendered in terms of quality and intensity? Is the color in the mental picture deeper or paler than it really is? Which camera settings and film choice will produce the imagined colors? Is the scene one of high or low contrast? Does the previsualized image adequately consider contrast by working with it or compensating for it? What is the best way to take a meter reading under the circumstances? If the scene is in dim light, will it photograph effectively at slow speed or with supplementary light, or can it be aesthetically reproduced by pushing the film, even if this makes the image grainy? If the subject is in motion, should that motion be frozen at fast speed or with supplementary light, or should it be incorporated as a delicate blur? Whether we like it or not, there are no shortcuts by which such decisions can be eliminated. Not, at least, if we care about the pictures we produce.

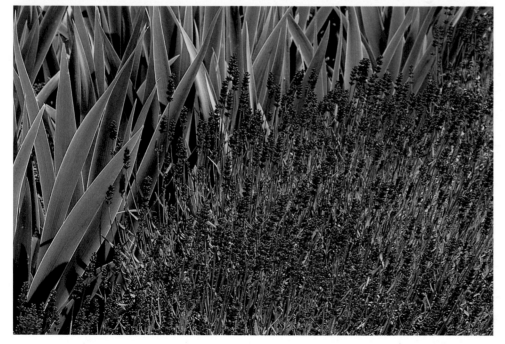

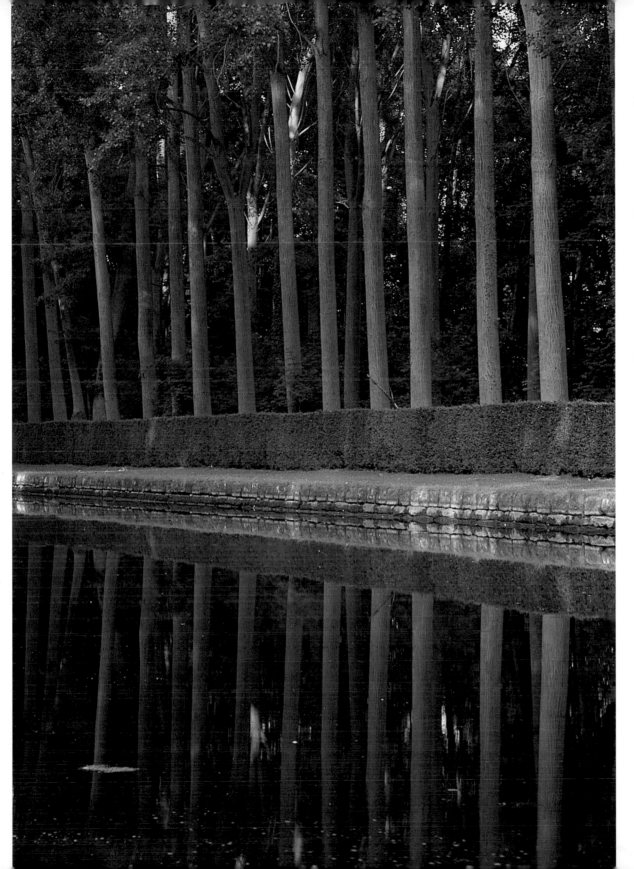

LEFT. *Film rated ISO 50 was "pushed" to ISO 100 for aesthetic reasons to intensify early morning highlights. The row of poplars in the gardens of Courrances, France, could thereby be seen in greater contrast with their dark surroundings.*

OPPOSITE TOP. *These ordinary geraniums in an improvised log planter were found hanging in front of a woodshed in Switzerland. This picture becomes aesthetically pleasing by placing the floral subject in the center of the frame and by including the cut ends of the logs and twigs as a charming backdrop.*

OPPOSITE BOTTOM. *A telephoto lens was chosen for the aesthetic effect of compressing and contrasting the different textures of the sharp-edged grasses and the spikes of lavender.*

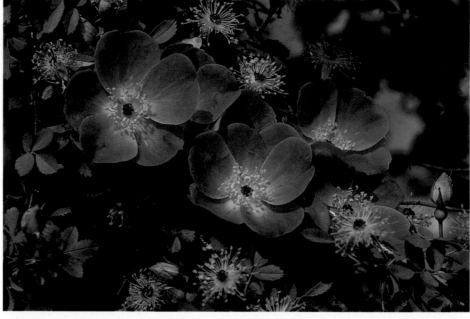

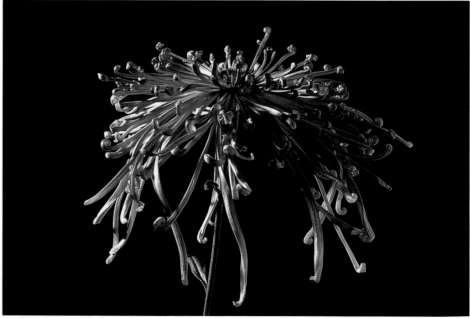

ABOVE. *A photograph can portray flowers at various stages of their life cycles, as shown by these blossoms at Giverny in France. Here, several flowers are at their peak while the rest have aged.*

TOP RIGHT. *A "family portrait" of these Rosy Wing roses—with some members in full bloom and others past their prime—is achieved in strong daylight which creates deep shadows, setting the flowers apart from their shrubby surroundings.*

RIGHT. *A straightforward portrait of this chrysanthemum is enhanced by isolating the flower with a telephoto lens and photographing it against a shadowy backdrop.*

Documentation

Deciding what a photograph is documenting is less onerous for some than weighing all the aesthetic options that need to be considered before releasing the shutter. In flower and garden photography one is especially apt to forget that each image should be about something. It need not be a documentary illustration, but it should contain some information. Using previsualization, the photographer should have a clear notion as to what subject is being documented with each shot.

On the simplest level, such documentation could be nothing more than showing what a particular flower species looks like. There is nothing dishonorable about such a goal, and if it is combined with the proper aesthetic decisions, the result could be a most evocative portrait—rather than a floral "mug shot" so often in evidence.

Alternatively, why not document the parts of a flower. Those interested in close-ups might venture into a blossom's interior to document its structure. There are also wonderful opportunities to show the less commonly depicted side of flowers, such as the underside or the back. Even a petal can be beautifully portrayed. Or show a flower at some stage other than in perfect bloom.

Photographs of garden details can document the juxtaposition of groups of flowers in terms of their color, shape, or texture. For broader garden vistas, elements of design can be revealed with the camera. The photographer can pinpoint the geometry of a garden layout, the use of paths and borders, and the placement of sculpture, gazebos, and other structures within the larger framework. The photographer may also choose to show the way trees form linear avenues or soften the harder architectural elements within a garden setting.

While there is no end of interesting subject matter in a garden, it is not always clear what one wants a specific photograph to show. When thinking about what is being documented, it sometimes helps to imagine a finger pointing at the critical subject, as if to say, "Look at that!" And *that* is what the photograph should focus its attention on. Previsualizing the image, as this phantom finger would indicate it, is another step toward successful photography.

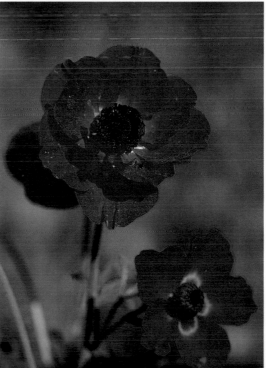

ABOVE. *This portrayal of the conservatory dome behind a bed of tulips and a magnolia tree documents spring at The New York Botanical Garden.*

LEFT. *For identification purposes, a straightforward portrait, such as this pair of anemones, is useful as a document.*

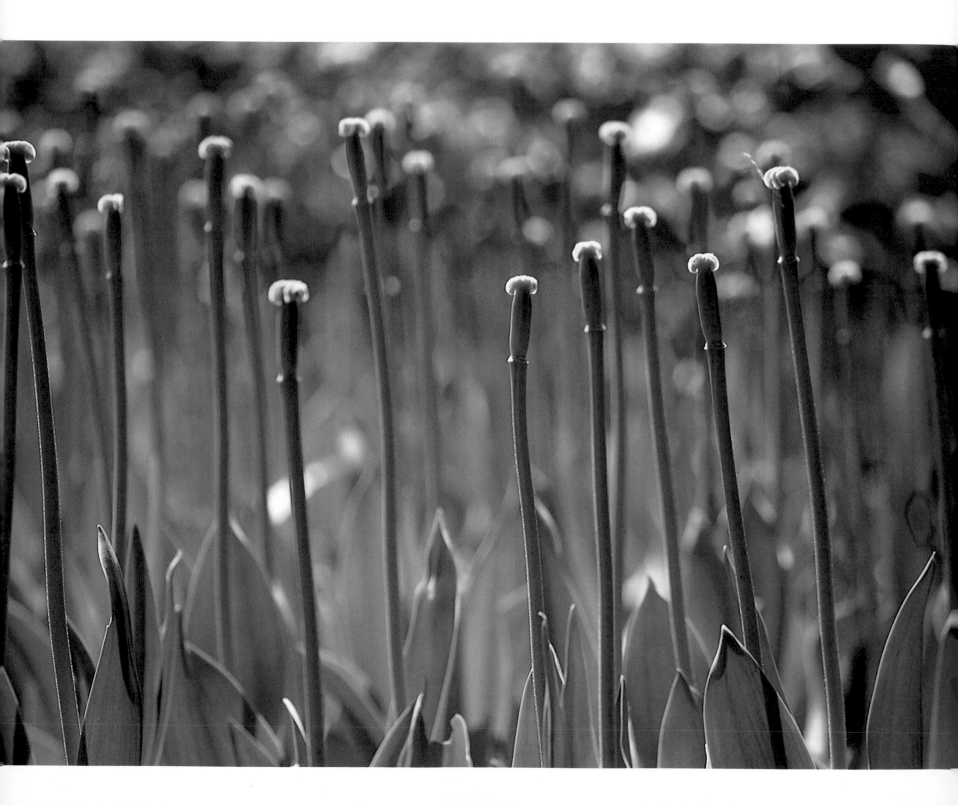

Editorial view

Perhaps the most difficult achievement in any art form is what is sometimes called a personal style or signature—those factors that make a work recognizable as belonging to a particular individual. It may be the quality of a singer's voice, a painter's brushstroke, a violinist's tone, a dancer's stage presence, or a writer's syntax. Most often a personal trademark is a combination of elements, some verging on the philosophical, the psychological, the emotional, and even the mystical.

In this same way, a photographer tries to develop a personal vision. Each photographer, wittingly or unwittingly, imposes an editorial view on everything he or she chooses to portray. Beginning with the subject itself, continuing to a preference for—or an aversion to—certain equipment, to a leaning toward particular perspectives, colors, moods, and types of film, nearly everything a photographer does in the exercise of the craft has the potential for becoming an artistic statement.

Returning to the idea of previsualization, the photographer with a strong sense of purpose, a well-defined understanding of his or her way of looking at the world—whether based on aesthetics, emotional responses, or even political allegiance—can consciously impose that point of view on the raw material the world presents.

The photographer of flowers and gardens has a difficult task in this respect. To begin with, the subject is already delineated and therefore somewhat restricted. We bring to it a lifetime of associations, preconceptions, and stereotypes. We have learned to see flowers and gardens in a certain way, and we must unlearn those habits if we want our vision to emerge with originality.

Moreover, people's expectations of floral and garden photography have been shaped by their exposure to an existing body of artistic images. Many of these images are wonderful inspirations, opening our eyes to possibilities we may not have thought of, and we tend to want to mimic them or borrow our way of seeing from them.

Learning from the past, by trying to reproduce or duplicate images, certainly has its place. It shows us the difficulties of achieving what others have done and trains us to discover techniques we may not have otherwise attempted. That, in fact, is the spirit in which innovations occur. The chapter on masters of flower and garden photography reflects upon the contributions, over the 150-year history of photography, of the pioneers and explorers whose portrayals of flowers have become embedded in our collective unconscious.

Discovering an individual perspective in light of these magnificent inspirations is the photographer's ultimate challenge and a lifelong pursuit.

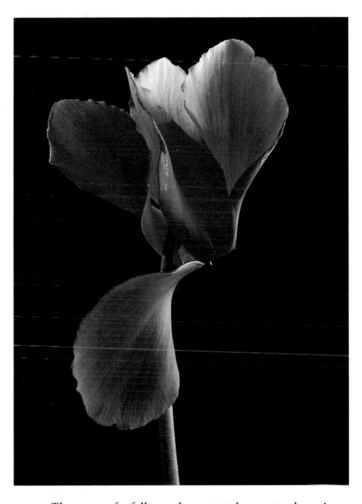

ABOVE. *The curves of a fallen cyclamen petal suggest a dancer's movement held in repose. To dramatize form and color in this portrait, studio lighting was used.*

OPPOSITE. *This mini-forest of tulip stems offers strong vertical lines for composition, beautiful light on each tip, rich colors, and a backdrop of negative space, created by taking a low perspective.*

2
Visual Tools

"The camera should be an extension of your eye, nothing more."

ERNST HAAS, 1971

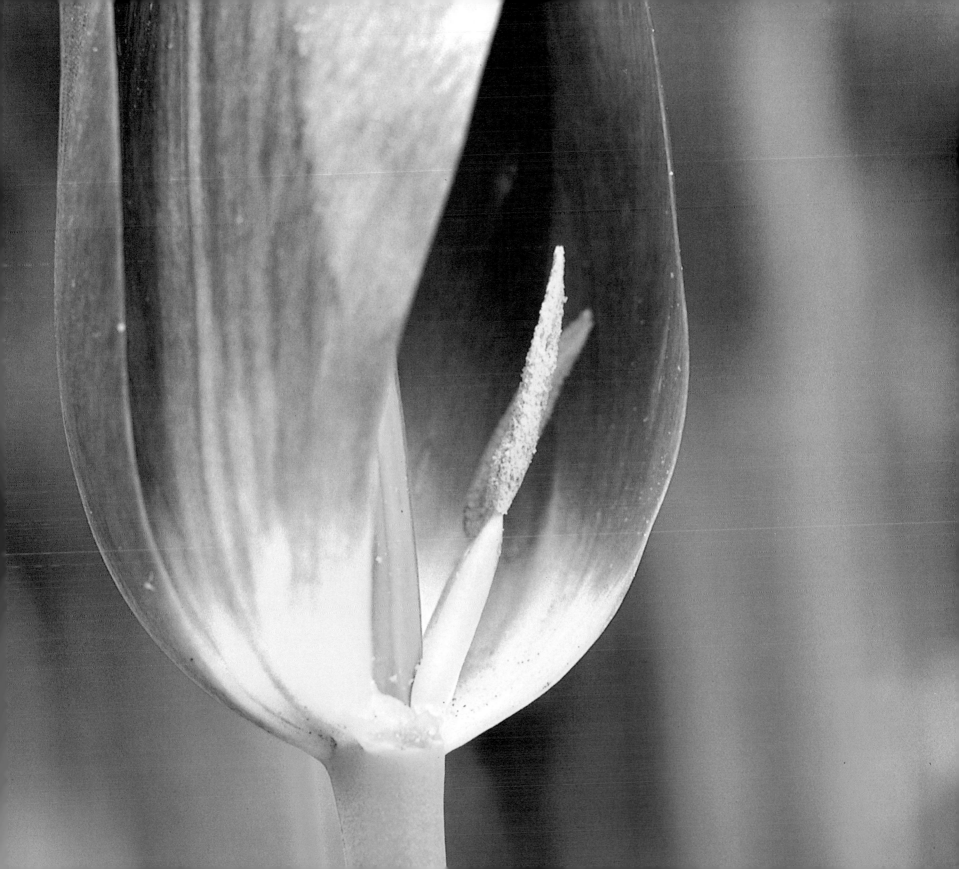

CAMERAS

Photographers of the past, and even a few pure souls today, have managed to create images of great beauty and charm with equipment as basic as a pinhole camera. Yet among aspiring photographers a great source of insecurity is the fear—encouraged by advertisers and salespeople—that quality photographs depend more on equipment than on the photographer's skill. A bag full of gear is supposed to ensure outstanding results, but nothing could be further from the truth.

Our advice to students is to develop their skills to the utmost with the equipment they have now—or to purchase the best they can afford of a few essentials—before venturing into the money pit of gear accumulation. But let us assume that we are working with a camera of some sophistication. For photographing flowers and gardens, a 35mm single lens reflex (SLR) camera is a good starting point. These small cameras have a number of advantages. They are relatively light and portable. They accept a variety of interchangeable lenses for greater latitude in framing and composition, and they can be equipped with some useful accessories.

Though passionate defenders of one make or another will argue the virtues of their favorite, all the major 35mm SLR camera manufacturers today produce a fine piece of equipment. Differences in camera quality do not account for the differences one sees in photographic results.

Professionals, by the way, often prefer a certain company's product not because of its superior optics but because of its superior resistance to the constant abuse that their equipment must endure. Reliability, ruggedness, and ease of repair can outweigh strictly technical advantages for the professional.

Which brings us to another bugaboo: how sophisticated should a camera be? Today's cameras are computerized wonders. Nevertheless, professionals still swear by manual cameras, which are increasingly hard to come by. Automatic cameras are today's norm and are beneficial for general photography, especially for action shots, when careful exposure is less critical than capturing the instant. But in garden and flower photography, there is time to fine-tune settings for the aesthetic advantages they afford. Therefore, we would caution every serious photographer to make sure there is a manual override in any automatic camera being considered for purchase. Autofocus cameras are for those who want snapshots, not photographs. And the marvels of digital cameras are only in the experimental stage.

The simpler the camera, the easier it is to understand, and the cheaper it is to maintain. Computerized cameras are useful in specific, limited situations, but they can never do all the thinking for you. They can make the easy decisions, but not the difficult ones that make the difference between adequate and excellent results. A simple 35mm SLR, used with precision and purpose, will serve you well for many years.

Flower and garden photographers sometimes turn to medium- and large-format cameras, such as 2 1/4 by 2 1/4 inches, 4 by 5 inches or larger. Such cameras can solve particular problems that a professional photographer may encounter. For example, some magazines request large-format transparencies for reproduction to achieve greater sharpness and detail in shadow areas. Large-format cameras also make it possible to maintain parallel lines for architectural photography.

The vast majority of the photographs in this book were taken with 35mm SLR cameras, using slide film. That is what we recommend.

PAGES 42–43. *Close-ups, such as this one of a tulip, with its interior structures visible, require the special equipment of a macro lens for high magnification and short-distance focusing, and a tripod to ensure steadiness and sharpness.*

OPPOSITE. *A camera that allows the photographer to control shutter speed was important to this portrayal of a garden fountain in Courrances, France. A ¼-second exposure time was needed to retain movement in the water, turning it a milky white.*

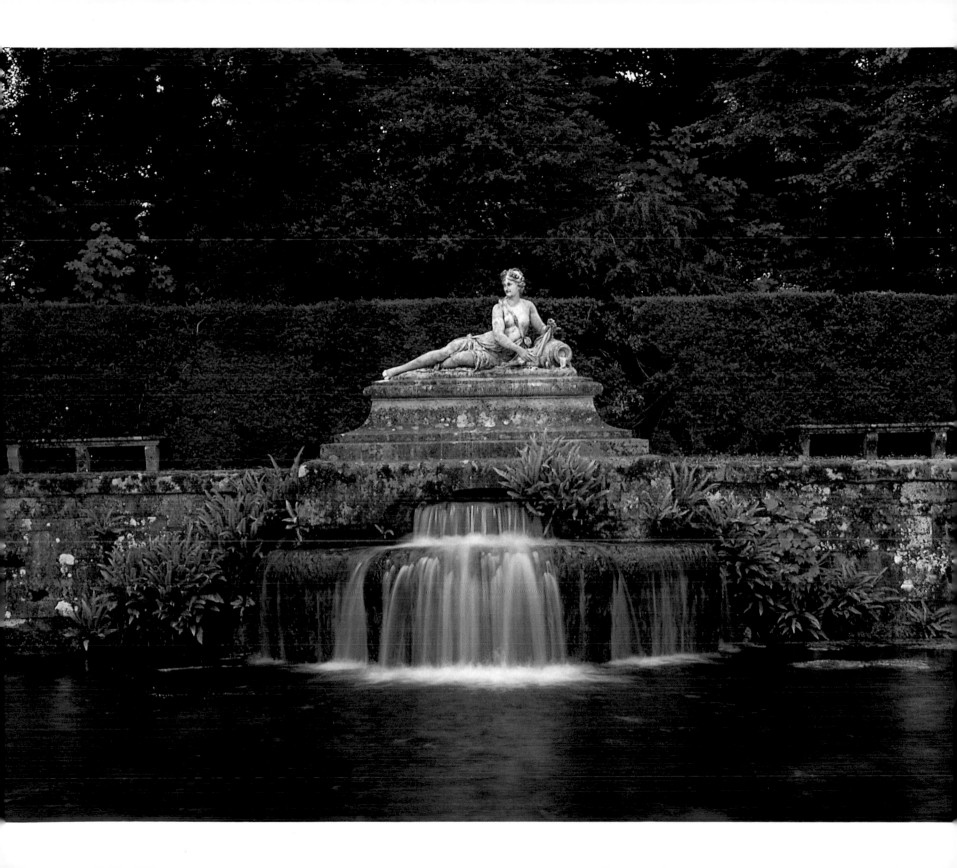

LENSES

Lenses last for many years, so they should not be purchased frivolously. By exploring the scope of one lens and determining through experience what it can and cannot do, a photographer develops a true appreciation of that tool. And if the photographer finds that some other lens is required for the images he or she wishes to produce, then the photographer's interest and direction will dictate a new purchase.

Ernst Haas once said that he often took only one lens with him when he went photographing. The discipline of having to make the most of that one lens was a deliberate exercise designed to stretch his imaginative powers and to force him to explore the world more creatively.

One student on a photographic journey in West Africa discovered the same thing. We told him to leave his camera bag in his room and take only the lens on his camera, plus one he could fit in his pocket. He was immediately less burdened, not just because his gear was left behind, but because his decisions were more clearcut and limited. Knowing that there were only certain types of photographs he could take, he concentrated on making them as good as possible. His best photographs, he said after the trip, were taken when he had only one or two lenses with him.

Much more important than how many lenses to own, or which lenses are best, is developing a clear perception of what each kind of lens can do to enhance an image. Lenses are tools that can open creative and expressive possibilities to all photographers, provided they are used knowledgeably and purposefully.

Lenses vary according to three main factors: sharpness, speed, and focal length. Sharpness is something that concerns certain professional photographers to such an extent that they will test several identical lenses by the same manufacturer before choosing one to buy. However, it should be mentioned that tests performed by reputable photography magazines have shown that there is no significant difference in sharpness among lenses manufactured by the major optical companies. Some brands have achieved a reputation for greater sharpness,

which has often led to inflated prices. For most photographers, differences in sharpness are related less to lens quality than to care and precision in its use.

Lens speed is indicated by the f-stop for the maximum aperture to which each lens can be opened. We consider anything below f/2.8 a fast lens for the purpose of flower and garden photography. The faster the lens, however, the heavier and larger it is, and the more expensive. Also, the additional glass needed to increase the speed serves to decrease the lens's sharpness. The advantage of a greater lens speed is that it enables the photographer to shoot under lower light conditions. But this is of no major benefit for flower and garden photography, since we strongly recommend using a tripod.

Focal lengths range from extreme wide-angle fish-eye lenses—as short as 6 mm—to extreme telephoto lenses—up to 2000mm. For flower and garden photographers, the most useful lenses are in focal lengths from 28mm to 200mm. Within this spectrum, the photographer can discover numerous opportunities in framing, the main purpose of changing focal lengths.

Zoom lenses offer photographers a continuous range of focal lengths within a single instrument, some even spanning everything from moderate wide-angle to telephoto. Some photographers scoff at these lenses as the domain of the undecided or the lazy. Zoom lenses do, in general, trade off optical precision for flexibility and convenience, which is why absolute purists (including many professionals) do not use them. However, they also open up wonderful possibilities for composition and, especially for those who are traveling far from home, they often mean the difference between taking a camera along at all or leaving it back in the room. While there is no such thing as a true all-purpose lens, there are times when a zoom lens comes close. Zoom lenses of 35mm to 70mm, 28mm to 48mm, and 80mm to 200mm have proven most useful in our flower photography.

Now let's consider the most common classifications of lenses, with a particular eye to determining the advantages of each for flower and garden photography.

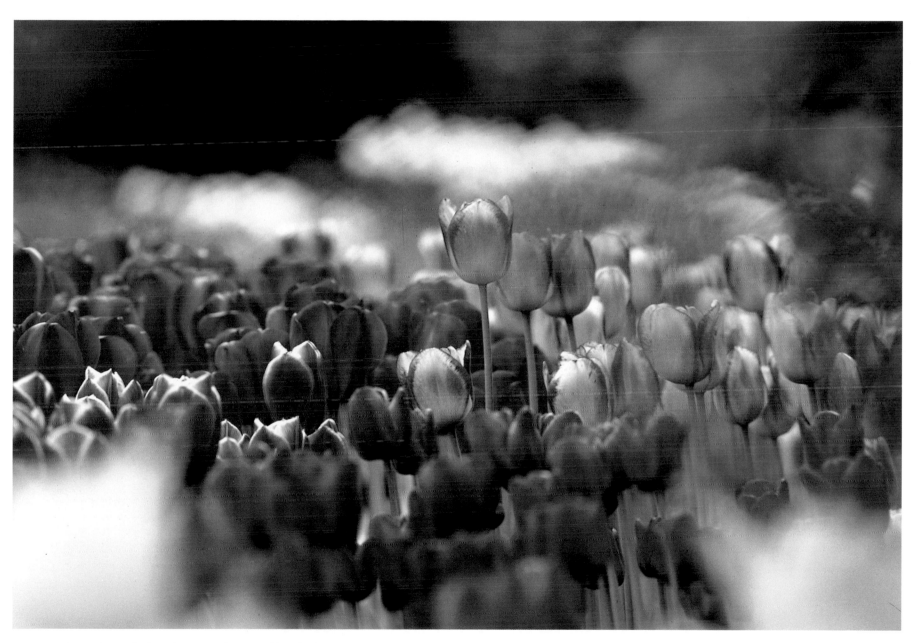

A very long telephoto lens was chosen to blur the foreground and background tulips so that only a selected cross section of the flower bed remains sharp.

Normal lens

A normal lens can encompass the foreground and background, as in this landscape in Israel.

Most 35mm SLR camera bodies are sold with the so-called standard lens (45mm to 55mm). The main advantage of this lens is its affordability and versatility. It is relatively light, especially at a speed of f.2, which is quite adequate for photographing flowers and gardens. Faster lenses are not worth the extra expense since they are heavier, less sharp, and are not really needed for non-action photography.

This lens is especially suited to capturing landscape scenes and garden details at moderate distances. At more than 20 feet, a normal lens can encompass enough of a garden to reveal aspects of design, without distorting the perspective as seen by the eye. Its relatively shallow depth of field makes it possible to photograph a few flowers at close range (2 feet or so) by throwing the background out of focus.

A normal lens can even be adapted with accessories that enable the photographer to get closer to the subject and produce true close-ups. The best of these options are extension tubes, which are placed between the camera body and normal lens. These are discussed in greater detail in the chapter on close-ups. Magnifying filters, which screw onto the front of the lens, are available, but they tend to degrade the image slightly.

Those who already own a camera with a normal lens can certainly create lovely photographs. We encourage photographers to discover the full range—and the limitations—of this lens through extensive experimentation before contemplating the purchase of any additional lenses. That way, the new acquisition will fill a real need, one that cannot be satisfied with the standard lens.

However, for those who do not yet own a 35mm camera but are planning to buy one, we recommend omitting a normal lens altogether in favor of a 55mm macro lens. Such a lens serves the same purpose as a normal lens, but has the added benefit of its close-up capabilities, which are invaluable to flower photography.

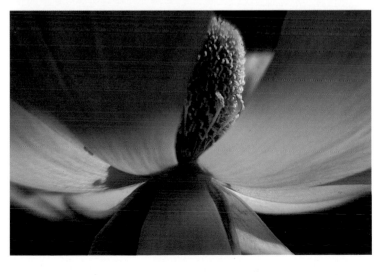

RIGHT TOP. *Normal lenses are also ideal for details which portray groups of flowers in gardens and wild places. This lawn of Dutch spring crocuses is depicted as an abstract composition.*

RIGHT CENTER. *Moderate close-ups, such as this one of colorful poppies in a Tucson, Arizona, garden are easily taken with a normal lens at its closest focusing distance. However, the smallest aperture should be used to maximize depth of field.*

RIGHT. *A magnification of ⅓ of life size was achieved by photographing this tulip with a +2 diopter on a normal lens.*

Wide-angle lenses

Wide-angle lenses, as their name implies, are uniquely designed to encompass a broad viewpoint, and they are especially valuable for photographing gardens or nature. They range from 35mm to the extreme of a 6mm fisheye lens, but we recommend those from 35mm to 28mm, because they are less likely to distort the image as a wider angle lens will do.

Wide-angle lenses can dramatize garden and wildflower scenes by enlarging objects in the center and foreground of the frame. Since it is possible to get relatively close to a subject—as little as one foot away—a few flowers in a garden or field can be prominently featured, with the rest of the scene still visible within the frame.

In addition to their broad field of vision, wide-angle lenses are also noted for their great depth of field. These features open up new compositional opportunities. It becomes possible to combine a bold floral subject in the foreground with an expansive view of the setting in the background, keeping both reasonably sharp. This is an important difference from the telephoto or macro lenses, which can magnify the foreground, but severely limit the scope or sharpness of the background.

When the background remains a visible component of the composition, the photographer should carefully con-

ABOVE. *An extreme wide-angle lens was chosen to enlarge the seaside roses in the foreground, while showing their relationship to the Maine coastline setting.*

RIGHT. *Because a moderate wide-angle lens exaggerates distances and strong converging lines, it was chosen to underscore the third dimension in this documentary view of the gardens of Versailles.*

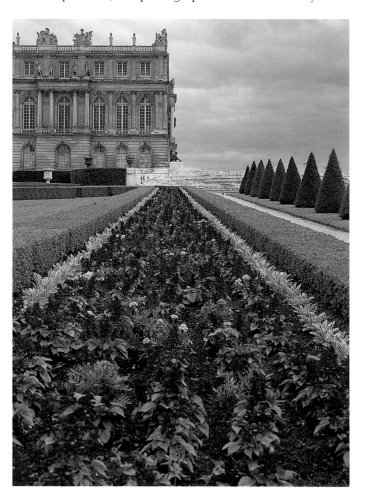

sider its relationship to the primary subject and be sure that it serves a meaningful purpose. Unwanted surroundings can be thrown out of focus by reducing the depth of field. As a rule of thumb, however, the wide-angle lens is preferable if the setting is vast and warrants inclusion. If the backdrop is distracting or unimportant to the visual impact of the photograph, a normal, macro, or telephoto lens may be preferable for filling the frame with a few flowers.

Some words of caution: exaggerating the center foreground can become problematic if the wrong object is given prominence. Special care should be taken with paths, which can dominate an otherwise effective composition. It is also wise to keep in mind that wide-angle lenses tend to curve or bend straight lines at the edges. Garden photographs that include buildings; structures, such as trellises or gazebos; or other straight-line objects such as tall trees at the periphery must be composed carefully with this lens to minimize such distortions. To achieve truly parallel lines, where these are essential, more complex lenses, such as those with perspective control (PC lenses), may be necessary.

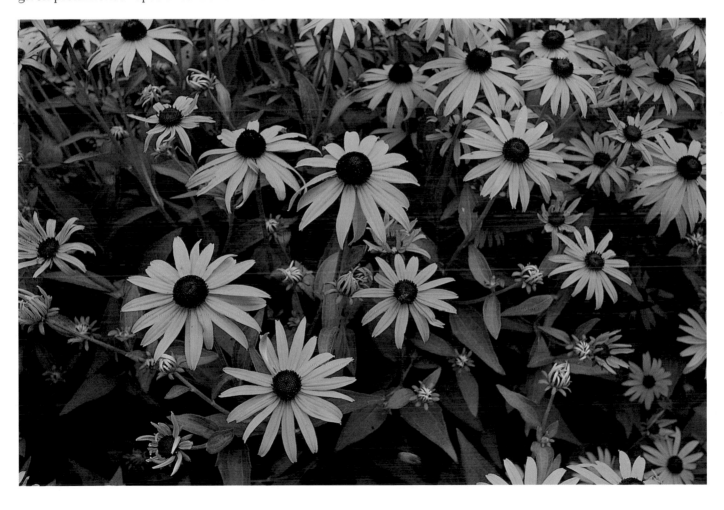

Wide-angle lenses at their closest focusing point can produce moderate close-ups, such as this one of black-eyed Susans.

Telephoto lenses

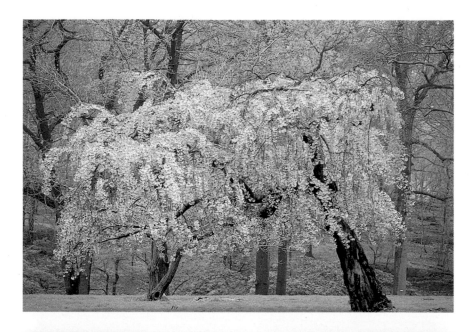

Although the telephoto lens is generally associated with long-distance photography, for the flower photographer this lens has very special capabilities. In fact, it is an invaluable tool even at relatively short distances.

Telephoto lenses are available in many focal lengths, from 80mm to 800mm. The longer the lens, the heavier it will be, and the harder to hold steady. Because all telephoto lenses exaggerate "camera shake," they should be used with a tripod—a necessity for lenses longer than 200mm. For flower photographers, the most useful focal lengths are those between 80mm and 200mm.

The most salient feature of telephoto lenses for the flower and garden photographer is their ability to compress space and reduce depth of field. At relatively short distances, between 10 and 15 feet, a telephoto lens enables the photographer to soften foregrounds and backgrounds by throwing them out of focus or to obliterate unwanted distractions in front of, or behind, the primary subject. The pictorial result is a "slice of space" or a cross section of flowers isolated from its surroundings.

At moderate distances, between 15 and 30 feet, the telephoto lens's ability to compress space makes it possible to juxtapose colors more emphatically. Groups of brightly colored flowers that may be several feet apart can be made to appear closer together because of the foreshortened space. If color is the main attraction of a photograph, the telephoto lens can enrich the image by concentrating a single color or pushing nearby colors into closer proximity. This is especially desirable in fields of wildflowers, which are not massed as garden flowers often are, and which are often subtler in their colors.

Beyond 30 feet, the telephoto lens serves to magnify and give prominence to distant subjects. It does wonders for framing a group of flowers within a garden or isolating a portion of a field. It lets us reach over obstacles, such as a bog or a pond, to capture a lovely floral scene. It enables us to retrieve an inaccessible spot of beauty—among pines or across ravines. Because it compresses space and distance, the telephoto lens can reveal elements of a garden's design that can be seen only from a distance, while maintaining a sense of nearness to the scene. Placing magnification filters on a telephoto lens produces a soft-focus, romantic effect, which many find attractive.

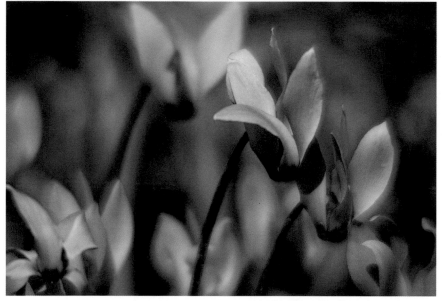

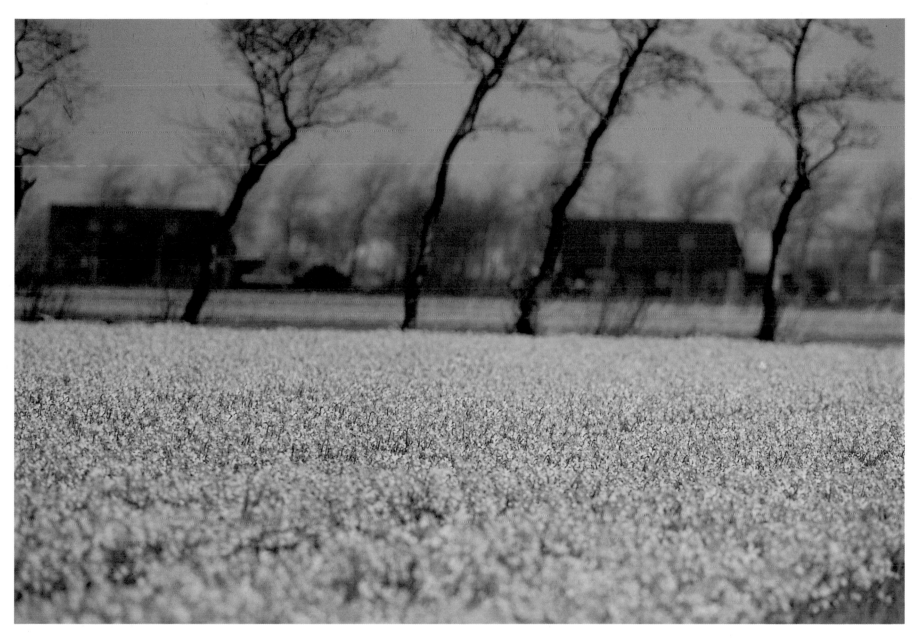

ABOVE. *These rows of daffodils in Holland were rescued photographically with a powerful telephoto lens. A 600mm lens concentrated the bright yellow flowers and softened the background for an effective abstract composition.*

OPPOSITE TOP. *At a distance of 150 feet a telephoto lens magnifies this weeping cherry tree, concentrates the white of the tree's*

blossoms, and compresses the deep space behind it into a flat, dark backdrop.

OPPOSITE BOTTOM. *At a short distance of 10 feet, a telephoto lens can isolate a "slice" of a scene. Here a wild cyclamen found in the Galilee is in sharp focus, while the others softly echo its fluttering, upswept form.*

Macro lenses

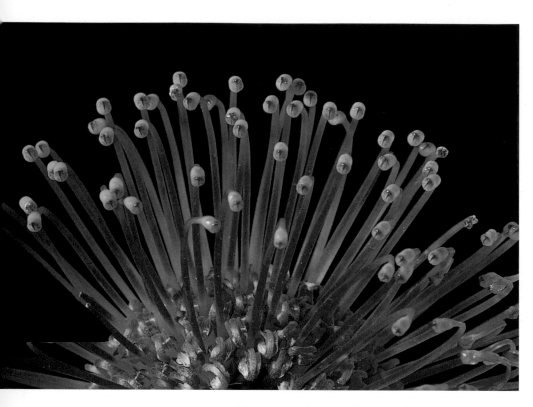

The term *macro* is applied to lenses that can be focused to distances shorter than their focal length, a feature that makes it possible to produce superior close-ups. Macro lenses come in various focal lengths, from 55mm to about 200mm. The beauty of the 55mm macro lens is that it also functions as a normal lens. Since it can do double service, it is well worth the extra expense, especially if it is purchased with the camera body instead of a normal lens.

The 55mm macro is the lens of choice for those who want to do a lot of photography at less than 2 feet from a subject. Anyone serious about flower photography will want to invest in this macro lens at some point because it

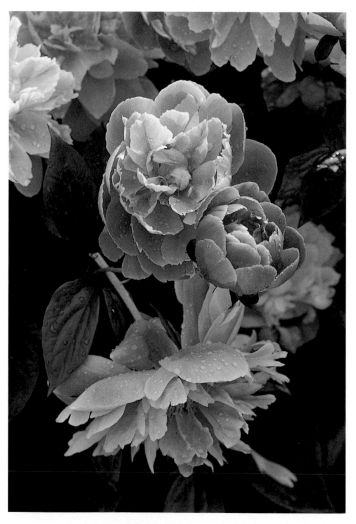

ABOVE. *A 55mm macro lens at a distance of 6 inches was used for this close-up of a South African protea flower. To maximize sharpness at such close range, a point of focusing was carefully selected, the smallest aperture was used, and an electronic flash unit added light.*

RIGHT. *A moderate close-up of peonies at The New York Botanical Garden was taken with a 55mm macro lens. While this degree of magnification is possible with a normal lens, the 55mm macro lens has greater flexibility for composing close-ups.*

OPPOSITE. *Since it was not possible to come close to this orchid at a New York flower show, a 200mm macro lens was selected to achieve a high degree of magnification from a distance of 18 inches.*

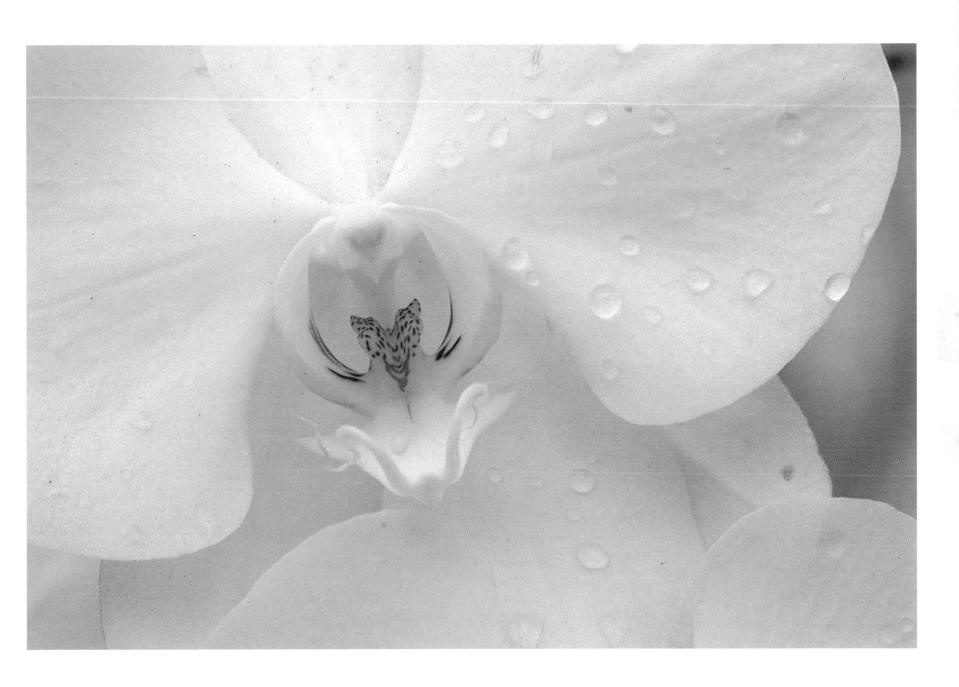

Most macro lenses, when fully extended, produce an image on the film that is at least half life-size. This means that a flower with a 2-inch diameter will be 1-inch across *on the film*. Once that image is enlarged through printing or projection, it will appear quite impressive indeed. Whatever the focal length of the macro lens, it should produce a film image of this size or it is not truly a macro lens. The 100mm telephoto macro lens, for example, creates half of the life-size subject at twice the distance from the subject as a 55mm macro lens; the 200mm macro doubles the working distance once again.

Using a macro lens takes a bit of getting used to, especially for those who have been photographing with a normal lens. Most newcomers to the macro lens are startled by how close they can get to a flower and by their sudden ability to fill the frame with a single bloom. No other lens gives a photographer the compositional option of totally eliminating the background in this way.

Macro lenses can be combined with extension tubes and magnifying filters for even greater magnification. Those who want to look into the interior of flowers may discover structures they never noticed before, or at least never saw as photographic possibilities.

Close-up photography with macro lenses always requires the use of a tripod. The closer the photographer is to the subject, the greater the effect is of camera shake. Rather than risk spoiling a lovely image with an unsteady hand, mount the camera on a tripod and attach a cable release. The photograph can then be composed comfortably and slowly, using whatever ungainly position may be needed to achieve it. Once the image is set, the photographer can assume a more natural stance from which to observe the subject and determine the exact moment for releasing the shutter. If a tripod is unavailable, find a suitable means of support for the camera: brace it against a sturdy object, such as a tree, wall, or fence. It is most important that the camera remain steady while the shutter is released.

A 90mm telephoto macro lens provided nearly ½-life-size magnification for these tiny pasqueflowers, without requiring the photographer to stoop all the way down to the ground.

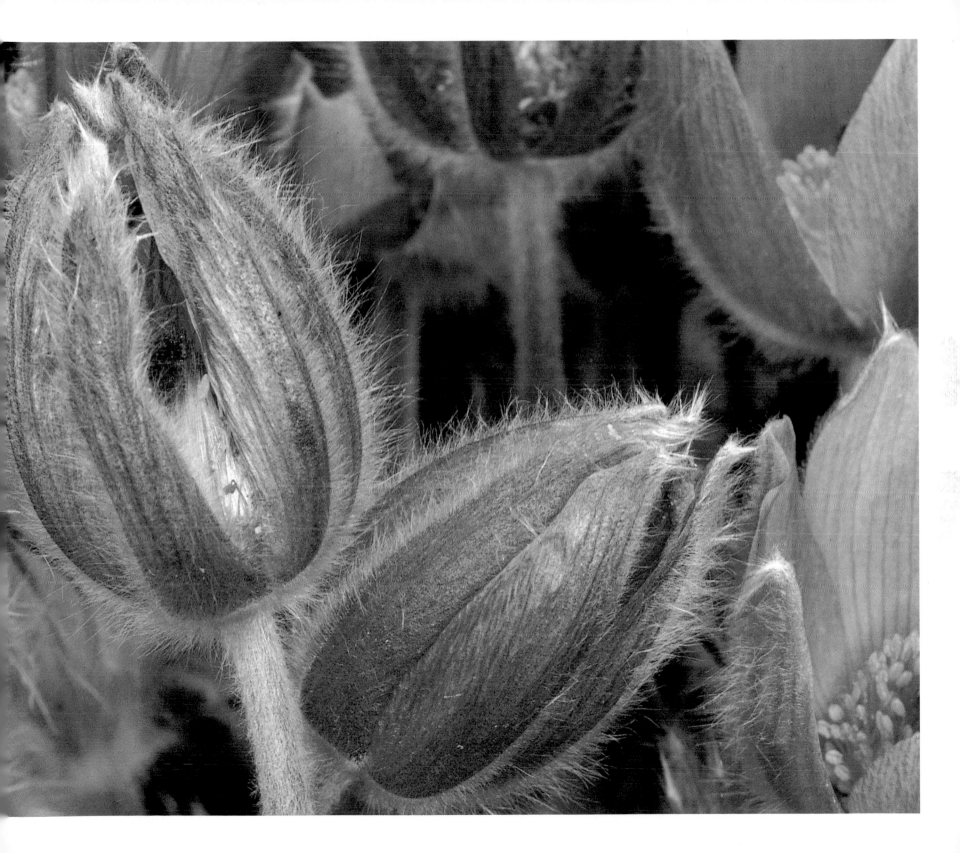

ACCESSORIES

Flower photography does not require extensive or elaborate accessories. However, the few add-on items that are handy—a tripod, a ball joint head, filters, and supplementary lights—are so useful that they should be of the highest quality affordable.

Foremost among required accessories is a tripod. A strong, sturdy tripod is the truest, most reliable friend of the flower and garden photographer. A tripod makes it possible to compose with care and to make numerous fine adjustments without the burdensome or uncomfortable chore of holding the camera. Using a tripod, the exact composition can be reshot at several exposures, ensuring a good selection. A tripod also removes the concern about a steady hand when there is so much else to think about.

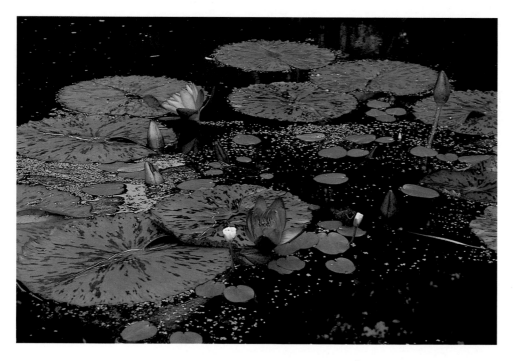

A polarizing filter turned the reflective surface of the water in this lily pond nearly black, giving a brighter appearance to the colors of the flowers and the lily pads.

For the greatest compositional flexibility, the tripod should be purchased with a short central column that is interchangeable with the standard length column. The low column can be set very close to the ground, offering the more inventive photographer some unusual perspectives.

A tripod should be selected with minimal compromise, since it is a purchase that should last for many years. Inadequate models will soon lead to frustration and dissatisfaction. The finest tripod on the market today with the features discussed above is the Gitzo.

A ball joint head is another invaluable accessory and should be purchased with the tripod. Such a head connects the camera to the tripod to allow total maneuverability with a single lock mechanism. The ease and simplicity of using the ball joint makes it preferable to any other kind of head.

Another vital accessory is a lens shade, preferably one for each kind of lens. Lens shades prevent extraneous light from entering the lens, thereby reducing glare and flare, and concentrating light for easier metering. They also shield the lens from damage when cameras are bumped or dropped.

Reflectors are clever aids for providing fill-in light to shaded areas. They can be purchased inexpensively as lightweight boards with a reflective surface on one side, either in white, silver, or gold. They can also be improvised from foil-covered cardboard. A mirror can serve as a reflector, although its light will be quite harsh.

With the camera on a tripod, the reflector can be maneuvered to angle reflected light to exactly the area where it is needed. Moving the reflector closer to or farther from the subject helps control the intensity of the reflected light. Reflectors can be hand-held, propped, or clamped to stands.

Another inexpensive accessory is a raincover. The EWA Cape Raincover is a transparent PVC rainhood that protects the camera completely and has a lens cap that lifts for picture taking. Thus, some lovely photographs can be taken in the rain and mist without jeopardizing one's equipment. In a pinch, just take a large

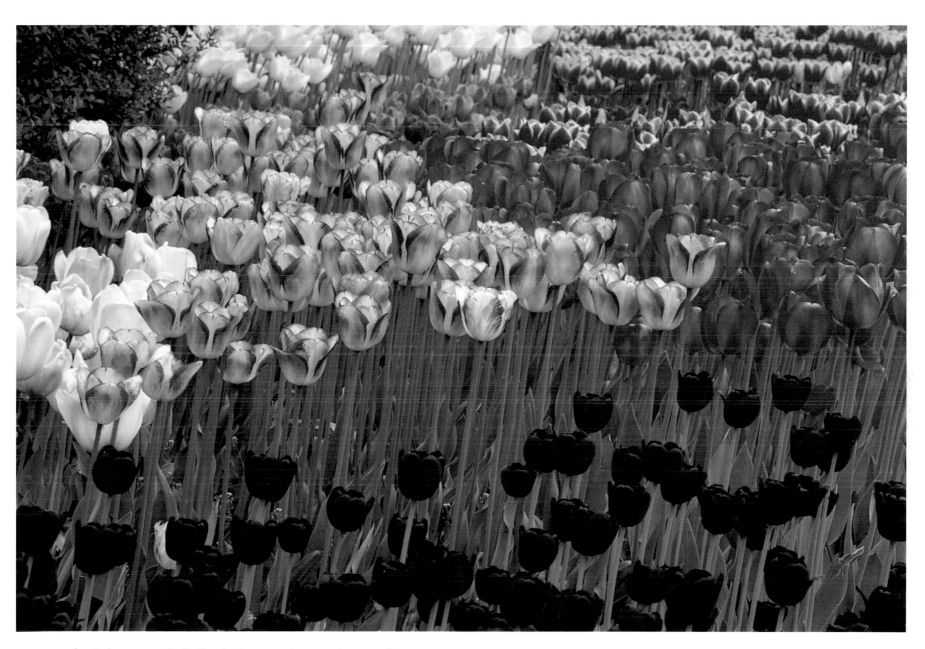

plastic bag, cut a hole for the lens, and secure it around the camera with a rubber band.

Additional accessories include filters and supplementary light sources.

A tripod was needed to steady the camera at a slow shutter speed so that a small aperture could be used to maximize sharpness in this photograph of a bed of tulips.

Polarization turned the sky a rich blue, which provides balance and contrasts dramatically with the yellow of the mustard field in Israel.

Filters

A few well-chosen filters can make the difference between good and outstanding photographs of flowers and gardens.

A polarizing filter can dramatize landscapes, garden vistas, and compositions with sky, water, or reflective greenery. An effect of this filter is to deepen and brighten colors that may be washed out by reflective highlights. The polarizing filter consists of two rotatable pieces of glass that screw to the front of a camera lens. As it is rotated, the filter refracts the incoming rays of light so as to reduce or eliminate glare, a noticeable problem with flowers and foliage photographed in full sun.

There is a small price to pay for polarization: light intensity is reduced by about 1 1/2 f-stops. Since a polarizing filter is most effective in very bright light, however, this is not a significant loss. And with the results visible through the camera lens as the polarizing filter is turned, only the desired degree of polarization need be selected.

In addition to removing reflections and glare from vegetation, the polarizing filter is invaluable for enriching the color of a pale sky. Flowers and gardens are frequently set against the background of at least some sky, but if the sky is light in color it may detract from the overall impression. If the sun is at the proper angle to the camera—best at about 90 degrees to the camera lens—polarization will significantly deepen the blue of the sky. At other angles, the polarization will not be as dramatic, but in any event, the exact results can be seen through the lens as the polarizing filter is turned. If not enough change is visible, moving slightly to another angle may improve the picture.

If the sky is overcast, the polarizer will not help significantly. To overcome the unattractiveness of a washed-out, white sky, especially if there is no way to eliminate the sky entirely from the composition, it may be worth trying a split image filter. This filter is half blue and half clear. A +2 filter indicates that there is a 2-stop difference between the light and dark areas. By positioning the blue half on top, the sky will take on the blue color of the filter, while the lower portion of the composition will be unaltered.

Color correction filters neutralize light of a complementary color, which is handy when the natural colors of a flower or scene have been unattractively influenced by the tonalities of the available light. For example, the orange-magenta of light at sunset would be neutralized with a blue 82A filter, while a magenta filter would counteract the green color reflected by an overhead tree. By superimposing the complementary color onto that of the direct light, these filters effectively restore the tonalities as they would appear in white light.

Several other specialty filters are worth considering. An 81A warming filter adds warm tones to scenes with too much blue reflected from the sky or nearby water or shade. Magnifying filters, especially a +1 diopter, can be added to telephoto lenses in the 100mm to 200mm range to create soft-focus effects.

Although it has no major photographic utility, a 1A, 1B or UV filter is a favorite means of providing protection to the lens.

A +1 diopter on a 200mm telephoto lens softens the edges of these wild poppies in Arizona, giving them a radiant glow.

Electronic flash

Though flowers and gardens are generally photographed in daylight, supplementary light sources make it possible to fine-tune lighting conditions in a number of commonly encountered situations:

1. To highlight a selected area for increased sharpness
2. To brighten a subject in dull light
3. To stop motion due to wind
4. To add light in shadow areas on a bright day
5. To increase the contrast between the subject and the background

For outdoor situations, the photographer has the option of choosing a general purpose flash unit or one specially designed for close-up work. A general purpose unit is designed for illuminating subjects that are between about 3 and 15 feet away. These limits must be carefully observed or the image will be much too bright if the subject is too near, or much too dim if too far. Since the burst of light from the electronic flash must travel to the subject and bounce back to the camera, only a small portion of the powerful flash is actually utilized. That is why flash photographs taken at greater distances are bound to be disappointing.

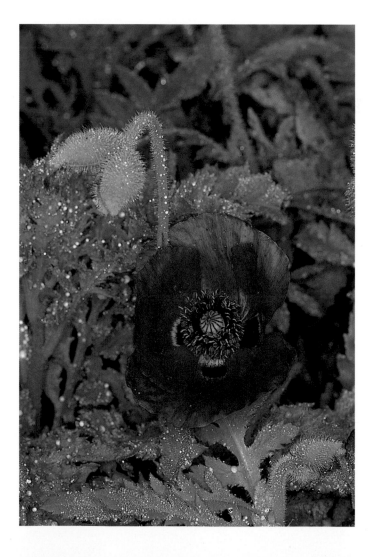

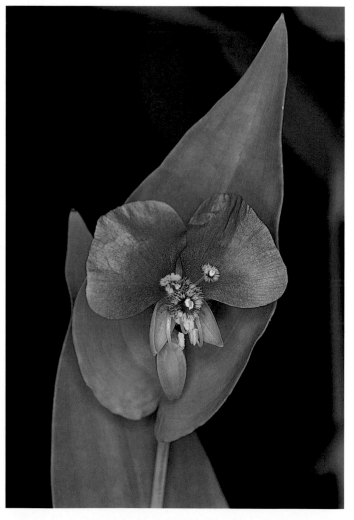

The general purpose electronic flash unit of choice should be lightweight and portable, and it should be possible to fire it off the camera, away from the on-body hot shoe.

General purpose units vary considerably in their light output, and they increase in price according to their maximum power. The high light output of the more powerful units can usually be compensated for by reducing the lens's aperture. Also, many powerful units offer options for being set at a decreased output, making them truly adaptable. They can even be used at distances less than 1 foot, provided they are set at low power or the flash head is covered with lens tissue. To determine the best combination of power output and f-stop requires testing the flash unit (see the test in the appendix).

Those who intend to do a great deal of close-up photography may prefer a ring flash unit, which is very popular and easy to use. As its name implies, the ring flash provides a circular burst of light around the subject. The even and diffused quality of this light is particularly appealing in close-ups. The most sophisticated of the new multiple light systems for close-ups are twin macro flash units, made by Olympus, that are designed to maximize lighting control. How to use flash units is described in detail in "Light Is Everything" and "Style and Focus" and in the appendices.

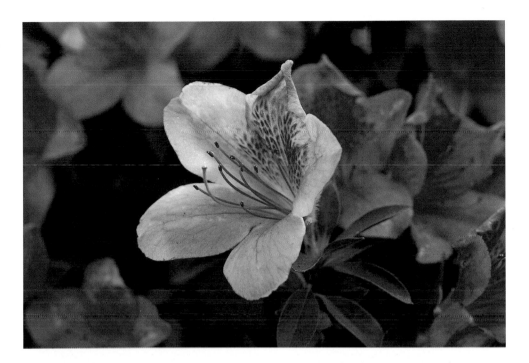

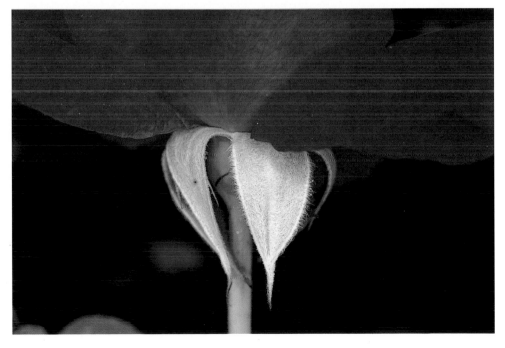

TOP RIGHT. *A single electronic flash unit, held to the left of the camera, creates a burst of fill-in sidelight which stops the movement of the wind on these azalea blossoms.*

RIGHT. *A ring flash provides strong, uniform light on the sepals of this rose and darkens the background due to the increased contrast in light intensity.*

OPPOSITE FAR LEFT. *An Olympus twin macro-flash unit was used to increase sharpness, to provide uniform illumination, and to highlight the water droplets on this anemone in Texas.*

OPPOSITE LEFT. *A ring flash brightens this tradescantia, thereby increasing contrast with the background garden, turning it black.*

3
Light is Everything

"I seized the light—I have arrested its flight!"

LOUIS-JACQUE-MAUDE DAGUERRE, 1839

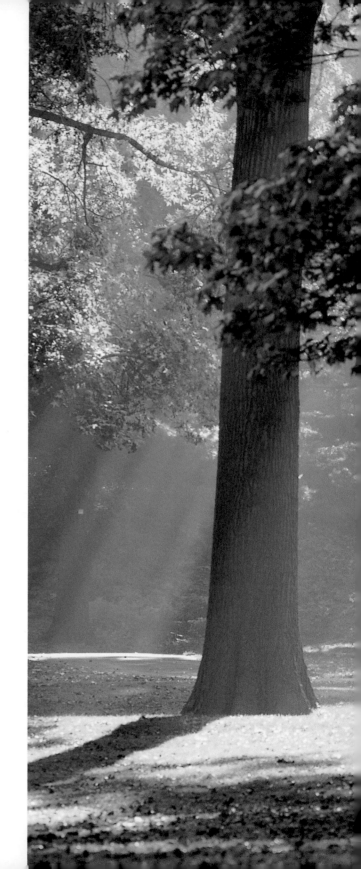

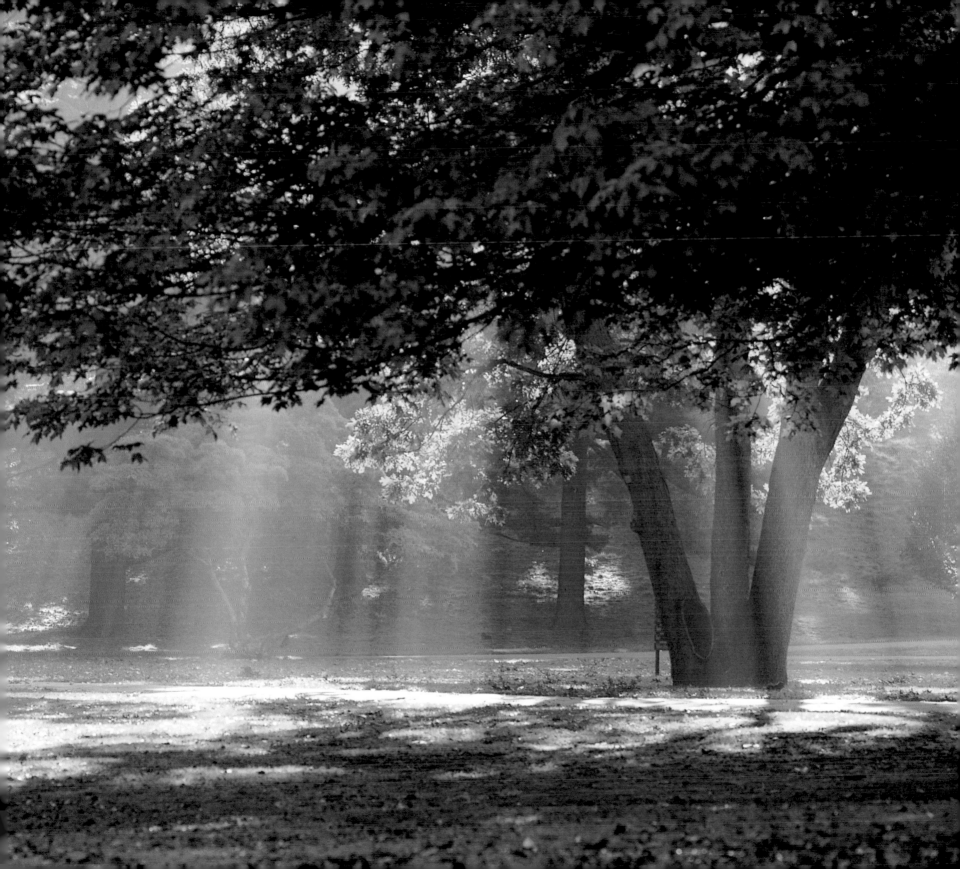

INTENSITY

Light is the raw material that the alchemy of camera and film transforms into the gold of magnificent imagery. But unlike the elements of chemistry, that are consistently the same, the elements of light, especially natural light, never repeat themselves exactly. There are characteristics that various lighting conditions share, however, and these can be analyzed according to such factors as intensity, color, and direction.

Intensity is the most fundamental feature of light, but also the most difficult to gauge. Daylight can be very strong, as in bright direct sunlight, or quite dim, as during a thunderstorm. In between is a vast range of possibilities, each with the potential for creativity and for problems. There is no ideal or perfect light, only interesting opportunities that each kind of light presents, if we recognize them and make the most of them.

PAGES 64–65. *Shafts of strong, early morning light stream through the trees onto the great lawn of The New York Botanical Garden.*

Intense daylight is not the ideal light many amateurs imagine it to be. In fact, it requires considerable know-how to bring out its positive qualities. It can be characterized by the deep shadows it casts and by a high incidence of reflections. This dichotomy between deep shade and bright glare produces the high-contrast conditions that strain the latitude of most films.

Nevertheless, strong daylight has some distinct advantages. Small apertures from f/8 to f/22 can be combined with fast shutter speeds of 1/125 of a second or faster, enabling the photographer to maximize sharpness and freeze movement—a boon for shooting field flowers tossed in the breeze. Intense light offers the photographer the greatest flexibility in the choice of camera settings, so that aesthetic judgment, rather than technical necessity, can dominate those decisions. There is great potential for rich, vibrant, saturated colors in bright light, perhaps with some polarization or underexposure. And the very high-contrast conditions that are often problematic can be turned to one's advantage through knowledgeable juxtaposition, such as setting a luminous subject against a dark, velvety backdrop.

Diffused light ranges from hazy sunlight, in which shadows tend to be gray but reflections may still exist, to the dull light of an overcast sky. The major benefit of diffused light is its evenness and uniformity, with a minimum of contrast. This is excellent light for capturing subtle colors, such as pastels, which can be softened further with some overexposure. Vibrant colors also photograph well since they are free from annoying glare.

The diffused light of shade, even on a bright day, is preferable for many garden shots, especially those including people. Portraits often suffer from unwanted shadows when taken in bright light, something one can avoid in the even light of shade.

Fog and mist, by their very opaqueness, can create a lovely, obscured background for floral subjects. Colors may shift toward the cool tones of blue and gray, which can be brought out deliberately to add to the mysterious aura of a misty scene.

The special light produced during rain and snow is all the more remarkable because so few people bother to record it in photographs. In some respects, rain and snow

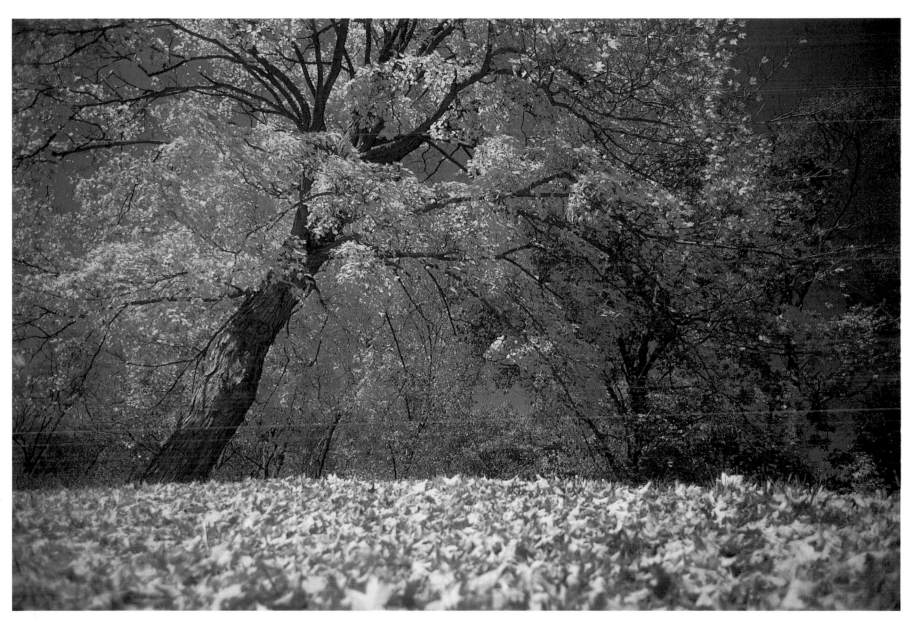

encourage an impressionistic bent similar to that of fog and mist, but the inclusion of moving particles through space adds a new challenge. And the visual prospects after the rain or snow has fallen, while more familiar, are always worth exploring in the garden or field.

ABOVE. *Intense sunset light bathes this entire scene with warm golden tones that complement the autumn foliage.*

OPPOSITE. *In the deep shade of an overhead shrub low-intensity diffused light enriches the color of these poppies at Giverny.*

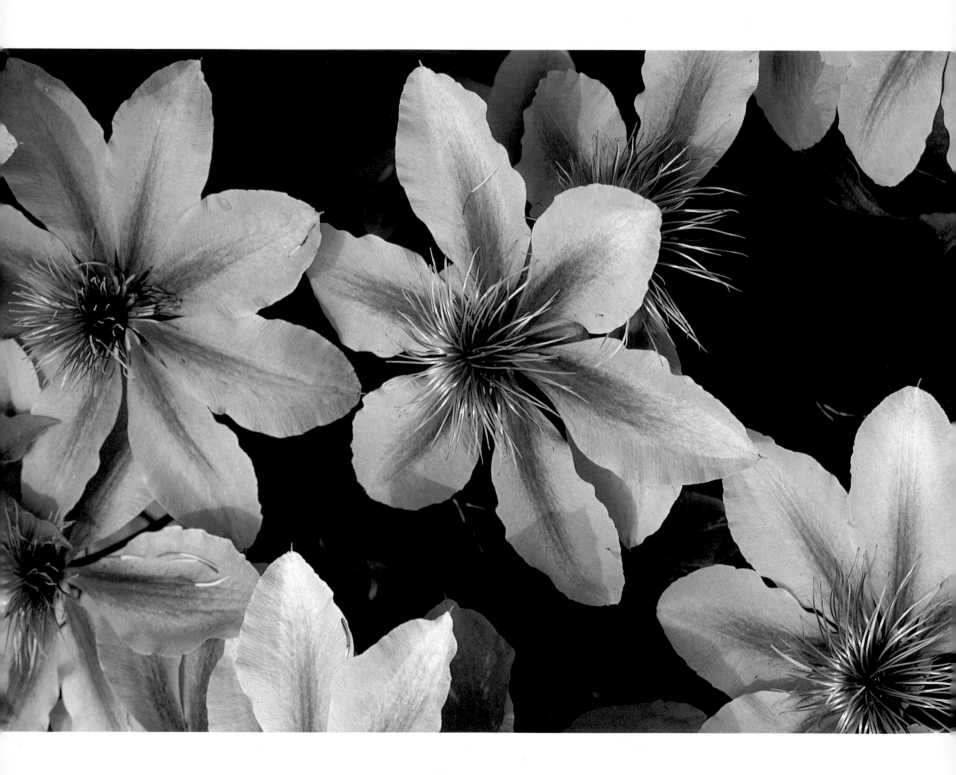

Strong daylight

The two major difficulties that the photographer faces in strong daylight are the presence of deep shadows and glare. Both of these obstacles can be overcome through the development of judgment.

The first step toward developing that judgment is to learn to observe a scene carefully. At first, shadows may not be apparent to the eye, which, as we have said, tends to disregard what the mind considers unimportant. It is worthwhile to be as objective as the camera, looking especially within and among flowers, near trees and shrubs, and wherever there are people and such structures as trellises, fences, or buildings.

Once the scene has been scrutinized, the next step is to determine whether the subject of interest can be photographed effectively. Depending on the nature of the subject, a number of approaches can be taken:

1. The composition can be framed totally within the area of strong daylight, eliminating the contrasting shadows entirely.
2. The shadows can be imaginatively utilized as part of the composition, either to create a dark background or to emphasize the structure or texture of the subject.
3. A compromise is possible by exposing correctly for one area of priority—either the bright or shadow portion—while sacrificing the contrasting area. If the bright area is central to the purpose of the photograph, then details in the shadow areas will be lost in darkness. On the other hand, if the shadow area contains the primary subject, then the sections in intense daylight will be overexposed.
4. It is not possible to expose adequately for both the bright and shadow portions of the composition since there is a difference of 3 or more f-stops between them.

A word of caution: bright spots within the shadow area, or beyond it, tend to draw the eye away from the focal point of the photograph. One way to minimize this distraction is to limit the depth of field. By using a wide open aperture, such as f/1.4, f/2, or f/2.8, the bright areas will seem to bubble out, losing their definition and forming a wash of light. Also, those with automatic

cameras that set exposure may do well to measure the amount of light in the primary subject carefully, locking in the meter reading, and then compose the picture as desired. This will provide a safeguard against the possibility of an inaccurate exposure reading based on the contrasting light conditions within the frame. Remember, when studying the meter reading, you are evaluating which combination of f-stops and shutter speeds will best achieve your desired aesthetic result.

ABOVE. *Details are sacrificed in the areas in shadow of this Dutch garden scene to maintain color saturation in the brightly lit flowers.*

OPPOSITE. *Strong daylight casts deep shadows behind the clematis blossoms emphasizing the shape and texture of the flowers.*

Diffused light

Diffused light lacks the intensity and drama of strong daylight, but it offers a softness and uniformity that is especially lovely for the subtler aspects of flower photography. This is the gentle light of an overcast day, the delicate light that filters through the dense canopy of foliage in a woods or a forest, and the velvety light one finds in the shadows of an otherwise brightly lit scene.

Diffused light has the advantage of minimizing or eliminating shadows and glare, with the side effect of reducing the three-dimensional quality that modeling shadows create. While forms and shapes are harder to define, surface textures photograph quite well, especially with bright colors. It is marvelous light for playing up the fuzzy edges on flowers. In close-up work, backgrounds blur out easily and pastels retain their integrity. Because the light is so uniform, pure colors are easily saturated without the need to underexpose them, and detail can be maintained when pale and dark colors are juxtaposed.

Still, there are some pitfalls. One common difficulty occurs when an overcast sky is given prominence in a landscape or scenic view of a garden. Despite a decrease in light intensity, a cloudy sky is still much brighter than the land below. Proper exposure for the land portion generally causes the sky to go white, leaving an empty, unattractively overexposed space over the entire scene.

The simplest solution to this problem is to minimize the amount of sky one includes in panoramic compositions on overcast days, either by tipping the camera down slightly or by including some foliage at the top of the frame to mask the sky. If the sky must be included, try using a split image neutral density filter, as described in the chapter on equipment, "Visual Tools."

The major precaution to exercise when photographing in shadows on a bright day is being aware of the color of the light reflected from the surroundings into the shadows. One may need to use a color correction filter or electronic flash to restore the natural colors.

TOP. *The diffused light of a rainy day intensifies the subtle color in this scene taken at Longwood Gardens in Pennsylvania.*

LEFT. *A meter reading was taken of the sky to keep its deep color, and, through overexposure, to brighten the forsythia.*

The uniformity of low-intensity, diffused light benefits this close-up of a pink begonia. The light saturates the begonia's color and maintains detail in both the pale and dark colors.

Rain, mist, and snow

A fascinating time to photograph flowers and gardens is during inclement weather. This special situation is all the more alluring, because it is visually less familiar.

Fog and mist offer the photographer a chance to portray a garden's more unusual moods. Trees are shrouded in a compelling mystery, while flowers emerge through a veil of obscurity.

Fog and mist can be brighter than they seem. Therefore, meter the subject carefully to avoid underexposure. Overexposing fog will do no harm.

Though fog is usually white, occasionally it has a color tint. Like ice, it seems to pick up barely visible hues, such as blue, gray, or pink. These tones can be accentuated, either by photographing flowers whose colors are complemented by the fog's pastels, or by shooting a film that favors the fog's hue: Fuji chrome to highlight cool colors or Kodachrome to play up warm tones.

Photographs of flowers after the rain have become something of a cliché. To simulate a dewy effect some people regularly take a spray bottle of water into the field. But there are numerous photographic possibilities throughout a rainy period for those with daring and imagination. The fringes of a storm, or the intermittent rain of a summer thundershower, often produce a beautiful, celestial light, with strong rays of sun edging over a foreboding cloud cover. The patches of brilliant light against the dark sky illuminate portions of a garden or landscape with a halolike brightness.

A determined downpour—shot from the safety of a nearby porch or interior—can create a strong sense of mood and movement, despite the fragmentation and obscurity of the scene. High-speed films, up to ISO 1000, accentuate the grainy effect produced by these conditions and eliminate the need for a tripod. The falling raindrops can themselves add to the atmosphere, either by being represented as streaks shot at exposures of between 1/2 and 1/15 of a second, or by being transformed into ghostlike, billowy miasmas at shutter speeds over 1 second. The same techniques can be used to photograph falling snow. Once the rain is over, there is interesting light to be found in reflections from shiny surfaces around the garden.

ABOVE. *The stark forms of a bench and bare tree overlook the snow-covered landscape of the Donald M. Kendall Sculpture Garden in Purchase, New York. The monochromatic tonalities reveal the garden's tranquillity even in winter.*

LEFT. *Early morning mist enshrouds a colonnade of tall trees, lining the entrance to Ghana's Aburi Gardens. A single distant figure walking along the path gives scale to the trees and contributes to the aura of mystery.*

OPPOSITE TOP. *An early spring snowstorm surprises a blooming magnolia tree. A slow ½ of a second exposure turns the falling snowflakes into diagonal white streaks.*

OPPOSITE BOTTOM. *The aftermath of a heavy downpour is visible in the profusion of droplets on the foliage and petals of this tree peony at Winterthur, Delaware. The heavy, bowed head of the flower, resting on the leaves, adds to the evocative mood.*

COLOR

In the realm of flower and garden photography, color is a vital component. There are those who, for the sake of pure form, prefer a black-and-white film medium, even for such unabashedly colorful subjects as flowers. Most photographers, however, find color a major appeal of flowers and wish to render it in its fullest magnificence.

To understand color, one must understand light, for color is a visual by-product of light as it is either refracted or reflected by the world around us. White light—that is, light with no visible color—actually consists of the entire spectrum of color frequencies when they are fused into one.

But since sunlight passes through our atmosphere before it reaches our eyes, it is affected by the conditions along the way. Everything influences the color of light, from water vapor, clouds, and pollution to trees, shrubs, and man-made canopies.

The color of light changes with the time of day. Since the sun's rays are bent at different angles from hour to hour, various parts of the spectrum gain dominance. First morning light begins with a flat gray changing to a delicate blue. As the sun emerges, colors warm to yellows, pinks, and oranges. The bright blue sky of midday gives a cool bluish cast to a scene. As the sun arcs down toward the horizon, fiery oranges, yellows, and reds wash over the earth. And at twilight, blues, violets, and greens dominate.

The changing seasons also affect the color of light. The low rays of the fall and winter sun have a golden glow, while the higher position of the sun, as spring turns into summer, washes the earth in a brighter, whiter light.

Weather conditions have a more visible effect on the color of light. Clouds, storms, haze, fog, and mist all contribute a distinct color, whether a pervasive gray, a milky white, a transparent blue, a ghostly green, or even a pastel pink or yellow.

In addition to developing a sensitivity to the color of direct light, the photographer should notice the hues of light reflected by the surroundings. Buildings, vegetation, and shadows reflect light onto nearby flowers and subtly change their natural colors.

Our minds, accustomed to adjusting for such color alterations, must learn to observe what our eyes actually see. An astute photographer notices the color of light and understands how it alters the color of a given subject. For instance, a pink flower under a hazy sky may actually give a grayish appearance. An awareness of this shift of tonality may alert the photographer to a choice: to record the color as it is in the available light or to restore the natural color of the subject, as it would appear in white light by using a color correction filter.

The blue-gray light of an oncoming thunderstorm was slightly overexposed to intensify the color of these dandelions.

*The orange-red glow of late afternoon sunlight mimics
the colors of the tulip.*

Direct light

Direct light is the light produced by a source, whether the sun, the moon, a streetlamp, a candle, or an electronic flash unit. Every source emits light of a specific color. Anyone who has taken indoor pictures has probably noticed that incandescent bulbs produce an orange light, while fluorescent fixtures generally emit a greenish light.

What is true of artificial light is equally true of natural light. It is up to the photographer to notice these variations, and then to decide whether to represent the subject in the available color of light, or whether to override the visible light in some way.

If we want to record a color as we have seen it, the task is relatively simple. When looking at our subject—whether a landscape scene, a garden detail, or a close-up of a flower—we would meter the brightest areas or highlights. These are the spots that are receiving the strongest direct light. Then, depending on the saturation of color desired, an underexposure of 1 to 2 stops is recommended.

Slight underexposure is more necessary in bright direct light than in hazy sunshine, and may not be needed at all in diffused light. Remember that the intensity of light will be a factor in determining the exact relationship between the color we see and how it will record on the film. If the light is of such great intensity that the color of our subject will be washed out compared to what we see, then underexposure will bring the recorded image more in line with our previsualization. Overexposure and lack of color saturation is a common disappointment among photographers of gardens and flowers, and one that is simply remedied with these measures.

It may also be helpful to use film that favors the particular tonalities of light at the moment, especially if we want to emphasize or exaggerate those hues. For example, Kodachrome film is considered strong in rendering warm tones, and, therefore, would be the film of choice if the flowers are red or if the scene is shot at sunset. Fujichrome film, by contrast, favors cool tones, and would be the film to use when greens and blues are most important.

If the direct light available distorts the color of our subject and we wish to restore it to its natural tone—that is, to render it as if it were taken in white light—then our task is a bit more complex. This problem usually arises at the extremes of the day or because of overhead foliage. In either case, the use of color correction filters will help.

Color correction filters neutralize light of a complementary color. For example, the orange-magenta of light at sunset would be neutralized with a blue 82A filter, while a sepia 85 and 81A filter would counteract the green color reflected by overhead foliage. By superimposing the complementary color onto that of the direct light, these filters effectively restore the tonalities as they would appear in white light.

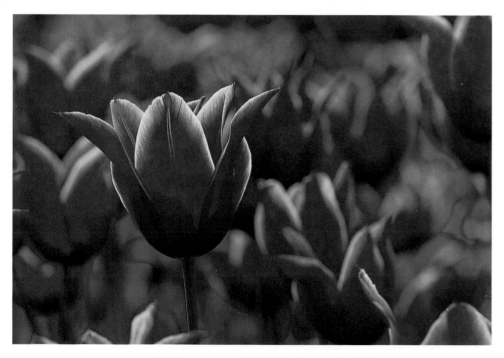

Underexposure of one full stop was needed to saturate the colors of these brightly lit tulips.

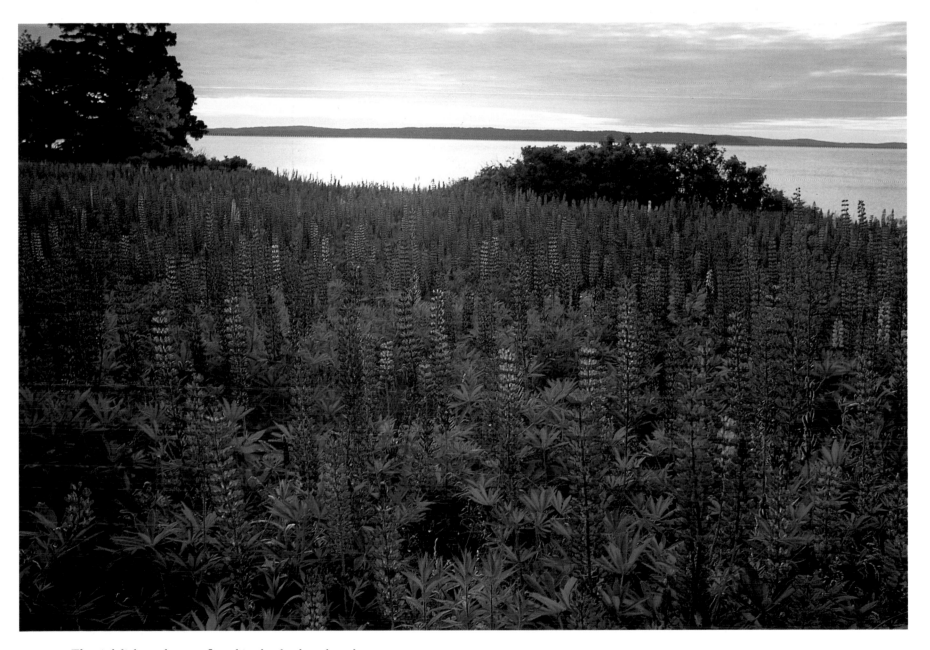

*The pink light at dawn, reflected in the clouds and on the
bay, required overexposure of ½ of a stop to achieve detail in
the shadowy foreground of this meadow in Maine.*

Reflected light

Once our eyes are used to analyzing the color of direct light, it becomes easier to judge reflected light as well. It is important to remember, however, that while direct and reflected light are derived independently of one another, the cumulative effect of their colors is cast on the subject.

Direct light must be considered in all photographic situations, but reflected light is most commonly faced by flower and garden photographers in two situations: First, if a large object such as a building, garden structure, or shrub is near enough to reflect its color on the subject; second, in photographing details or close-ups, where neighboring flowers may influence the color of a subject through their reflected light.

Anyone familiar with the paintings of the impressionists has noticed the varied mix of colors that they used to depict a single object. Although a water lily may be pink, the impressionist may have rendered it with spots of yellow, blue, purple, and green. The impressionists made a point of recording light and color exactly as they saw it, with the impact of direct light, reflected light, and shadows all taken into account in the final result.

Similarly if the effect is pleasing, the photographer may choose to mix colors. If the reflected light is displeasing, however, the photographer may eliminate what is unappealing. As with direct light, the color of reflected light can be neutralized with color correction filters.

Reflectors can also add illumination and color to the existing light on a subject. By angling the reflector, light is bounced off the reflector's surface onto the subject. Of course, the color of the reflector will determine the color of the light added, with white providing the most contrast, silver being intermediate, and gold creating the warmest, lowest contrast light.

LEFT. *The blue light around these cosmos blossoms is created by bright midday light reflected from the surrounding foliage.*

OPPOSITE. *A gray light, reflected through shrubbery, transforms the colors of these globe thistles and the foliage in the gardens of Giverny, France.*

OVERLEAF. *A yellow cast produced by pollutants in the air is reflected on this nasturtium plant in a Long Island garden.*

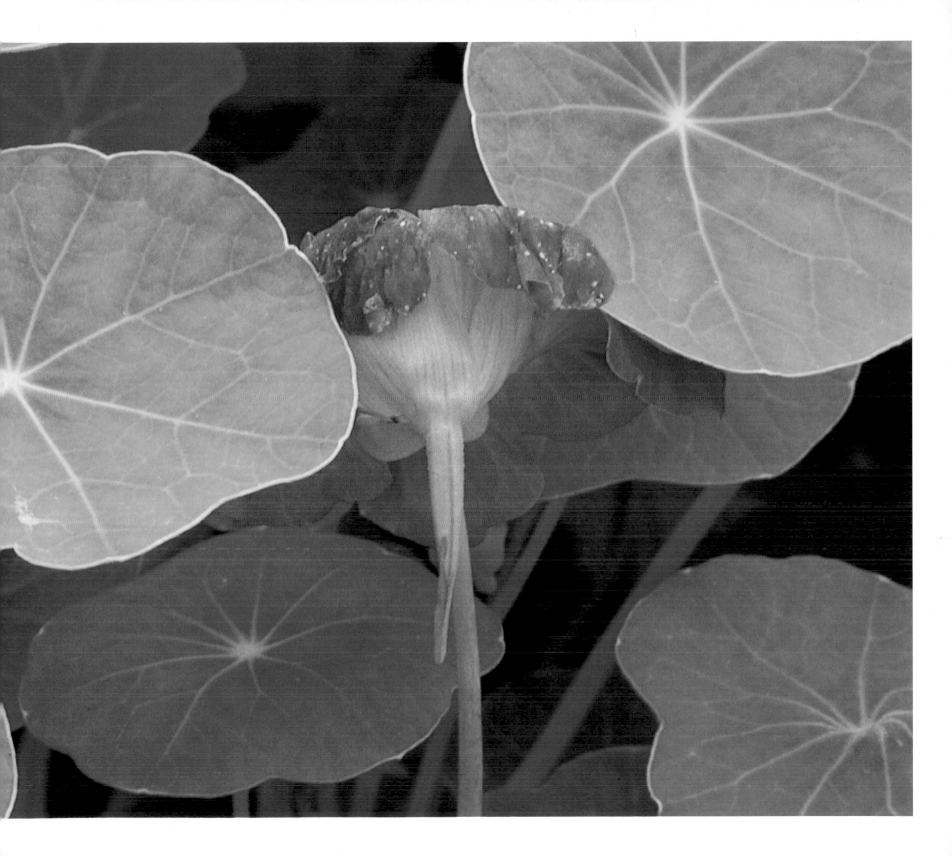

DIRECTION

No analysis of light would be complete without considering its direction. More than any other factor, the direction of light determines the degree of drama within a photograph, whatever the subject.

In outdoor photography, the direction of light is generally downward from above, but even this overall direction has its components. Rather than think of light direction strictly in terms of an arrow from the source, the photographer should think of the light direction in relation to both the subject and the camera.

The most typical arrangement—the one depicted in the schematics packaged with film, and the one most beginning photographers think is ideal—has the photographer between the light source and the subject. This means that light is directed frontally on the subject, either from straight overhead or somewhat over the photographer's shoulder. Such frontlight has definite advantages, but it takes great ingenuity to use well.

For flower and garden photographs, two other arrangements offer greater opportunities for spectacular light effects: backlight and sidelight. With backlight, the light source is positioned behind the subject with light directed toward the camera. Most of us have grown up with warnings never to take pictures under such circumstances. In fact, once the techniques of shooting photographs with backlight are mastered, this becomes a favorite, even to the point of becoming a cliché. Nevertheless, backlight is worth adding to one's repertoire since it can transform even ordinary scenes into ones of celestial beauty.

With sidelight, the light source is at about 90 degrees to the side of the camera, with the subject at the point of the imagined angle. Sidelight is closest in effect to the dramatic light called *chiaroscuro* associated with the paintings of Caravaggio and Rembrandt. There is both a sense of drama and a feeling of depth in these works, since objects seem rounded in the half-light, half-dark modeling created by sidelight.

Each of these directions offers benefits but also requires special techniques for the best presentation.

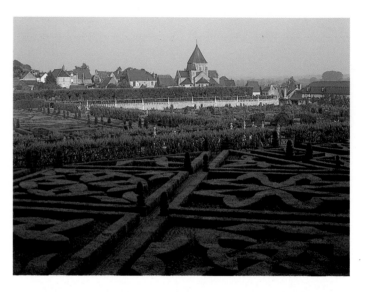

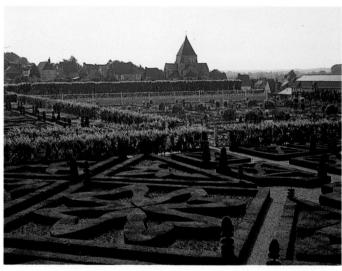

ABOVE. *The effects of differences in the direction of light are visible in these identical views of Villandry in France. The scene (top) is washed in early morning frontlight and (above) in backlight after sunset.*

OPPOSITE. *As the very low sunset light coming from the side was very dim, the shadowy areas were metered to maximize detail and overexpose the better lit portions along this canal in Courrances.*

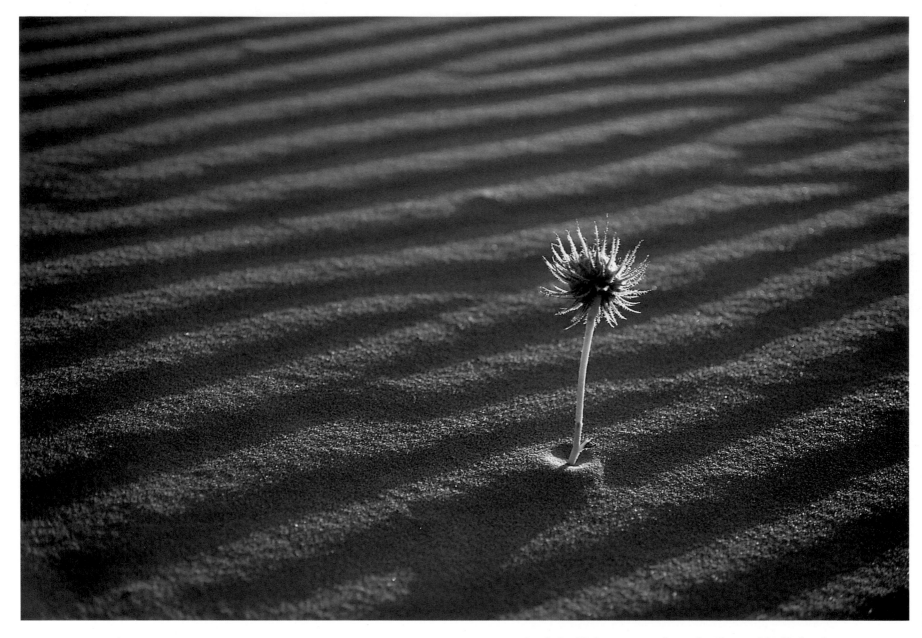

Bright backlight separates the sandy ridges and highlights the spiny head of this thistle embedded in the dune of Coral Pink Sand Dunes State Park in Utah.

Backlight

The rewards of mastering backlight are photographs with glowing, glorious colors and a celestial translucence. Backlight also enhances the three-dimensional quality of a garden or landscape scene and highlights the internal structure of flowers. What deters some photographers from working with backlight is the fear of having light streaming toward the camera. Undoubtedly, there are precautions to be taken, mostly having to do with proper metering, exposure, and the use of the proper lens hood.

Backlight is the most difficult to measure because the reading is overinfluenced by the direct light entering the lens or meter. Whenever possible, therefore, use a spot meter, or move very close to the subject for metering purposes. Then overexpose from that reading, up to 1 1/2 f-stops to get proper exposure. The reason for overexposing is that the meter is essentially taking a reading of the sky. But if the very bright sky is in good exposure, the subject in front of it is bound to turn into a silhouette. If that is the purpose—as with a bare tree set against a sky at sunset—then the meter reading will do, or you may even underexpose to enrich the color of the sky. However, if the purpose is to bring out the color or structure of flowers in a garden or field, then the meter reading must be overridden to let more light in. Only in this way will there be enough light registering on the film to portray the primary subject with good detail and color rendition.

Of course, the darker the subject is to begin with, the more overexposure will be needed. A row of deep red tulips will need more exposure than a field of yellow poppies. With close-ups as well, overexposure is recommended in backlit situations.

When framing a backlit subject, it is important to eliminate the light source from the frame and to show only the effect of light on the subject, unless the stream of light adds interest to the image. To avoid unwanted flare be sure to use a lens shade. Remember that lens shades come in sizes that match the lens they are designed for. The widest variety of useful lens shades is manufactured by Heliopan.

Even with the correct lens shade, check carefully that all flare has been eliminated before releasing the shutter. If not, it may be necessary to shield the lens with your hand. Be sure that the flare has been removed and that your hand is not visible in the picture.

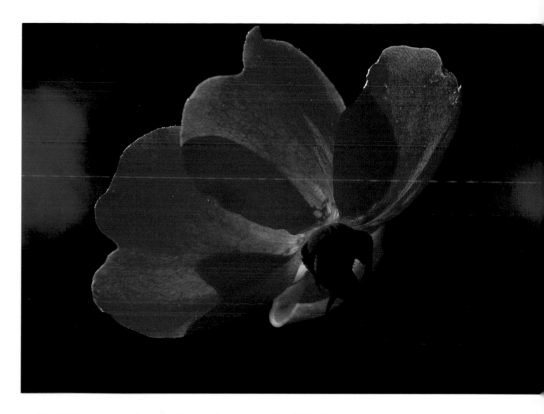

Backlight passing through the translucent petals of this 'Betty Prior' rose creates a radiant, shimmering effect reminiscent of stained glass.

Sidelight

Sidelight is excellent for emphasizing the shapes of flowers, garden ornaments, and trees, and it is the best light for giving a garden a three-dimensional quality. Unlike backlight, which is direct light, sidelight is reflected from a photographic subject before it enters the lens. Like backlight, it is most dramatic when the subject is set against a dark, contrasting, or black background.

There are some difficulties to overcome, however. Sidelight invariably creates high-contrast conditions, making metering rather problematic. When strong light illuminates one side of the subject but not the other—with a difference of up to 4 f-stops—the photographer is wise to work with this disparity, not against it. The dark half of the subject may have to be sacrificed and left in the obscurity of shadow. The bright half, however, must be properly exposed, as if only this side mattered. For purposes of exposure, only the bright side warrants consideration in a sidelit composition.

The best procedure for achieving this end is to meter the bright highlights, then underexpose sufficiently to saturate colors. The amount of underexposure will depend on the color of the subject and the intensity of the light. The brighter the sidelight and the greater the degree of color saturation desired, the more underexposure will be needed. At times it may be necessary to add light to the dark side of a sidelit subject to reduce contrast. The easiest way to do this is to use a reflector or an electronic flash.

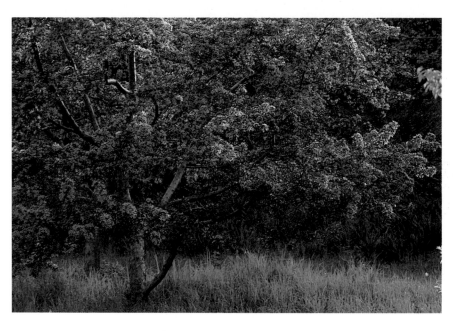

ABOVE. *Soft, afternoon sidelight bathes this crab apple tree in a delicate glow. Slight overexposure lightens the pastels and retains detail in the shadow areas.*

RIGHT TOP. *A shaft of strong, low-angled sidelight pierced through a conservatory spotlighting these Japanese chrysanthemums. The high-contrast light conditions turned the background dark.*

RIGHT BOTTOM. *Soft, late afternoon sidelight creates a rosy glow over this orchid in the conservatory of The New York Botanical Garden.*

Frontlight

Despite the earlier disclaimer about frontlight, it remains the one most photographers will choose. This is not only because it has been ingrained in us as the "right" light for photography, but perhaps more important, because it is the light most available throughout the day. There are those dedicated souls who will venture out at dawn and linger at dusk to capture the short-lived rays of low sunlight to be found at the extremes of the day, and they will be rewarded with the unusual photographs they can produce at those hours.

But even for the devoted practitioner, the overhead light of the day, despite its familiarity and its dramatic limitations, must serve if we are not to be severely limited in the time available for photographing flowers and gardens.

And, if the truth be told, frontlight has a number of fine qualities to recommend it. Foremost among these is the ease of metering, although as with any intense light, some underexposure of 1/2 to 2 f-stops is recommended for full-color saturation. If there is a great deal of glare, it is also advisable to use a polarizing filter. A pale blue sky can be considerably perked up with a polarizer, providing a rich backdrop for a brightly lit meadow or garden.

Unlike sidelight, which enhances the illusion of depth, frontlight tends to flatten distances, so that layers of colors can be juxtaposed as if they were bands in a modern painting. The flatness of the light, together with the use of a telephoto lens, promotes this bold abstract quality.

Open areas, such as fields and meadows, photograph well in frontlight if the photographer is interested mainly in bright splashes of color with a minimum of shadows.

For close-ups, unfortunately, frontlight tends to produce straightforward documents, the floral equivalent of the mugshot, rather than attractive portraits, unless the photographs are taken with great ingenuity and imagination.

ABOVE. *The bright frontlight on these wildflowers was used to display splashes of color. A wide-open aperture diffused the light and blurred the edges of the flowers. The shadows in the distance helped create a feeling of depth and served to separate the flowers in the foreground from those in the rest of the field.*

OVERLEAF. *Strong, overhead incandescent bulbs at an Israeli flower show bombarded these gerbera daisies with a powerful frontlight.*

MIXED LIGHT

High-afternoon sidelight skimmed the tops of these tulips but did not reach all parts of the flowers, creating a mixed light situation. Exposure was taken on the shadowy parts of the flowers to retain color saturation, leaving the tips slightly overexposed, which is a satisfactory compromise.

The elements of intensity, color, and direction work together at all times to create the special conditions we encounter every day. It is up to the photographer to learn how to analyze these elements, for without an awareness of them, it is impossible to know what techniques to use to enhance the natural conditions.

For the sake of simplicity, these elements have been discussed individually, but in the real world, not only do they work together, but they are often not in their purest and most definable form. On a typical partly cloudy day, there may be moments of intense sunlight alternating with moments of generally diffused light. A bright swath of sunshine may be moving visibly across a landscape. Parts of a flower may be in bright light while other key parts are in deep shadow. What does one do in such confusing, changeable circumstances?

To begin with, be assured that there are no easy solutions, if any solutions exist at all. Even professionals find themselves facing conditions that they recognize as beyond the realm of possibility. If they are under the pressure of a deadline and they must produce, they will work very hard to make the best of a bad situation. They will not be thrilled about it, but that is their professional responsibility.

For the nonprofessional the closest equivalent is that of the traveling photographer, who is at a certain location for a short time, and the weather is not ideal. Yet this time is the only opportunity to bring home souvenirs of that place. It's an unhappy situation but a real one. Given that this is how many photographs are taken, how can we work with those impossible conditions?

If time is not a major factor, patience may be the answer. When light is changing, then the light that works well will reappear shortly. Waiting out the "bad" light, which often takes but a few seconds, is far better than snapping when the light is not right. If the light is constant—though imperfect—utilize the measures discussed here. But what if the light is uneven and irregular, a combination of light and shade?

ABOVE. *The area of deep shade around these calla lilies at a New York flower show was transformed into a velvety dark backdrop, setting off the brightly lit foreground subject.*

RIGHT. *This flamingo flower is far from uniformly lit, yet the different degrees of brightness along its wide face and foliage—about 2 f-stops—could be photographed with acceptable exposure within the latitude of the film.*

Light and shade

The mixture of light and shade within a composition can be the most effective or the most distracting element within the frame, depending on how skillfully the light is handled.

In the best of circumstances, the photographer is aware of the high-contrast situation, and works with it in some way. Perhaps the best way to deal with a discrepancy of 2 or more f-stops within a frame is to isolate the bright area by setting it against its neighboring shadow portion. The area in deep shade can become a velvety dark backdrop for the brightly lit foreground subject. For example, a row of flowers in a garden can be set off against the shadow of a nearby tree.

But what if the shadowy portions are so close to the bright spots that they cannot be set off effectively against one another? Then the photographer may have to sacrifice one part for the sake of the other. If the area in shadow is more crucial to the purpose of the photograph, then the exposure should be taken for that portion only, using a spot meter or a close-up meter reading. The sunny part of the composition will then be severely overexposed, and should be placed within the composition so that its extreme brightness will do the least damage. Conversely, if the bright segment is of greatest interest, then the exposure should be taken for that area only, permitting the dark portion to go still darker. Once again, the framing of the composition should incorporate the obscured area in the best way possible.

Happily, there is another alternative if the light and shade are so close that they fall irregularly within the entire frame. The dappled light of deciduous forests, for instance, while very attractive to the eye, rarely produces photographs of charm. Because film exaggerates the contrast between light and shade, photographs of dappled light often appear splotchy and confusing. A simple solution to such a situation is to add light. This can be done with a reflector, as described earlier.

If no ready-made reflector has been brought along, one can be quickly improvised, even with a sheet of

The dark foreground portion of this garden view of poppies was kept in good exposure while the bright areas behind it were sacrificed to overexposure. A limited depth of field blurred the background to reduce the potential visual "hot spots."

white paper. A helpful friend, who is willing to hold the paper at just the right angle to add light to the subject, is most welcome at such moments. The impact of the added reflected light can be seen through the lens and adjusted until it is right.

Those who anticipate the need for more added light can go a step further by taking along an electronic flash unit for the ultimate in fill-in light.

Fill-in flash

Even on the brightest day, a flash unit can make the difference between passable and unsurpassable photographs. Often electronic flash units are relegated to indoor purposes or photographs taken in the dark. Photographers of flowers and gardens, however, should consider a flash unit indispensable as a source of fill-in light.

Fill-in light refers to light that is added to brighten the shadow areas of a composition lit by the primary source, usually the sun. The fill-in light should never be stronger than the light of the sun at that moment, or else the flash becomes the primary light source. Ideally, the flash unit plays its secondary role in such an unobtrusive way that the end result looks as if it were taken entirely with natural, even illumination.

With backlight as the primary direction, for example, a flash unit can provide some frontlight or sidelight to illuminate a flower facing the photographer. This makes it possible to maintain color saturation in a sky at sunset, retain the halo effect of the backlight, and still show some detail in the subject. With sidelight, the high contrast can be softened a bit with fill-in flash on the dark side. And with splotchy conditions due to shadows cast by foliage or an arbor, the fill-in flash can even out the light. This is most welcome for portraits, but is also a good way to photograph flowers with internal shadows.

Fill-in flash has its limits, because it is not effective farther than 15 feet away, which makes it useless for landscapes. It can do wonders, however, for garden details and vignettes, or for close-ups.

To maintain the dominance of available light over that of the flash, it is important to keep the flash's power output below what is recommended on the unit for proper exposure. Since flash units synchronize at specific shutter speeds, meter the highlights within the composition at that shutter speed setting, then use an aperture setting 1 f-stop smaller than the one recommended on the flash unit.

In close-up photography, if the smallest f-stop is already being used, the power output can be lowered in several ways. Some flash units have variable power settings, so use a low setting. With constant power units, the output can be decreased with a diffuser or lens tissue. Or the flash unit can be placed on a stand at a distance farther away than the camera.

LEFT. *Low power fill-in flash was used to freeze the erratic wind-tossed movements of this Colorado Indian paintbrush.*

OPPOSITE. *Fill-in flash increased illumination on this Texas thistle so that a small aperture could be used for maximum depth of field and sharpness. To retain the feel of the natural diffused light, the flash was set at low power.*

4
Exposure in the Elements

"Aim for the natural."

SONJA BULLATY, 1983

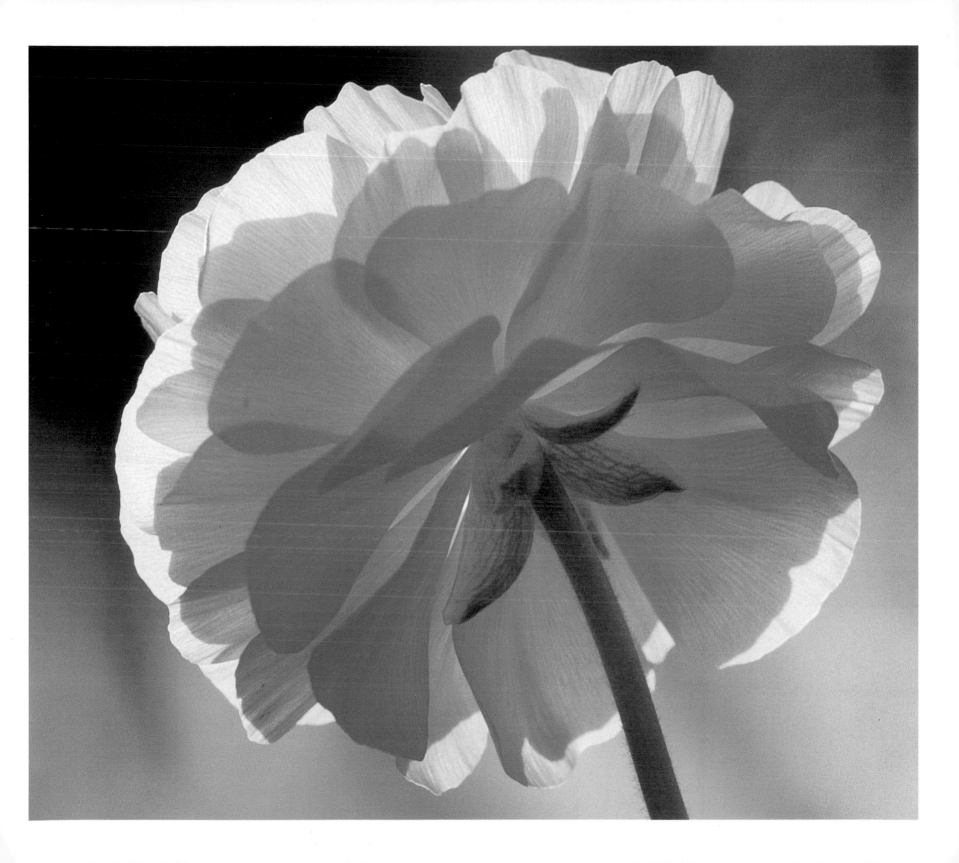

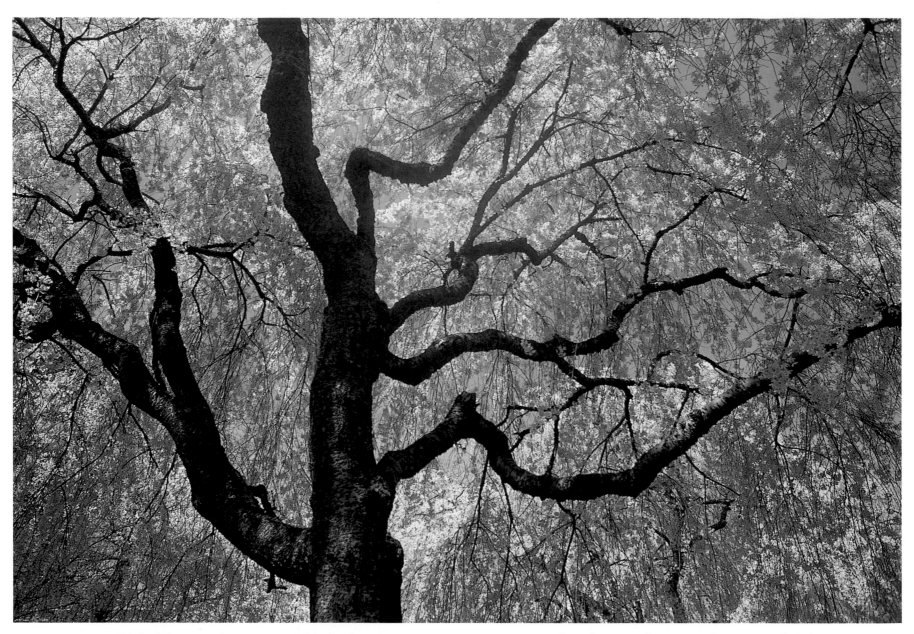

PAGE 97. *This backlit ranunculus was metered 5 inches from the flower's center and then overexposed by 1 f-stop to keep the various intensities of yellow bright.*

ABOVE. *Several meter readings were taken to gauge the light on this backlit cherry tree in Branch Brook Park in New Jersey. As a compromise, an underexposed setting was chosen to retain color saturation in the pink blossoms, leaving the tree's branches in silhouette. A polarizer deepened the blue of the sky.*

THE LIGHT METER

Proper exposure is a challenge to all photographers, regardless of their experience. Ideally, the light reflected by the myriad objects in the visible world is represented through a rich array of tonalities in each photograph. But light is such an evanescent, insubstantial thing that taking its measurement can be like chasing after moonbeams. It's a tricky endeavor, to say the least.

The tool that photographers have long used to help them gauge the intensity of light is the light meter. Light meters vary in several important ways. Some models are hand-held, but most are built into the camera. One hand-held variety is the spot meter, which measures a very narrow scope of only 1 degree, a handy feature when a photographer wants to take several exact measurements across a scene that is not uniformly lit.

Other hand-held meters, like most built-in types, are averaging meters, which gauge light intensity over an entire scene and find the average. Some built-in meters are center-weighted, a variation on the average meter that gives greater consideration to the center of the frame. The main drawback of a center-weighted system is that it assumes that the primary subject will be at the center, which is not always the case.

Whatever the type, all light meters essentially consist of a photoelectric cell which responds to light according to calibrations that have been worked out against the standard brightness of an 18 percent gray card. For those not familiar with this card, it is a simple piece of cardboard with one side a uniform shade of gray. Having a gray card is important, and we recommend you purchase one.

The importance of understanding the relationship between light meters and the gray card is that the meter is designed to read the brightness of any subject as if the photographer wanted it rendered with the same intensity and brightness as this card. Many photographers carry such a gray card for metering purposes when they want a very exact measurement of light intensity under difficult conditions. Since the gray card has a known level of reflectivity, it functions as a standard for comparing all other colors.

The real world, of course, spans many shades of gray, and for all these shades—or their color equivalents—to be reproduced accurately, the photographer must judge whether the intensity of light reflected from a chosen subject is greater or lesser than that of the gray card. If the subject is brighter, the meter reading will tend to darken it; if the subject is darker, the meter reading will tend to lighten it. In both cases, the meter reading is designed to turn the subject toward the 18 percent gray standard to which it is calibrated. The light meter reading, therefore, must be interpreted by the photographer if exposure and color rendition matter.

Moreover, light meters that take average or center-weighted readings can be fooled easily by extraneous light that is not part of the intended photograph. This situation commonly arises when a garden scene is framed with the sky as part of the composition. The sky is usually so much brighter than the rest of the subject that it throws the meter reading off.

What this means, as many a serious photographer has discovered, is that the light meter can't always be trusted, not because it is not working properly, but because it is made to work in a specific way. It should be used as the invaluable tool that it is, but the photographer's judgment must always play a part.

To minimize having the meter fooled, try as much as possible to take close-up readings, as near as 1 foot from the primary subject, especially if the composition entails a close-up of a flower or a garden detail. Once the reading has been taken, make a note of it or lock it in, since moving farther away from the subject to compose and photograph will alter the meter reading. If moving closer is not possible, meter a nearby object of the same color and in the same light.

Where very bright areas, such as sky, are to be included in the composition, tip the camera down so only the garden scene is metered and, again, lock in that reading. Polarize compositions that include sky, water, or highly reflective surfaces.

In the previous chapter, we focused on the photographer's ability to distinguish the many qualities of light. Now we want to consider more technical matters, always with an eye toward using technique not as an end in itself, but in the service of our inner vision.

Camera settings

A meter reading states exposure in terms of two camera settings, each of which controls the amount of light that will strike the film. These two settings—the shutter speed and the aperture, or f-stop—work in a reciprocal relationship to achieve the same exposure.

The shutter speed setting regulates how long the aperture will remain open, measured in fractions of a second—1/60, 1/125, and so on. The aperture setting, or f-stop, determines how large the aperture opening is, stated as a sequence of numbers from, for example, f/1.2 for the largest opening to f/22 for the smallest. Each increment in exposure time or aperture size doubles the amount of light intake.

Since these two settings are reciprocal with respect to exposure, it is possible to admit the same amount of light using a range of settings. For example, an exposure of f/8 at 1/60 of a second, would be equivalent to f/5.6 at 1/125 of a second, since one setting doubled the amount of light, while the other cut it in half. So the same exposure can be achieved with a variety of combinations of shutter speed and f-stop.

This matter is complicated, because the same settings control factors other than light input. Shutter speed is important in the rendering of movement, with faster shutter speeds needed to stop action and slower ones to create selective blurs. Aperture settings determine depth of field, which refers to the area of sharpness in front of and behind the point of focusing. The smaller the aperture, the greater the depth of field, which is desirable if the photographer wants maximum sharpness. But if the composition calls for the separation of a foreground subject by the use of a blurred background, then the photographer will want to minimize the depth of field with a wide aperture setting.

These aesthetic considerations should be foremost in deciding which aperture and shutter speed settings to use. Only after these decisions have been made should the photographer choose the combination that will ensure proper exposure. Moreover, it is rarely possible to combine the fastest shutter speed with the smallest aperture, even if that reflects our aesthetic ideal. Compromise, with knowledge and good judgment, is often the best one can do in photography.

What about automatic cameras? Cameras with sophisticated light meters linked to shutter speed and/or

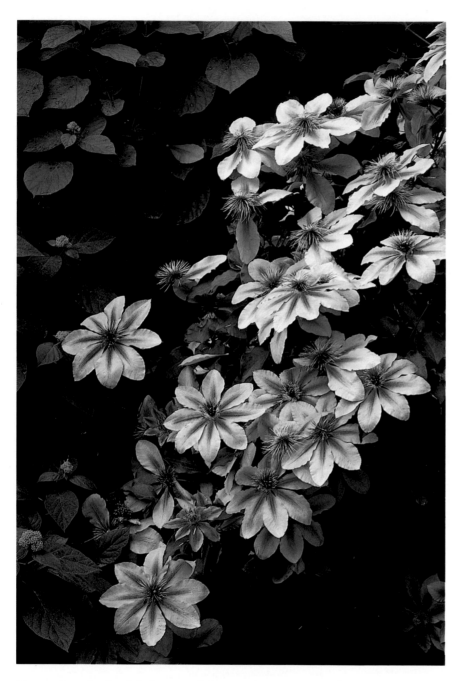

To reproduce this brightly lit sprig of clematis, the greatest possible depth of field was needed to maximize sharpness.

aperture controls are a genuine boon in situations that demand split-second timing, such as photojournalism or sports photography. But the photographer of flowers and gardens is usually more concerned with aesthetics and rarely confronts now-or-never circumstances. In such a case, an automatic camera is best if it offers a manual override so that the photographer has the option of choosing whether priority should be given to aperture or shutter speed.

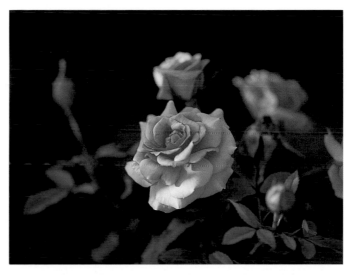

RIGHT. *A fast shutter speed of ½250 of a second took priority in photographing these wind–blown roses despite a reduced depth of field.*

BELOW. *This telephoto shot of a garden in winter required the greatest possible depth of field for clarity.*

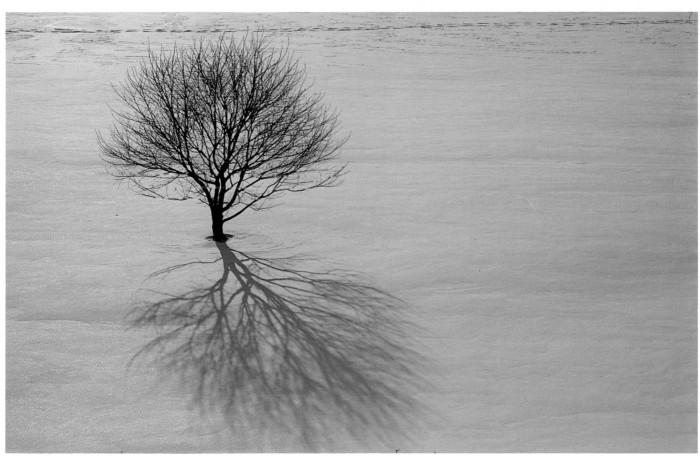

Bracketing

Even after taking careful meter readings and choosing the best camera settings for their aesthetic results, most professional photographers remain humble in their exposure determinations. In part, that is because professional photographers insist on getting the most perfect exposure possible, with the best possible color saturation and detail in the most important areas. They know that as good as their instruments are, they are merely tools, and that to be certain of the best exposure, they must hedge their bets.

This hedging process is known as bracketing. It is the photographer's insurance policy, and it costs only as much as a few extra frames of film. Bracketing is most crucial when shooting positive film—slide transparencies—because they leave no room for error. With negative film, whether black-and-white or color, there is greater latitude in the film and greater flexibility for making adjustments during the printing process.

To bracket, the photographer must first establish the combination of camera settings that will serve the aesthetic purpose of the picture and reflect a well-taken meter reading. In general, one frame should be exposed at the meter reading. Other frames can be either underexposed or overexposed from the meter reading; the ex-

Fujichrome 50, 35mm lens, f/16.

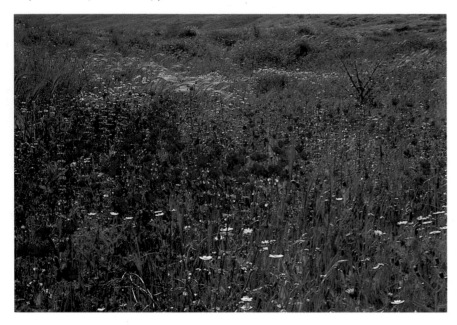

A shutter speed of ¹/₁₂₅ of a second was selected to stop movement in this field of wildflowers in Israel. Bracketing was achieved by varying the aperture opening. This image represents an underexposure of 1 full stop from the meter reading.

Fujichrome 50, 35mm lens, f/13.

An underexposure of ½ of an f-stop from the meter reading deepens the reds and increases sharpness of detail. For projection purposes and for high quality publications, an underexposed version may be preferable because of its color intensity.

act amount of over and/or underexposure depends on the nature of the subject (see the next section about "Making Decisions").

To bracket, the photographer can alter the f-stop or the shutter speed, but only one of these should be changed for any series of bracketed shots. If the aperture setting is to be kept constant, the shutter speed can be changed. If the shutter speed will be kept the same, the aperture setting can be varied. The reasons to retake a shot with identical settings are if something went wrong the first time and to have another original of an important shot.

It is possible to bracket even with automatic cameras that do not have manual override. One way is by changing the ISO setting to a different film speed. The camera will automatically adjust as if a faster or slower film were in the camera. Use a faster film speed setting to underexpose and a slower one to overexpose. Or turn the exposure compensation dial on cameras that have one. This dial indicates positive (+) settings for overexposure and negative (−) ones for underexposure. Be sure to return the ISO or dial settings back to their original positions after the bracketed sequence has been completed.

Fujichrome 50, 35mm lens, f/11.

This photograph represents the meter reading. Without the bracketed alternatives, it would be an acceptable rendering of the scene. Bracketing fine-tunes the exposure and provides the photographer a choice among several good alternatives. The version chosen depends on its use and on individual preference.

Fujichrome 50, 35mm lens, f/9.5.

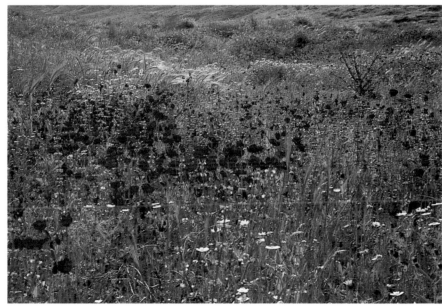

This overexposure of ½ of an f-stop from the meter reading may be the one to use for producing a color print or for newspaper reproduction, since it creates the highest degree of detail in the shadows.

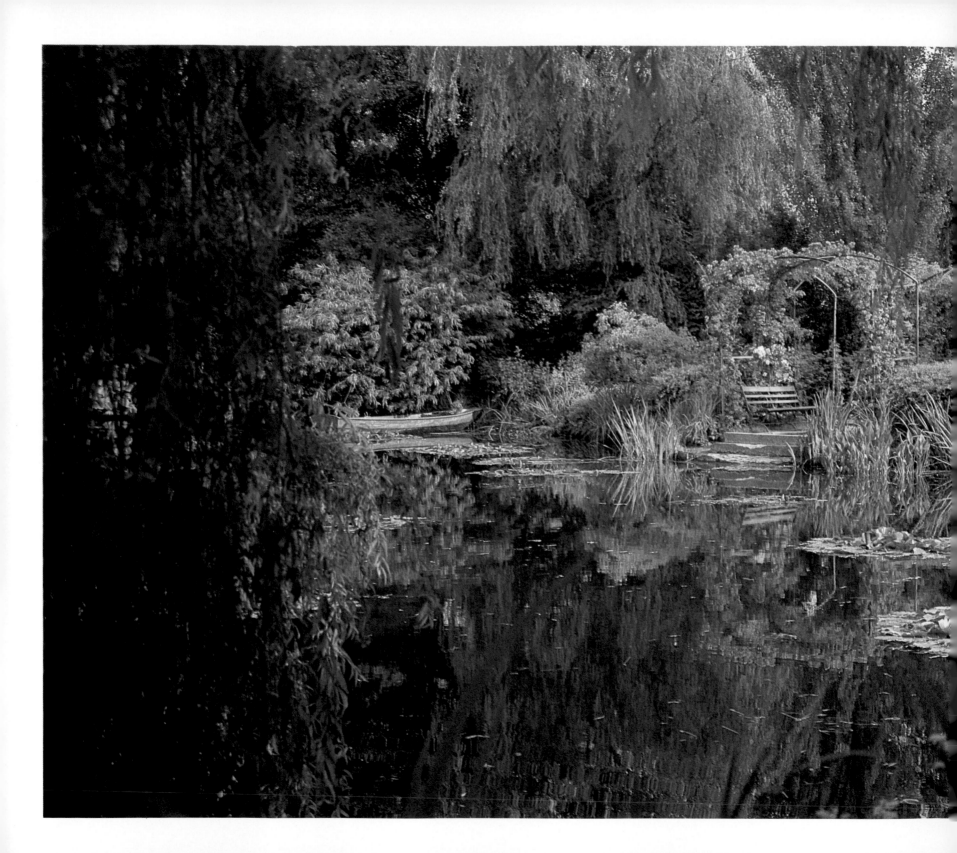

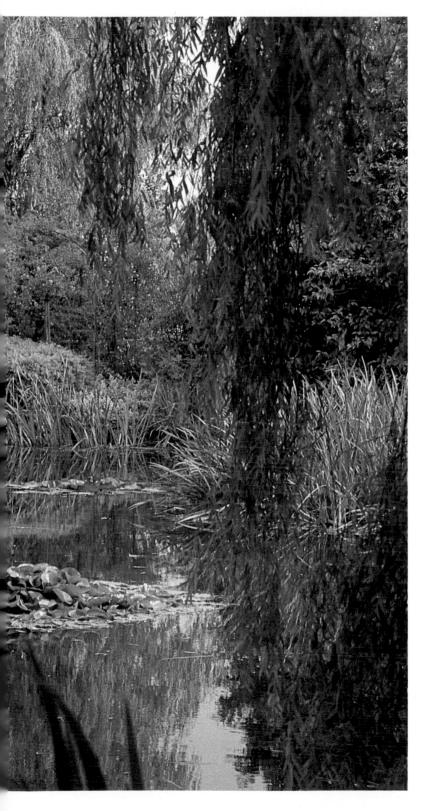

MAKING DECISIONS

While most people shy away from decisionmaking, it is necessary to control how our photographs will look. With respect to exposure, the decisions that need to be made are quite precise. The photographer must select a combination of camera settings that determine the amount of light that will reach the film. How much light is controlled by the aperture size (f-stop) and the amount of time (shutter speed) that the aperture will remain open. The choice depends on aesthetic judgment about depth of field and movement and on technical data from the light meter (or a visual assessment of light conditions).

In flower photography, the most difficult aspect of this series of decisions concerns metering and interpreting the meter reading. This is partly because most flower and garden photography is done outdoors, where light conditions are not in the photographer's control and are often influx. Moreover, floral subjects vary greatly in color, and contrasting colors are often juxtaposed within the same frame. Meter readings will not be consistent across the entire composition under these circumstances. Differences of several f-stops may show up, and the photographer may be understandably frustrated and confused.

If we think back to the previous chapter on light, we can apply its lessons to help us make decisions about exposure. To that earlier information, we now want to add a new understanding of how color density influences meter readings. We need to assess whether the colors we want properly exposed are darker or lighter that the 18 percent gray card.

Two broad kinds of exposure conditions will face us: those that are uniform as to color and light, and those that present us with contrasting colors and light. The next two sections give details on how to handle each situation.

OPPOSITE. *Due to the presence of deep shadows and brightly lit areas, reflections in the water, and a midday, washed-out sky, it was complex to photograph this water garden at Giverny. Exposure was based on the highlights, and the composition was framed to camouflage the sky.*

ABOVE. *Moderately intense diffused light softens the pastels of these wildflowers in an Israeli olive grove. Slight overexposure keeps the colors delicate and pale.*

OPPOSITE. *Diffused frontlight mutes the greens of the foliage and contrasts them against the dark shadows behind the perfectly spaced row of trees at Vaux de Vicomte in France.*

Uniform color and light

Uniform conditions are invariably easier to expose properly than those that are not uniform, since the light meter is less likely to be misled by any color or light that is radically different from the rest within the frame.

Let's consider four variations of uniform conditions typically encountered by flower and garden photographers:

Pastel colors in diffused light. Diffused light is generally soft, creating a minimum of shadows. Still, there is a noticeable difference between the low-intensity diffused light of fog, mist, or deep shade and the higher-intensity diffused light of an overcast day. When low in intensity, diffused light is wonderful for bringing out the softness of pastels. Therefore, the photographer may want to overexpose slightly from the meter reading to keep the tonalities light, delicate, and pale. With higher-intensity diffused light, pastels will have a slight glow. To capture this luminosity and retain color saturation in the pale tones, expose at the meter reading.

Pastel colors in bright light. As soon as we are working with bright light, we have to pay attention to the direction of the light in relation to the subject and the camera. Backlight with pastel flowers is quite effective, but the meter will tend to overvalue the brightness. Therefore, shoot at the meter reading and bracket toward overexposure at 1/3-stop intervals to 1 full stop. With sidelight, which is very tricky, try the meter reading, and bracket 1/2 of a stop toward both over and underexposure. Frontlight tends to be harsh and unflattering for delicate pastels. To make the best of this situation, try to find a dark shadow area to position behind the flowers. If a good photograph is not possible, it might be best not to take one at all.

Bright colors in diffused light. Full color saturation is readily achieved by using the meter reading for bright flowers in diffused light. If the intensity of the light is very low, consider slight overexposure.

Bright colors in bright light. Once again, with backlight it is best to shoot at the meter reading and overexpose to compensate for the meter's likely overvaluation of the brightness. For sidelight and, especially, for frontlight, use the meter reading and underexpose to retain full-color saturation.

ABOVE. *The uniform, diffused light at Longwood Gardens in Pennsylvania contrasts with the bright yellow lady's slipper orchids. The exposure was ½ of an f-stop below the meter reading of the highlights.*

RIGHT. *The mixture of bright light and deep shadow in this Sinai desert scene is typical of high-contrast conditions. Since the highlights were uniform in color, only they were metered, and the shadows were used as a black backdrop for the flower.*

OPPOSITE. *In this high-contrast composition of Texas bluebonnets and Indian paintbrush, a general meter reading was taken and then the frame was underexposed by 1 f/stop to saturate the blues and reds.*

Contrasting colors and light

Metering and making decisions is much more complex when contrasting conditions of color and/or light exist. The ability to previsualize is severely tested when the photographer has to imagine how a particular combination of colors, bright areas, and shadows will be reproduced based on the latitude of a particular film. The following guidelines may be helpful.

Contrasting colors in uniform, diffused light. This is the simplest of many complicated possibilities. Since the light is uniform and diffused, or soft, the important variable for purposes of exposure is the variation in colors of the flowers or garden elements in the composition. Several meter readings should be taken at close range or with a spot meter, if at all possible. Concentrate on metering the extremes—that is, the lightest and darkest colors within the frame. If those extremes fall within 2 1/2 f-stops of one another, find the average by splitting the difference. Shoot at that meter reading, and bracket in both directions.

Uniform color in high-contrast light. This situation is typified by the mixture of brightly lit and deeply shaded elements. Since the color is uniform, the main consideration is how best to render that color as it appears in the highlighted portions of the composition. In other words, the photographer should meter the highlights, ignoring the shadows for the purposes of exposure. With bright light, good color saturation will require shooting at that reading and bracketing toward underexposure. In either case, the shadow areas within the frame will be further underexposed, turning them nearly black. The photographer must imagine the intended image with the shadow areas black and decide whether the image works If so, take the exposure. If the black shadows spoil the image, then the photographer may add fill-in light with a flash or reflector, or forego taking the picture.

Contrasting colors in high-contrast light. So often, these very difficult circumstances are the ones that most attract us to picture taking. We respond to the warmth of a sunny day and admire the colorful array of flowers in a garden or meadow. Photographically, however, this is a situation that tries the skill of even the most experienced photography aficionado. Essentially, the procedures outlined above must be combined. Whenever flowers of varying colors are encompassed in a single composition, meter the extremes—the lightest and darkest colors.

However, since this is high-contrast light, meter the highlights of those extremes, preferably at close range or with a spot meter. If the two meter readings are within 2 1/2 f-stops, split the difference, as above. If they are 3 or more f-stops apart, more decisions must be made. If one color is more important for the desired image than the others, expose properly for that color, using the guidelines for uniform color (above). Or add fill-in light if the image is a garden detail taken at a distance of less than 15 feet with a normal or long lens. In any event, bracket liberally but intelligently to achieve the best results under these difficult—though common—conditions.

5
Style and Focus

*"I believe we have obtained a
fairly final expression of
mechanical technique. . . .
and I think our next step
should be the relation of this
technique to a more thorough
and inclusive aesthetic
expression."*

ANSEL ADAMS, 1924

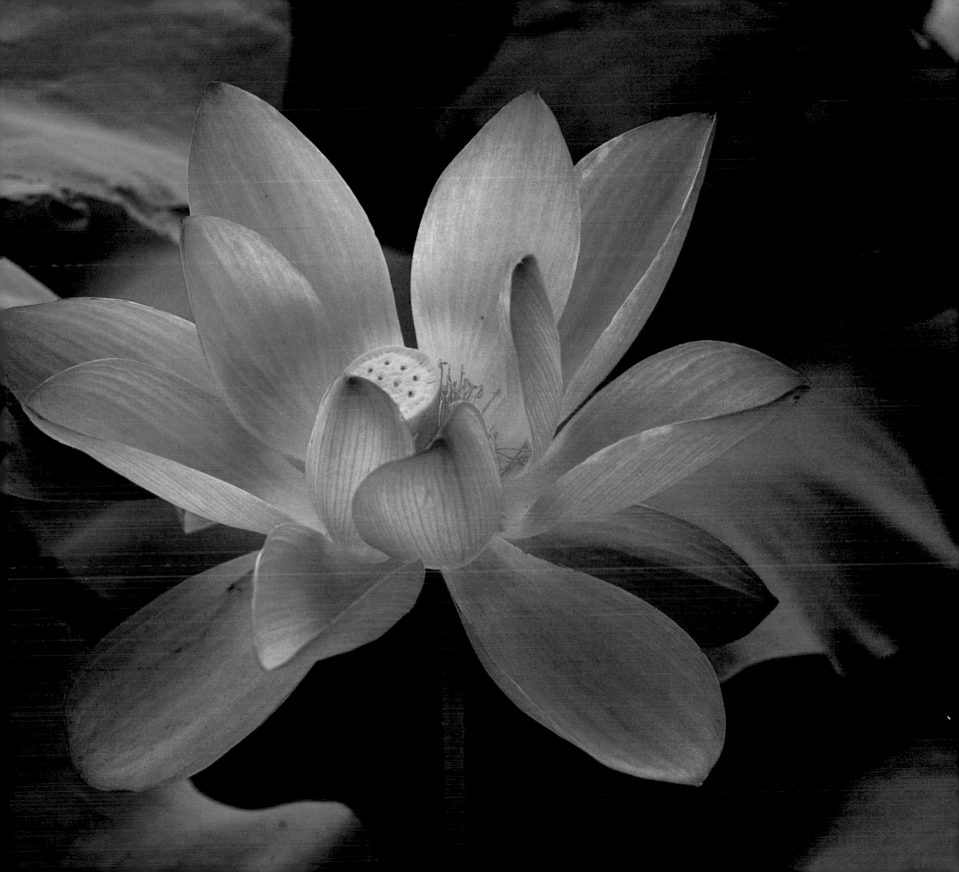

TECHNIQUES AND

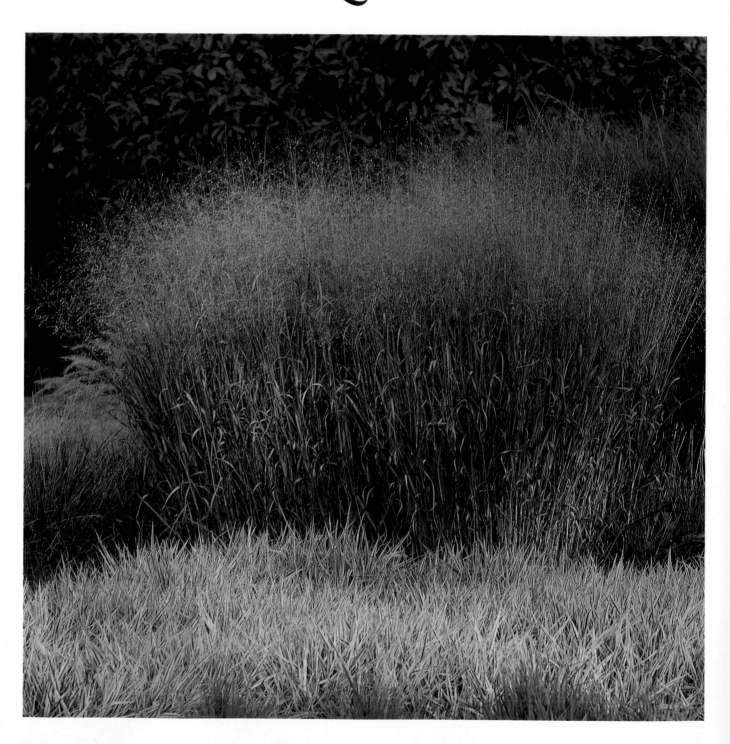

AESTHETICS

Sharpness in garden and flower photography is a matter of the utmost technical importance, and at the same time, a matter of individual preference.

How can that be? Since photography is a visual medium, we bring to it the expectation that it will recreate the eye's ability—albeit sometimes with the aid of optical lenses—to see clearly. In fact, one of the great pleasures of looking at photographs is the sensation that details have been reproduced with a clarity beyond what our eyes are capable of seeing. The ultracrisp photograph is like a jewel with crystalline edges that make everything sparkle. The techniques needed to achieve high levels of sharpness will be discussed in this chapter.

The tools of photography, unlike the eye, can be used to select degrees of sharpness. Some visual elements can be sharp while others deliberately lose clarity and definition, according to the photographer's instructions.

Because this capacity is so unlike the normal functioning of the eye, new photographers have great difficulty achieving proper sharpness, meaning the degree of sharpness that may be desirable in each instance. They may retain more sharpness than the image requires, reducing the impact of their subject. Or they may fail to provide enough sharpness for an image that cries out for crispness and clarity.

Knowing *when* to maximize sharpness and *when* to minimize it is a matter of aesthetics and judgment. It is here that the photographer's creativity and imagination come into play, for this is where a personal vision can be imposed successfully on a less than perfect reality to produce something of beauty.

Understanding *how* to create the exact degree of sharpness that is right for a particular subject is a matter of knowledge and technique. It is here that the photographer's grasp of focusing procedures and camera settings, with respect to depth of field, comes into play. The process of attaining sharpness reflects these two steps: First, the photographer imagines or previsualizes the final photographic product, with respect to sharpness; second, the photographer chooses the technical means for creating that result.

Achieving proper sharpness will be a time-consuming and difficult task, even for those with much experience.

Nor is sharpness something the modern automatic or electronic cameras can control for us with the degree of accuracy they have for exposure. Still, learning how to control sharpness is one of the surest sources of joy for photographers. The lessons on the next few pages are well worth mastering.

ABOVE. *In this soft-edged portrayal of a rose nestled among other roses, sharpness is limited. A telephoto lens was used at a wide aperture with the addition of a +1 diopter.*

OPPOSITE. *Sharpness was paramount for depicting these autumn grasses aesthetically. The low-angled sidelight set the fine textures in high relief, and the smallest aperture ensured the greatest possible depth of field.*

PAGES 110–111. *Selective focus was achieved with a telephoto lens at an aperture of f/8 to portray this lotus crisply, while slightly blurring the background foliage.*

Focusing

An exercise in sharpness begins with the focusing ring. Looking through the eyepiece of an SLR camera while turning the focusing ring will reveal that the image in the screen becomes sharper or blurrier. This occurs because turning the ring moves the lens within the barrel, changing the focal distance.

Precision focusing requires that we choose a specific spot within the frame to focus on by turning the focusing ring until that spot is as sharp as possible. To become skillful at focusing, some practice is required, first without film and then with film to test our accuracy.

Naturally, the spot to focus on should be the main element within the image since, at the very least, the most important feature in the frame should be sharp. For close-ups of flowers, the main element may be a structure within the flower, and we should choose it carefully, because it may not be possible for all parts of the flower to be equally sharp.

The next important consideration is to determine how much of the total image will be sharp, beyond the spot we are focusing on. This depends on the depth of field, a concept that is vital to a mastery of sharpness. Essentially, depth of field refers to the area of sharpness both in front of and behind the point being focused on.

Several factors, all of which the photographer can control, determine depth of field.

1. *The choice of lens.* Wide-angle lenses have a greater depth of field than normal or telephoto lenses.
2. *The distance from the subject.* The greater the distance is between the camera and the subject, the greater the depth of field will be.
3. *The aperture.* The smaller the opening is, the greater the depth of field will be.

When the photographer knows exactly what portion of the image should be in focus, and the process of focusing precisely has been conquered, it is a relatively straightforward matter to choose a combination of lens, distance, and aperture that will create the desired degree of sharpness. To oversimplify, the photographer increases the depth of field by choosing a wider-angle lens, moving farther from the subject, or using a smaller aperture. To decrease the depth of field, choose a longer lens, move closer to the subject, or use a larger aperture.

ABOVE. *Only the center of this tightly coiled rose is in sharp focus, softening the effect of the harsh, intense afternoon light.*

RIGHT. *The orchid in the foreground is the point of focus and the smallest aperture was chosen to maximize sharpness.*

OPPOSITE TOP. *The motion of these wind-blown tulips was rendered as an impressionistic overlapping of colors. The camera had to be mounted on a tripod to produce the muted blurs at a slow ¼ of a second exposure.*

OPPOSITE BOTTOM. *With a very fast shutter speed of ¹⁄₅₀₀ of a second the swaying of these cone flowers was caught at the moment they were about to change direction.*

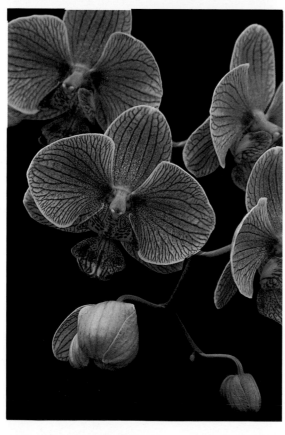

Motion

Another crucial camera setting for sharpness as it relates to motion, is shutter speed. A fast shutter speed will stop or freeze motion, while a slow shutter speed will render motion in some kind of a blur.

There are two main sources of motion: the photographer and the subject. If the camera is hand-held, a shutter speed of 1/125 of a second or faster is needed to avoid unwanted blurs from camera shake. To avoid this potential intrusion in flower and garden photography, simply set the camera on a tripod. Not only does this eliminate camera shake, it also frees the photographer to concentrate on more important matters. In general, motion caused by an unsteady hand is not desirable, although some pleasing results have come from deliberately moving the camera during exposure.

In most cases, then, the only motion that a photographer needs to cope with is that of the subject. Anyone who has photographed outdoors, in the garden or the field, has also realized that flowers and foliage do toss and sway in the wind—perhaps a joy to behold, but a trial to photograph.

What can be done? The choices are not as complex as they may seem. The photographer may opt to freeze the motion or to record the movement in some effective way, choosing from a range of shutter speeds to produce the desired effect.

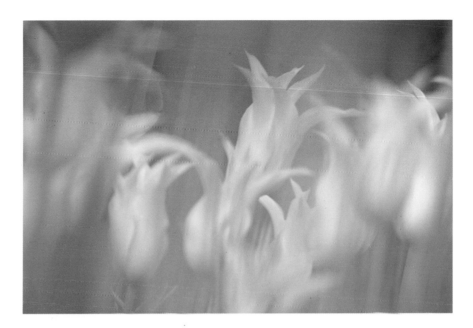

1. If there is sufficient light, and if the photographer wants to provide maximum sharpness with stopped motion, it should be possible to use a fast shutter speed in combination with a small aperture. If there is insufficient available light for a fast shutter speed, an electronic flash can freeze movement, provided the subject is relatively close.

2. Alternatively, the swaying motion can produce a partial blur, creating an aesthetic effect with a deliberately slow shutter speed of 1/30 of a second or less. But remember to keep the camera on a tripod so only the motion of the subject is registered.

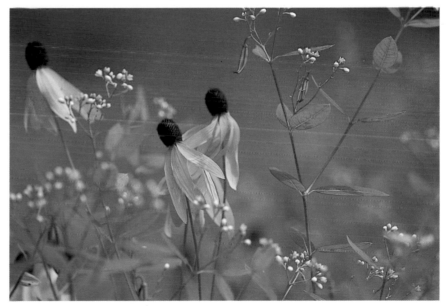

Achieving maximum sharpness

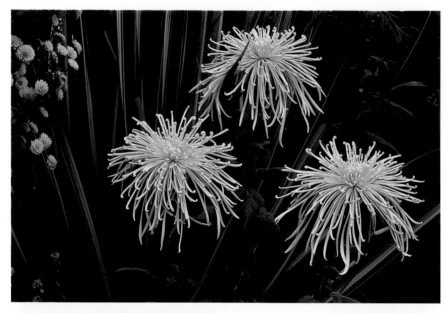

TOP. *Precision focusing on the center of the left Japanese chrysanthemum, a very small aperture, and the use of a darker, contrasting background maximize sharpness.*

ABOVE. *Because of the deep cup-shape of this crocus, the central structures and the rim of the petals are selected as the focal points.*

Maximum sharpness is not necessarily the ideal for every image. It is relative to the particulars and circumstances of each photographic situation. But there is a maximum potential to strive for, if the photographer's vision demands sharpness.

In addition to the general approaches already mentioned—precise focusing, increasing the depth of field, and fast shutter speeds to stop motion—there are two more options that warrant attention.

The added light provided by an electronic flash unit is wonderful for achieving sharpness, even in daylight. Its strong burst of light makes it possible to increase the depth of field by using a small aperture, a real boon for close-ups. The result is a greater overall sharpness and definition in the photograph. In addition, the burst of light, lasting no more than 1/400 of a second, is so fast that it freezes most movements, even though a slower shutter speed is set to coordinate with the flash unit.

For best results, use the flash off the camera to avoid the harshness of light aimed straight at a subject. An electronic flash is only effective at short distances from the subject—15 feet or less for a normal lens. Use it for details or close-ups, but never to shoot landscapes or full garden views.

Since flash units differ in light output, study the manufacturer's instructions and bracket by varying the aperture setting. In some of the new computerized cameras, very precise exposure is possible with an electronic flash since the aperture is programmed to respond instantly to the light that bounces back from the subject.

Another technique achieves some sharpness with contrasting light conditions. This is useful at times when a high degree of sharpness is not possible. For example, a garden detail across a pond may only be accessible with a telephoto lens, but this lens has a limited depth of field. Or a flowering shrub such as a rhododendron or azalea may be so irregular in shape that a close-range shot invariably makes some of the blossoms fuzzy.

In such instances, an illusion of greater sharpness can be created by juxtaposing brightly lit subjects against a darker, contrasting background. The high contrast between foreground and background emphasizes the edges and outlines of the subject, giving the appearance of sharpness.

On sunny days, contrasting light conditions are easy

to find. On overcast days, a dark shrub, wooded area, or wall can provide the necessary contrast. If contrasts are not readily found, an electronic flash can also serve to increase the light differential between foreground and background.

A fast shutter speed was needed to freeze the tossing motion of this Rocky Mountain columbine. Yet the low-intensity light precluded the use of a small aperture for the desired degree of sharpness. To improve the depth of field and create an illusion of sharpness through increased contrast, a reflector held by a companion was positioned to add light.

Aesthetics without sharpness

ABOVE. *The dull light and uninteresting setting around this tiger iris needed something to make it special. An experiment with magnifying filters to produce soft focus effects led to this result.*

OPPOSITE. *Bucking traditional, sharp portrayals of tulips, this image sought to re-create the sensation of looking at the flowers through the bed at ground level. While the central tulip remains sharp, a combination of moving grasses and selective focus produce an aesthetic effect without sharpness.*

While sharpness and clarity undoubtedly contribute to our appreciation of many photographs, there are times when other virtues warrant pursuit. And in the field of flower photography, there are certainly numerous examples of profoundly beautiful images whose aesthetics depend not at all on the sharpness. Ultimately then, decisions about sharpness are matters of individual choice, provided the photographer uses judgment with knowledge and clear intent.

For instance, it is quite difficult to combine the sensation of movement among flowers with a sharply rendered portrayal. Well-composed blurs taken at slow shutter speeds, on the other hand, can capture the lovely sway of meadow flowers in a gentle breeze, or the tossing of trees laden with spring blossoms. Shaking the camera deliberately can create interesting visual rhythms, while panning the motion of one particular flower produces fascinating swaths of color. Motion can be simulated with purposeful double exposure or images that are sandwiched.

Sharpness is not a virtue when it reveals what should have been hidden. That is the beauty of selective focus, since the photographer decides just what should be sharp—and what should not. Through the judicious use of depth of field, a flower in the foreground can be crystal clear while an unpleasant background is indistinct. Beyond such utilitarian approaches, the photographer can restrict sharp focus to a small portion of a flower or group of blossoms, to a thin cross-section of a field, or to nothing at all, preferring the out-of-focus impressions of billows of color and light. Again, it is the photographer's vision and mastery of technique that make such choices possible and meaningful.

Finally, the photographer may wish to communicate the softness of petals and colors through a blurring of definition. There are filters that soften focus, smudging edges, and producing a halolike aura. Lacking such filters, the photographer can breathe on a lens, reproducing the fuzziness of fog or mist. Or film can be pushed in low light to increase its graininess, reducing definition and creating a painterly image.

Neither photographic conventions, nor the nature of the subject, nor the capabilities of equipment, but the vision of the photographer should dictate decisions about sharpness—or the lack thereof.

6
The Creative Viewpoint

"I love art . . . because it doesn't have rules."

HARRY CALLAHAN, 1981

FRAMING

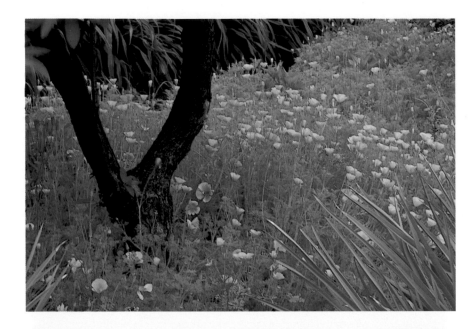

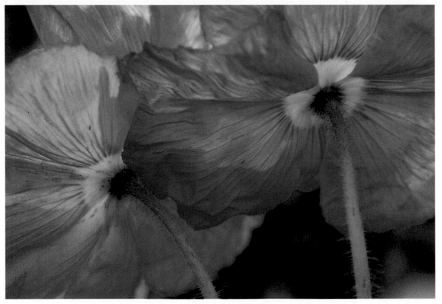

The creative viewpoint, or effective composition, has long preoccupied those in the visual arts. Some have devised specific principles that ensure the right combination of equilibrium and tension within a composition. But for every set of rules, new artists arise who defy them and find other ways of organizing their visions.

In photography, too, there have been many ideas about effective composition that have worked for some and not for others. Does that mean that there are no guidelines for good composition? Not exactly. In fact, we are about to present such guidelines, but we wish to caution the reader to view these more as suggested approaches to composition than as rigid laws.

To begin, let us think of photographic composition as a process of arranging elements within a frame. Later, we will come back to the elements themselves. For now, we want to emphasize the notion of framing, the process by which the photographer determines what belongs inside the box delineated through the viewfinder of the camera.

In flower and garden photography, we do not have the painter's license to adjust reality according to what we would prefer. We must train ourselves always to keep in mind the camera's objectivity in showing what our eyes and brains may wishfully omit.

To learn to look more carefully, we should begin to force ourselves to move in every available direction. Breaking the habit of looking at flowers and gardens from our accustomed upright, eye-level viewpoint will help us find unusual angles and interesting perspectives. This exercise is the necessary first step toward mastering the intricacies of precision framing.

TOP LEFT. *The disparate elements of this garden scene—yellow poppies, green grasses, and a dark tree trunk—are combined harmoniously. By omitting the tree's foliage, the eye is drawn to the often neglected elements below.*

LEFT. *This view from the rear tightly frames these Arizona poppies so that color and form dominate the composition.*

PAGES 120–121. *Tight framing is illustrated in this partial view of two gaudy ranunculus blossoms.*

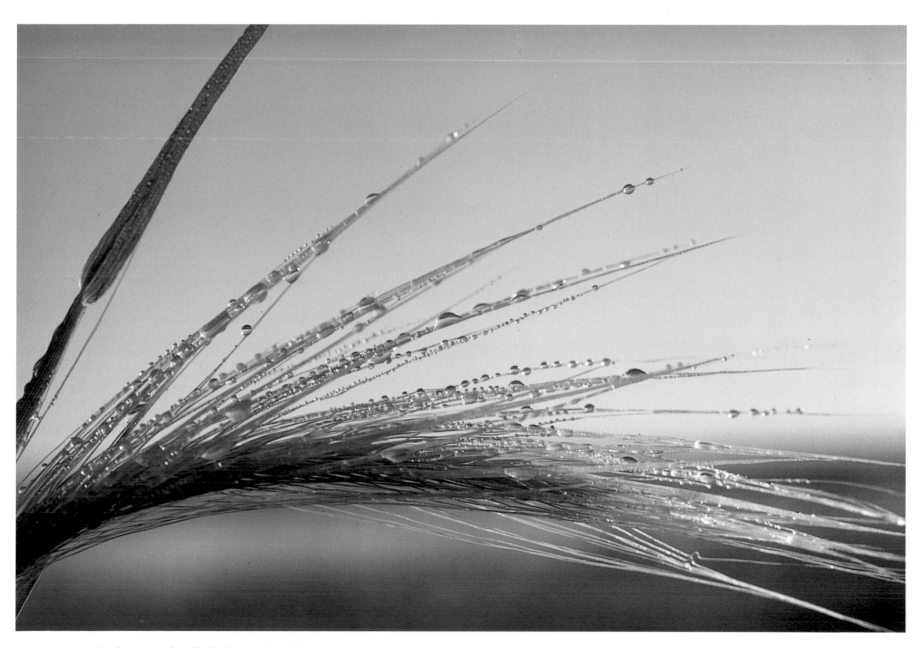

A single, dew-covered stalk of wheat in North Dakota is framed as a close-up, curving to the corner of the frame.

The subject in the settings

If framing is nothing else, it is this: including within the frame *only* what is necessary and excluding what is extraneous. To accomplish this, the photographer must become conscious of the relationship between the subject and the setting. Specifically, that relationship must be analyzed in terms of size, light, and focus.

Determining size is a crucial first step, for it defines the essence of what we have in mind for our photograph. If we could make a sketch, drawing the scene in the photograph, we would have to know the size of the various elements in relation to each other. Being able to identify clearly the size of those elements will guide us in our choice of lens.

For example, we may wish to show only one flower, at close-up range, in which case we may totally block out all aspects of the background. Depending on our distance from the subject, we may choose a macro lens or a telephoto lens, eliminating the setting totally, or blurring it out at the edges. On the other hand, we may wish to show this same flower as part of an arrangement or garden detail. In this case, we may choose a normal lens. We would still need to evaluate the background to see if it complements the flowers or presents an unwanted distraction, using selective focus to achieve the result we prefer. Or we may wish to show the same flower as a bold element along a garden path, with the plantings on both sides in as much full detail as possible. In such an instance, the setting takes on great importance as a significant backdrop for our primary subject. A large foreground subject with a well-defined background probably demands a wide-angle lens. In each of these examples, the same flower would be framed in different ways, depending on how the photographer sees its visual relationships to the setting, especially in terms of its size within the frame.

Light is another consideration in seeing the relationship between subject and setting. Is the subject in the same light as the setting, or is there a high degree of contrast between the two? Can the image we have in mind benefit from the existing light? For example, if our background is a jumble of clutter, it may not matter if it is in deep shade compared with a brightly lit foreground sub-

ject. If not, will the intensity or direction of the light be more favorable from a different position. Or should light be added to create the effect we want? Finding or creating the best combination of light on the subject and the setting is an important aspect of framing.

Focus is another consideration when framing, because the background can be rendered sharply or can be blurred. Remember that the photographer can control the degree of sharpness. Therefore, a distracting background can be thrown out of focus so the subject is dramatically set apart from everything behind it. But a desirable setting can be incorporated by maximizing sharpness.

ABOVE. *This low-perspective detail of a field of asters in Colorado shows a partially opened bud in sharp relief against its blurred, full-blossomed neighbors. The larger setting was unimportant to this composition, but the placement of the bud was crucial so it would block the yellow center of the flower just behind it.*

LEFT. *The Colorado setting of these columbines is eliminated through relatively tight framing, and blurred by limiting the depth of field.*

OPPOSITE TOP. *The ground-hugging heather on the moors of western England forms a carpet of color which is interesting as a part of the larger setting. The starkness of the wild terrain is emphasized by including the single, windblown tree.*

OPPOSITE BOTTOM. *A powerful telephoto lens pulls together the hillside of wild poppies, daisies, and grasses, and the desert mountains of Moab. This combination documents the flowers in their setting and creates an effective image of contrasting colors and complementary forms.*

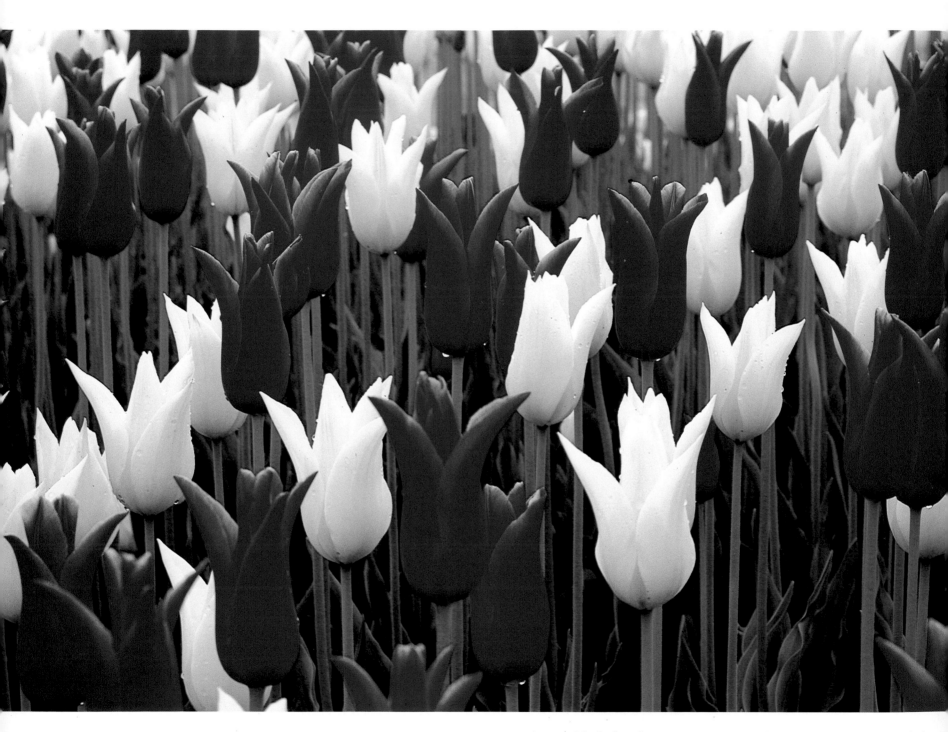

A powerful telephoto lens compresses space so these tulips appear to be stacked. Filling the frame with their repeating forms adds compositional value.

Choosing the right lens

Understanding the capabilities of various lenses further expands our ability to frame a subject in the most photogenic way. A novice photographer should experiment by looking at the same subject through several lenses to see how differently each lens handles the situation. How large is the main subject within the frame? How does the main subject relate to its surroundings? Does a lens include too much of a scene, or too little?

The normal 50mm lens is excellent for framing garden details and landscapes at a moderate distance. Its most admirable feature is its ability to render medium-range close-ups of 3 to 10 feet, especially those requiring a selective focus to obliterate an unwanted background. This lens is not suitable for a vast panoramic view. Nor can it take true close-ups or enable the photographer to shoot details at distances of more than 15 feet. For true close-ups, with a magnification of one-tenth of life size, the best choice is a macro lens.

Wide-angle lenses are best for incorporating a subject and its setting. Their greater field of vision makes them ideal for portraying broad vistas, whether in a garden or natural environment. With a vertical format, wide-angle lenses can encompass tall trees, although their parallel lines may appear to bend inward at the edges of the frame. The extra depth of field provided by wide-angles lenses keeps both a foreground subject and its background sharp, even at moderately close range. This is a major advantage for composing when the photographer wants to frame flowers in the foreground in a dramatic way yet retain a clear sense of their setting.

Telephoto lenses are the best choice for the reverse conditions. Because of their narrow field of vision, they restrict the background included in the frame. Moreover, because of their limited depth of field, they are best for isolating a flower or detail from its setting. In the garden at relatively short distances, telephoto lenses enable the photographer to feature a small part of the design against a blurred setting. Telephoto lenses' ability to compress space can reproduce beautifully the sensation of being in the midst of a field of wildflowers and grasses. And, of course, telephoto lenses are ideal for reaching across an obstacle, such as water, to magnify flowers that would be otherwise inaccessible.

Zoom lenses offer the photographer great flexibility in framing because of their range of focal lengths.

TOP. *A wide-angle lens was chosen for this garden vista so that the foreground trees could be encompassed within the frame, while the background setting reveals the design of the château grounds at Villandry in France.*

ABOVE. *This telephoto lens shot of a stone wall taken at Vaux de Vicomte was conceived as a study in geometric forms and lines.*

Format

Another aspect of framing is choosing the format—horizontal, vertical, or square—that will best represent the subject. This decision may be dictated by our equipment, or by the general shape of our subject.

Most photographers favor the horizontal format with 35mm equipment, in part because the camera seems more natural to hold in this direction, but also because we tend to experience the visual world horizontally. If this tendency is to be broken, a conscious effort must be made to look at every shot both horizontally and vertically before deciding which works better. For professional purposes, it is often wise to shoot both formats, since published photographs often fill predesigned slots.

There are no firm rules about which format to choose, but here are some pointers:

1. Whatever the format, be sure that the horizon line is level, even if it seems unimportant to the overall composition. A slightly slanted horizon line is especially distressing in the horizontal format, so take the extra moments needed to check and adjust it.
2. Get in the habit of looking to the edges and corners of each frame. This will help determine the most effective format in several ways. Debris or clutter at the bottom of the frame often goes unnoticed. If present, it can easily be omitted by changing from a vertical to a horizontal format. Also, look to the edges of the frame to notice if it includes too much sky. If so, switch from a vertical to a horizontal format. Even if staying with the original format seems right, tip the camera slightly up or down to see if this improves the framing.
3. Square-format cameras save us the trouble of making such decisions with each frame. They are generally chosen, however, not for their format, but for the larger negatives they produce.

Ultimately, the choice of format is a personal one. As long as the choice is made consciously and purposefully, it will be instrumental in more effective framing.

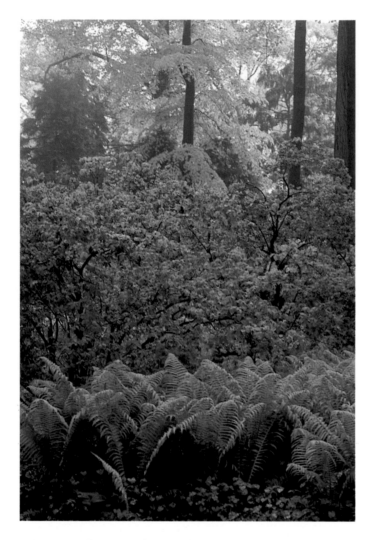

The vertical format made it possible to compose this garden detail at Winterthur, Delaware, as a series of three stacked horizontal bands—ferns at the bottom, azaleas in the center, and trees at the top.

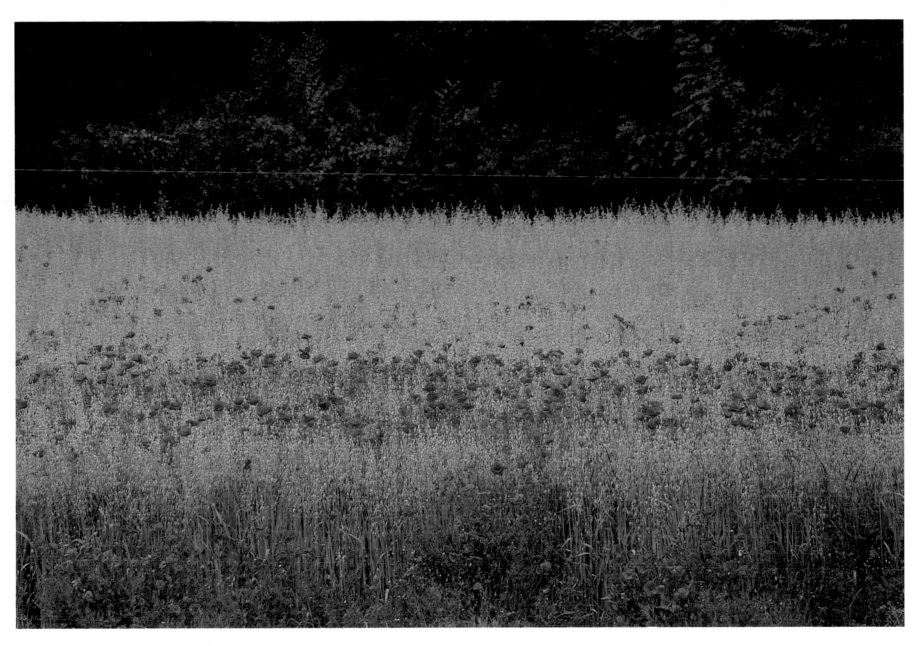

The horizontal format was chosen to emphasize the restful mood of this field in France. The muted colors—the bleached grasses and faded poppies—play against the shadows at the top and bottom of the frame to create an understated abstraction.

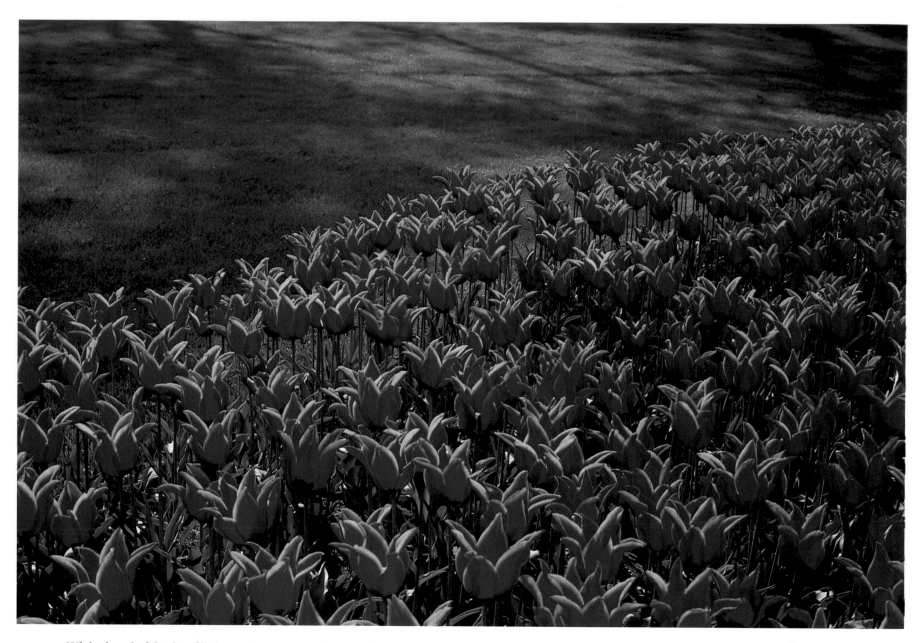

While the colorful tulips fill the positive space in this composition, the shadows and lawn of the negative space are important as complementary and balancing shapes.

Positive and negative space

An instructive way for the photographer to define the shapes within the frame is to think of them as positive and negative space. Like the idea of figure and ground, positive space suggests that there are shapes whose outlines we perceive as the primary subject, while negative space refers to the incidental shapes formed between and around the coherent shapes.

Even though the shapes of negative space may seem less important, they act as a foil or counterforce to the primary shapes, and in visual terms, become part of the arrangement of abstract forms within the frame. Negative space takes on the role of the supporting actors in a play: theirs may not be the central story, but without them the play would lose much of its fascination.

Some compositions consist of nothing but positive space. Very tight framing on a close-up of a single flower, a floral or garden display, or a field of flowers may leave no interstices of negative space.

When negative space is desirable or unavoidable, it should bring out the best in whatever occupies the positive space:

1. The color of the negative space should complement the primary subject. With flowers and gardens, the greens of nearby vegetation, the blue of the sky—especially if polarized—and the black of shaded background areas are generally available. White should be handled with special care as negative space, because it is highly reflective, tends to look very stark, and often draws the viewer's eye away from the main subject. A single color is safer for negative space than an assortment of tones, the exception being pastels, whose soft hues tend to merge when thrown out of focus.

2. The lighting of the negative space should harmonize with that of the positive space, either as light of equal intensity or high contrast. Contrasting bright positive space and dark negative space sets a subject off dramatically, while juxta-

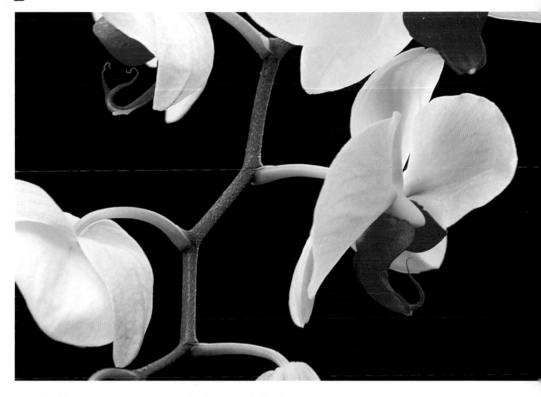

The black negative space—a shadow area behind the primary subject—forms a dramatic backdrop for the exotic orchids that occupy the positive space.

posing bright negative space and dark positive space creates a silhouette. Try to avoid uneven light with bright spots or glare in the negative space, since these will either distract the viewer or draw the eye away from the main subject.

3. Selective focus can be used to emphasize the separation of positive and negative space, usually by obscuring the background, but also by placing a subject along a well-defined slice, with the foreground and background out of focus.

The "pinwheel" at the center of this rose—a natural wonder and unexpected discovery—forms the basis for the composition of this close-up. The peripheral petals radiate outward, taking the viewer's eye from the center to the edges of the frame.

Photographic composition generally implies an arrangement of forms on a two-dimensional plane. In garden photography, the arrangement can reflect the photographer's understanding of the designer's or architect's plan, or it can be the photographer's original discovery of patterns that are delightful and pleasing. In field photography, nature's more casual order is organized by the photographer and presented either as a grand vista or a vignette. Flowers, whether in the garden or the field, contain a symmetry and rhythm that even a young child responds to spontaneously.

If we can retain a child's sense of wonder and discovery, while at the same time applying discipline and control to our method, then we will be on the way to effective composition. For in the truest sense, each photograph is unique, and what gives it the signature of its maker is the special vision that is conveyed through composition. These are not matters of technique or the latest equipment. These are matters of the heart, the soul, the mind, and the sensitive eye.

To compose well, we must know ourselves, and have an understanding of what it is that excites us when we see something. Is it the voluptuous shape of a flower, or the curve of its contour? Is it a velvety texture, or a coarse surface? Is it the rich color, or the subtlety of the hues? Is it the bold shapes or the seemingly random repetition of some interesting squiggle? It can and should be something new each time, something that makes us take notice.

Then, we must take that momentary spark, work to encompass what we felt, and communicate it on film. Notice that we said "felt" rather than "saw" or "thought." For while seeing and thinking are always important, we are striving to let the viewer reexperience the energy of our feelings.

Composition is the tool by which we give structure and form to our feelings of visual delight. Without composition, an image lacks coherence and clarity. And without those, we cannot communicate the emotions that moved us to take the photograph in the first place.

PATTERN

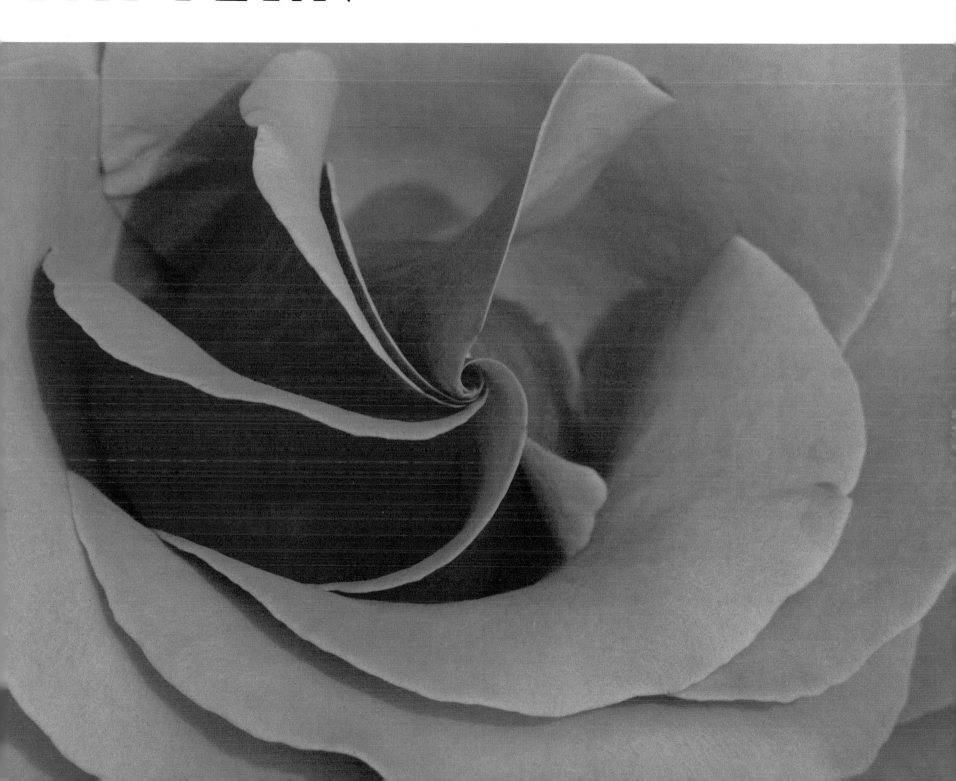

Lines and shapes

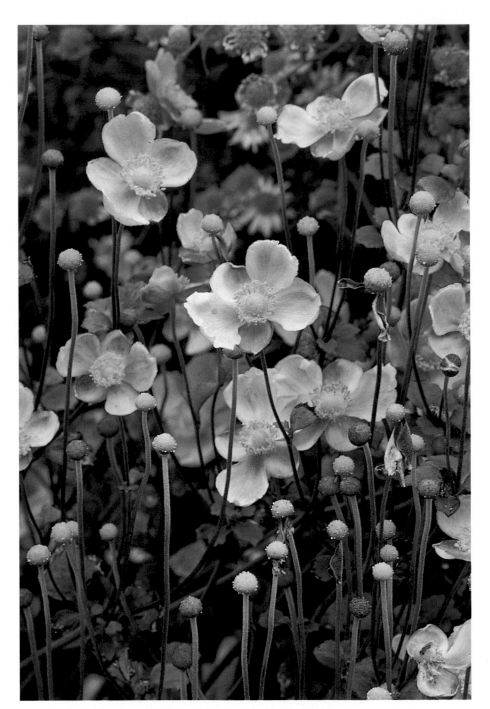

A stronger sense of composition may be developed by reducing visual subjects to their simplest forms, namely lines and shapes. When looking at a garden, do not think in terms of trees, shrubs, flowers, pools, pergolas, and benches, but in terms of cylinders, balls, rectangles, circles, triangles, and so on. Determine the predominant shapes within the frame, and move around until they form an effective arrangement.

The repetition of similar shapes in a pleasing pattern is often called rhythm. For the rhythm to work, imagine placing the repeated shapes along a line—like connecting the dots in a coloring book. Then decide if the resulting line is interesting in itself. If not, move a bit and try again.

Contrasting shapes can work in a composition, if they do not overwhelm the dominant ones. For example, a rectangular bench set in front of the strong cylindrical trunks of a stand of trees, topped by the vertical band of their foliage, can create a strong composition as long as the bench remains relatively small.

Another way to develop compositional skill is to think of the components within the frame, such as sky, ground, path, hedge, or pergola as lines that animate the scene and have the potential to give it energy. Different kinds of lines affect the viewer differently. Converging lines have a very strong dynamic quality, virtually sucking the viewer into the scene. Diagonal lines are also quite directional, leading the eye toward some unknown destination. Horizontal and vertical lines, while more static, have the ability to create a sense of calm and serenity. Radiating lines, like those found in many floral close-ups, push out the edges and involve the viewer actively in imagining what lies beyond the frame. Zigzags are whimsical, curved lines are alluring, and parallel lines are very formal.

Our purpose here is to suggest that these lines and shapes exist, both in nature and in man-made oases. If we train ourselves to find these elements, they will quickly become self-evident. Then we can use them creatively to give form and structure to our compositions.

OPPOSITE. *These unpretentious Japanese anemones, photographed at ground level, were composed for their whimsical repetition of lines and shapes. The pink blossoms are the dominant forms, but the bare yellow centers create an interesting counterpoint, as do the vertical stems.*

ABOVE. *The tightly packed gerbera daisies in an Israeli commercial greenhouse fill a box ready for shipment. Compositionally, they fill the frame as a series of bright yellow circles, made intricate by the radiating lines formed by their individual petals.*

Surface texture

Few of us can resist the temptation to touch plants, to feel their coarseness or their smooth surface, to confirm a hard and shiny texture or a soft and fluffy one. Fortunately, the delight in surface textures can be communicated through visual means, provided the photographer is aware of textural qualities and learns how to project them through imagery.

Surface texture plays an important role in composition because it acts as a counterpoint to the broader elements of line and shape. The arrangement of shapes into a configuration or design can be quite stark; surface texture softens the effect while maintaining the overall design. In addition, these textural elements strengthen the composition by providing repetitive patterns of their own to carry the eye across the picture plane.

The most important consideration for rendering texture effectively is absolute sharpness, which requires precision focusing and good depth of field. Without careful focusing, the clear edges that create the texture will lose definition. Even if the surface texture is soft or velvety, precise focusing and a point of uncompromising sharpness are needed to draw the eye's attention. For soft effects, however, it is possible to set the sharply defined point within a setting of blurs and diffusion.

To maintain the highest possible depth of field, use a small aperture. Usually this means shooting at a slower shutter speed with the camera on a tripod. Or, if the wind makes it too difficult to use slow speeds, add light with an electronic flash unit.

High-contrast light, especially backlight and sidelight, emphasizes surface texture because it highlights the edges, making them stand out with a special glow. Early morning and late afternoon light are sought out by serious photographers, for during those hours the possibility for capturing interesting surface textures increases considerably.

TOP LEFT. *The fragile white blossoms of an early-blooming cherry tree in Branch Brook Park in New Jersey present a textural contrast with the brittle grasses that have weathered the winter months.*

LEFT. *This close-up is a study in varied textures: the pointy shafts of grass and evergreen needles are interspersed with dried oak leaves from the previous autumn and pierced with the shoots of spring flowers.*

Abstractions

The fascination with lines and shapes often leads experienced photographers to experiment with more abstract compositions. Not only do they disregard what their subjects are, or what they are called, but they see them only in terms of the lines and shapes they create. Though the subject may be a flower or may have been found in a garden, it might not be easy to see that from the photograph.

Such photography can be great fun, although it is not in the mainstream of flower and garden photography. Its pleasure lies in finding new ways of looking and in creating images that serve as a kind of puzzle that asks viewers to discover what they are seeing and how the image was made.

Making an abstract composition is not as easy as it may seem. Abstractions generally fall into two categories: those which create an overall rhythmic pattern without calling attention to any individual elements and those which depend on bold shapes and stark contrasts of color or light. In both cases, the photographer is expressing the wonder and fascination of the abstract qualities as the central motivation for the image.

ABOVE. *A tightly framed image of a cherry tree at Branch Brook Park in New Jersey was taken with a telephoto lens to emphasize the abstract aspect of the lines and dabs of color.*

TOP LEFT. *A tumbling bramble resting atop some wild poppies in the Judean desert creates a fascinating abstract composition of squiggly lines and red splotches.*

LEFT. *The edge of a tulip, with one petal about to fall off, is turned into an abstract composition of pure form and color, set against a simple, solid backdrop.*

Depth

There are times when a composition calls for a sense of depth, though it is not always a necessity. Since film is flat, the idea of the third dimension must be conveyed through visual cues that we translate as depth.

Lines within the composition can increase the sense of depth. For example, lines that converge, or lines that emerge out of the corner to cross the film plane at a diagonal help represent the third dimension. Contrasting sizes also emphasize depth. Large foreground objects, with smaller ones in the background, are interpreted by the eye as visual distance.

Wide-angle lenses exaggerate this differential in size, and they also tend to stretch out and bend lines, making them particularly effective tools for portraying the third dimension.

Finally, high-contrast light can be used to emphasize depth. Shadows that photograph as dark areas create space between the brightly lit portions of a composition, so they seem to project forward. Alternating strata of light and dark bands separate the scene into overlapping layers, which contribute to a sense of depth.

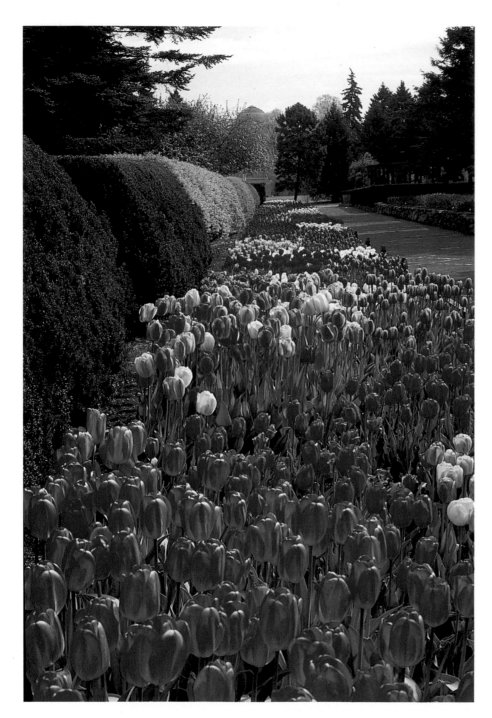

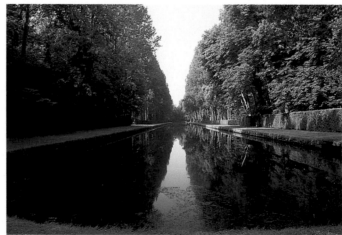

LEFT. *At The New York Botanical Garden's tulip walk, converging lines create a sense of depth.*

ABOVE. *In Courrances, this canal's parallel lines are bent inward by a wide-angle lens.*

Color

Indeed, color is such a powerful attraction that it is the sole inspiration for many photographs. In the wild, it becomes obvious that the photographer must organize nature's disparate elements into a pleasing display of color. In a well-designed garden, however, the designer or landscaper seems to have done some of the work for us by combining plants with colors that complement each other and should photograph well together. Even in such gardens, though, the photographer should select colors for their impact within the confined space of a visual composition.

Color is an element that works with line, shape, and texture to convey the photographer's vision. That is what makes it important not simply to accept the overwhelming reaction to color that most of us have but to begin to think of color's role in an image in more specific terms. Is there one predominant color or more than one? Are the colors bold or subtle? Are the colors warm or cool? Do the colors harmonize or clash? Each of these situations calls for a different approach to composition.

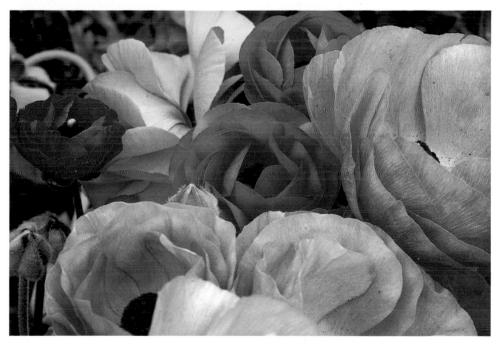

ABOVE. *This zinnia displays provocative colors.*

RIGHT TOP. *The peonies and foliage are a study in contrasting colors.*

RIGHT. *These ranunculuses display bright splashes of pure color.*

A +2 diopter added to a 200mm macro lens blurs the background roses behind this single bud beyond recognition, transforming them into a swath of vivid red, pink, and orange.

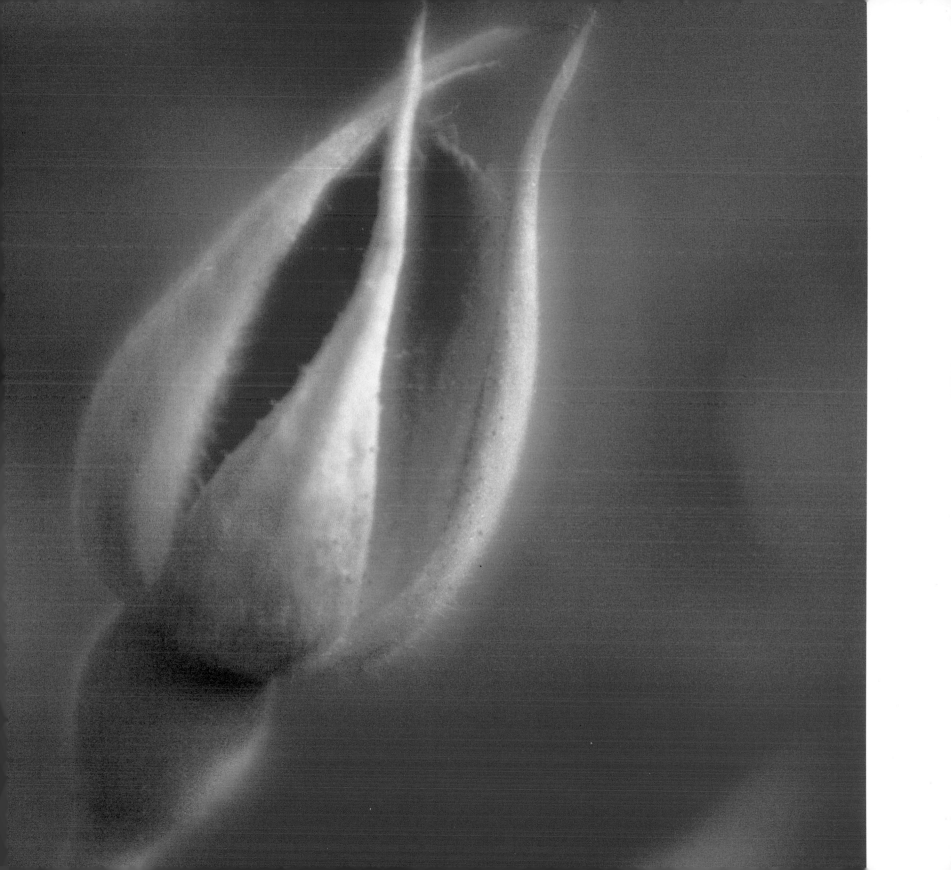

7
Beyond What Meets the Eye

"A flower is relatively small. . . . Still in a way— nobody sees a flower—so I said to myself—I'll paint it big. . . ."

GEORGIA O'KEEFFE, 1939

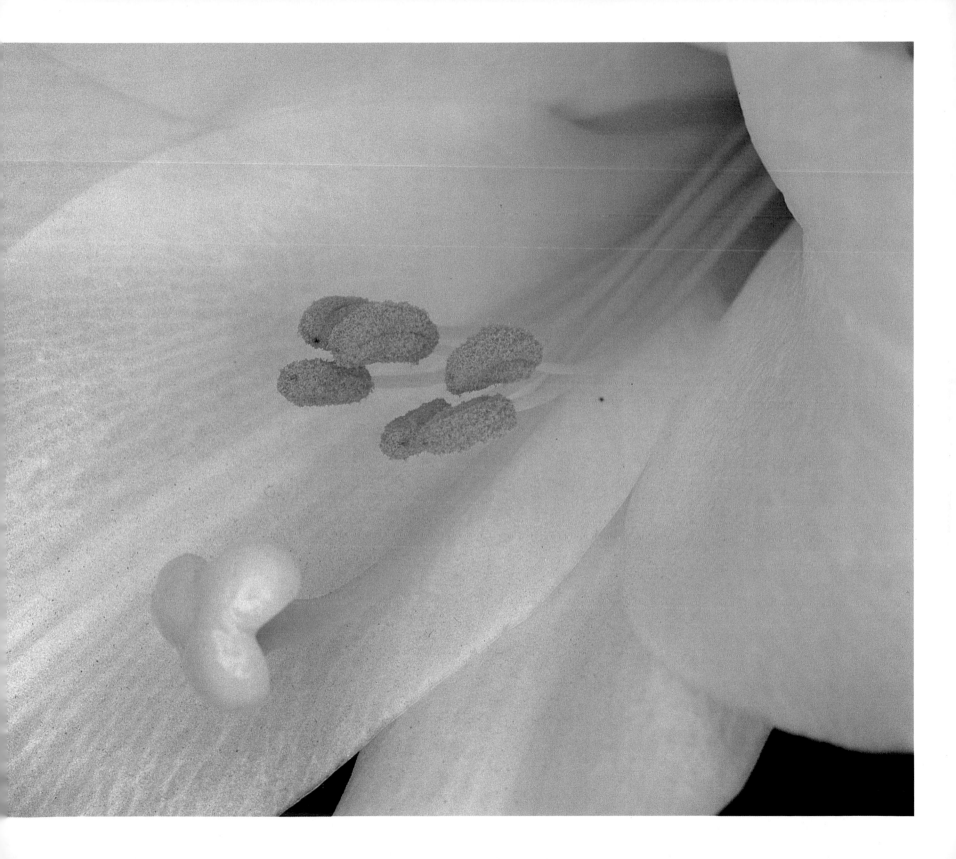

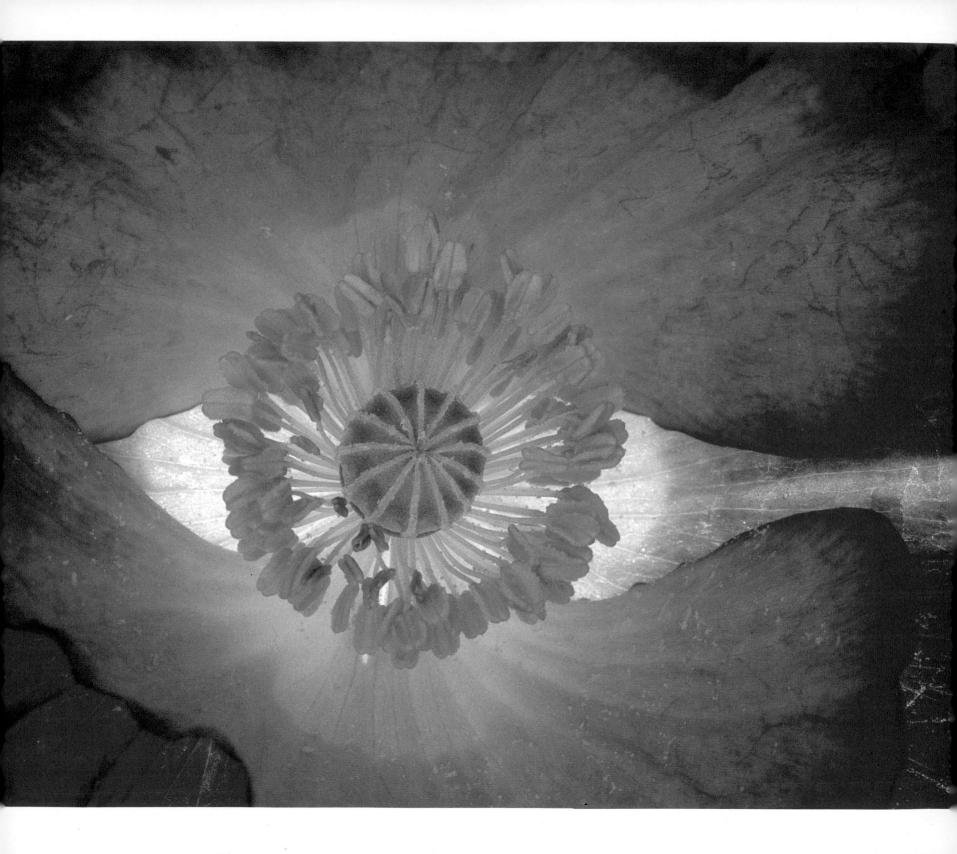

CLOSE-UPS

A photographer's first experiment with close-up equipment never fails to be a moment of utter surprise and amazement. Things that were familiar—and even ordinary—are suddenly transformed into the marvelous by virtue of photography's ability to magnify what the eye would ordinarily see.

Through close-ups, it is possible to take a fantastic voyage into a flower's interior, exploring a myriad of tiny and beautiful structures. There are anthers encrusted with pollen, fine-haired cilia, spiraling petals, and overlapping forms with a rich array of textures and colors.

Close-up photography refers to images that are 1/10 of the life-size subject or larger. This means that the image on the *film plane* is at least 1/10 as big as in reality. Since 35mm film is approximately 1 1/2 inches across, an area no more than 15 inches across would have to fill the frame to be considered a close-up. Moderate levels of magnification, from 1/10 to 1/2 life-size, are possible with most lenses except those that are wide-angle.

The subject is magnified by extending the lens farther away from the film plane, that is, closer to the subject. This is most readily achieved in two ways: by using a macro lens, which permits very close focusing on a subject; or by placing extension tubes between a normal lens and the camera body. For extreme close-ups, with magnification greater than 1/2 life-size, additional extension tubes will be necessary even when using a macro lens.

OPPOSITE. *An extreme close-up of an anemone taken from above creates an eye-like image formed by the central circle of stamens surrounded by the rosy petals. An electronic flash set from behind simulates backlight, while a second flash unit aimed into the flower maintains interior detail and color.*

RIGHT. *A moderate close-up of this cactus orchid reveals the pistils and stamens at the ends of filaments. Twin macro flash units were used for added illumination.*

PAGES 142–143. *To portray the inner structures of this lily requires special close-up equipment and a ring flash. Together, they make even the tiny pollen grains visible.*

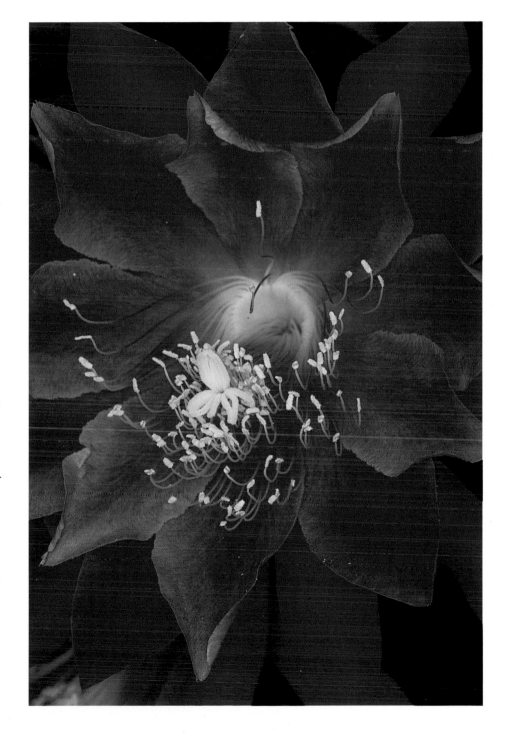

Moderate close-ups

Moderate close-ups—photographs that create images of 1/10 to 1/2 life-size—can be achieved with many lenses and with a minimum of special equipment. The only lenses that are not suitable for true close-up work are the wide-angle lenses.

To test the degree of magnification, use a flower with a 3-inch diameter, such as a lily, or a rose, or an iris. With a normal or telephoto lens used at close range, a 3-inch flower should fill at least 1/3 of the frame, a level of magnification that is about 1/10 of life-size. For the flower to fill the frame completely, it is best to use a macro lens that is especially designed for close-up work up to 1/2 of life-size magnification. It is also possible to use some supplementary items that can be added quickly and inexpensively to a normal or telephoto lens.

One such option is a set of magnifying lenses that screw onto the front of a camera lens. The set comes in three magnifying strengths called diopters: +1, +2, and +3. They can be used individually or in combination to increase the degree of magnification, with the most powerful lens attached first. The main disadvantage of such lenses is that they reduce sharpness somewhat.

For better quality, there are hollow extension rings or tubes, which are designed to be placed between the camera body and the lens. We recommend purchasing extension tubes made by the manufacturer of the camera body. The longer the tube, the greater the level of magnification will be. Extension tubes are light and sturdy, making them easy to carry along. As with magnifying lenses, they can be used singly or in combinations, without regard to size order.

Macro lenses are the most expensive but most versatile close-up alternative. They are specially designed for use at very close range—as little as several inches—and can be extended with tubes for extreme close-up photography as well.

Always use a tripod when shooting close-ups, since the increased magnification of the subject means an exaggeration of any movement due to camera shake.

ABOVE. *This moderate close-up of a wild columbine in Colorado's Rocky Mountains was shot with fill-in flash that stopped the persistent movement caused by the wind. With a short working distance, the background becomes a blur even if a small aperture is used to maximize sharpness.*

RIGHT. *Close-ups of flowering dogwood blossoms are difficult as they are tossed in the wind and are often well off the ground. This branch was caught after waiting for a still moment.*

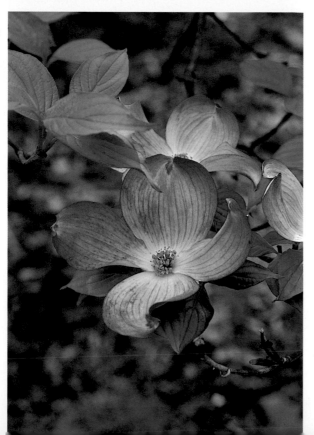

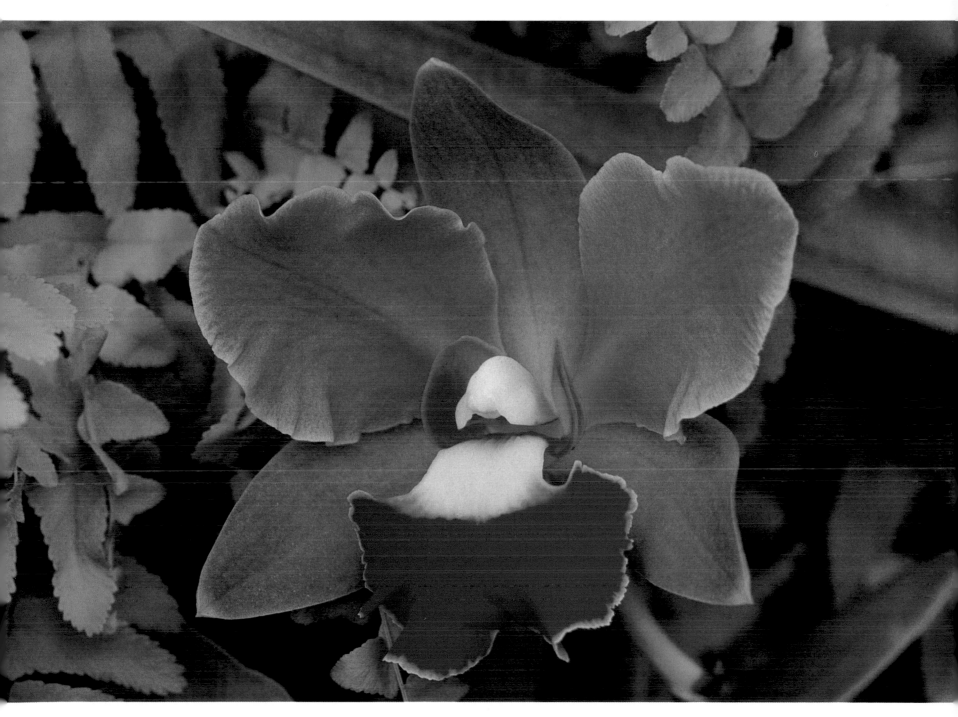

A straightforward portrait of this regal cattleya orchid was taken to emphasize its brilliant colors.

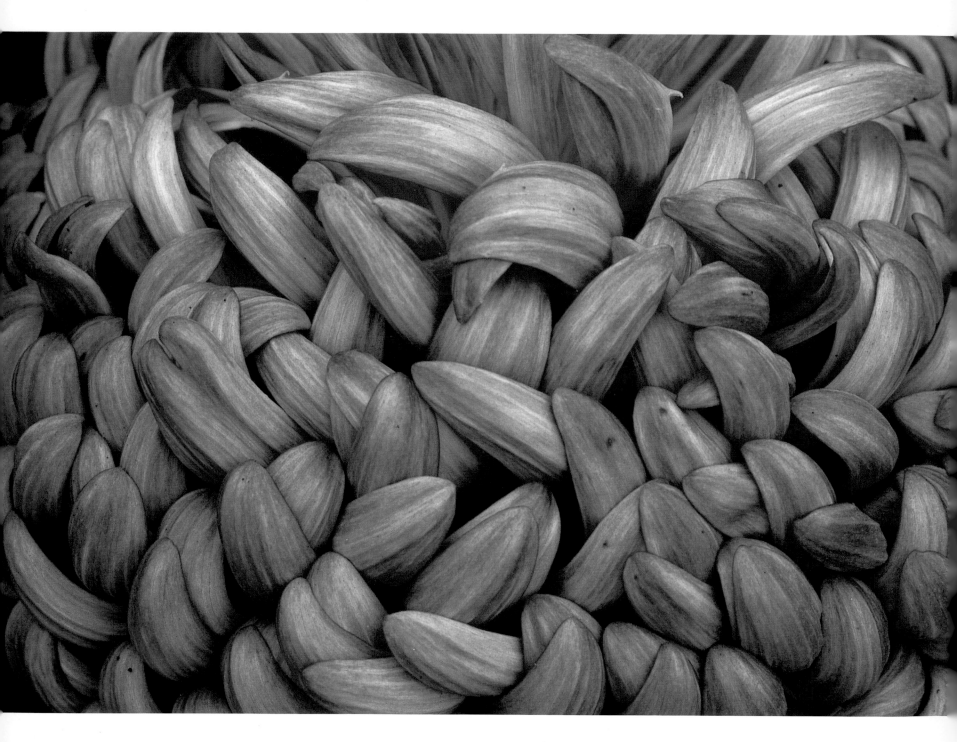

Extreme close-ups

Despite the great appeal of extreme close-up photography, it is a highly specialized field. Very few do it well, which is why those who do so are well regarded.

The chief obstacle in the pursuit of excellent extreme close-ups is the time and patience needed to set up each shot. Because they entail high magnification, extreme close-ups make the use of a tripod and cable release mandatory to eliminate camera shake. Very high magnifications also reduce depth of field and make focusing more critical than ever.

A small aperture improves sharpness, but there are inherent problems: either a very slow shutter speed must be used (not a practical solution outdoors where even the slightest movement of a flower would ruin the shot), or very bright light must be available from nature or from an electronic flash unit. These difficulties explain why so few have pursued this intriguing field.

In addition, magnifications greater than 1/2 life-size require the use of special equipment: a macro lens, extension tubes, or bellows, or some combination of these. Most macro lenses will produce an image 1/2 life-size. Together with extension tubes, considerably higher levels of magnification are possible, allowing the photographer to portray worlds unseen by the naked eye.

Bellows, while helpful in situations that call for a flexible extender, are generally not recommended for field photography. They are too bulky to carry around comfortably, they tear easily, and they are hard to use because they need numerous adjustments. If extension is needed, extension tubes are preferable.

Despite the difficulties and special requirements of extreme close-up photography, those who dedicate themselves to it are rewarded with unparalleled visual experiences and with photographs that make those experiences available to others.

OPPOSITE. *The surface textures of a Japanese chrysanthemum are depicted in this extreme close-up.*

RIGHT. *The rich color and the overlapping forms are the focal points in this extreme close-up of a Heliconia.*

OVERLEAF. *The green buds of a hyacinth in the process of blooming are the focal point of this extreme close-up.*

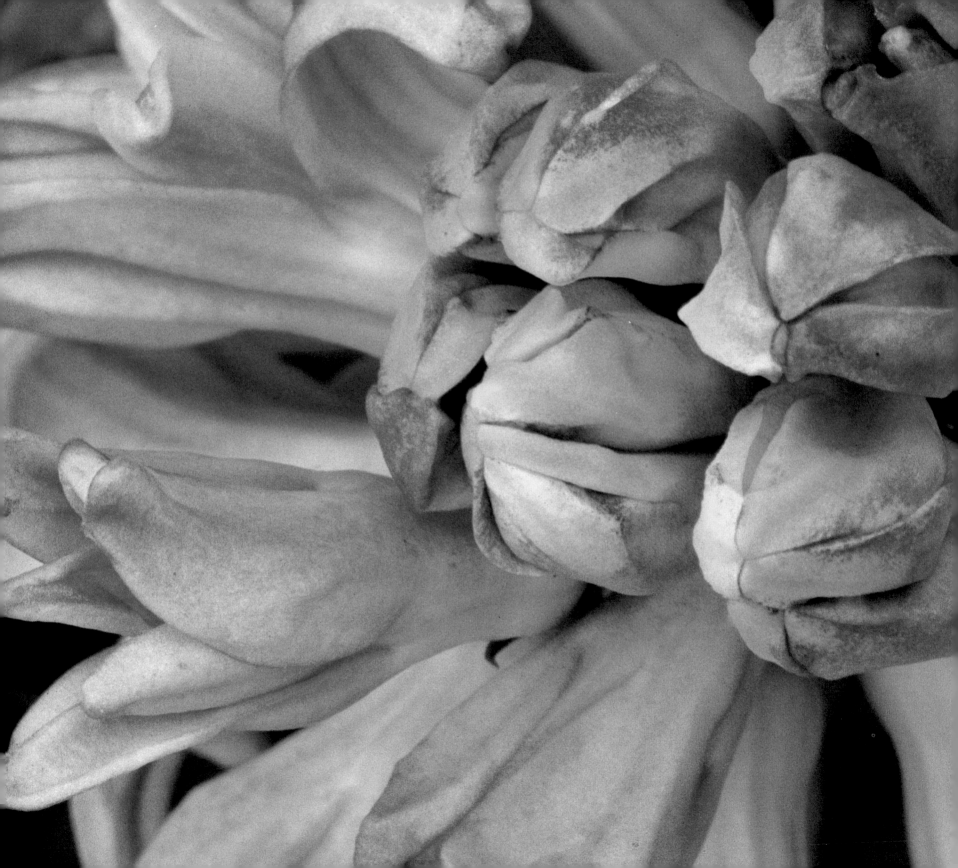

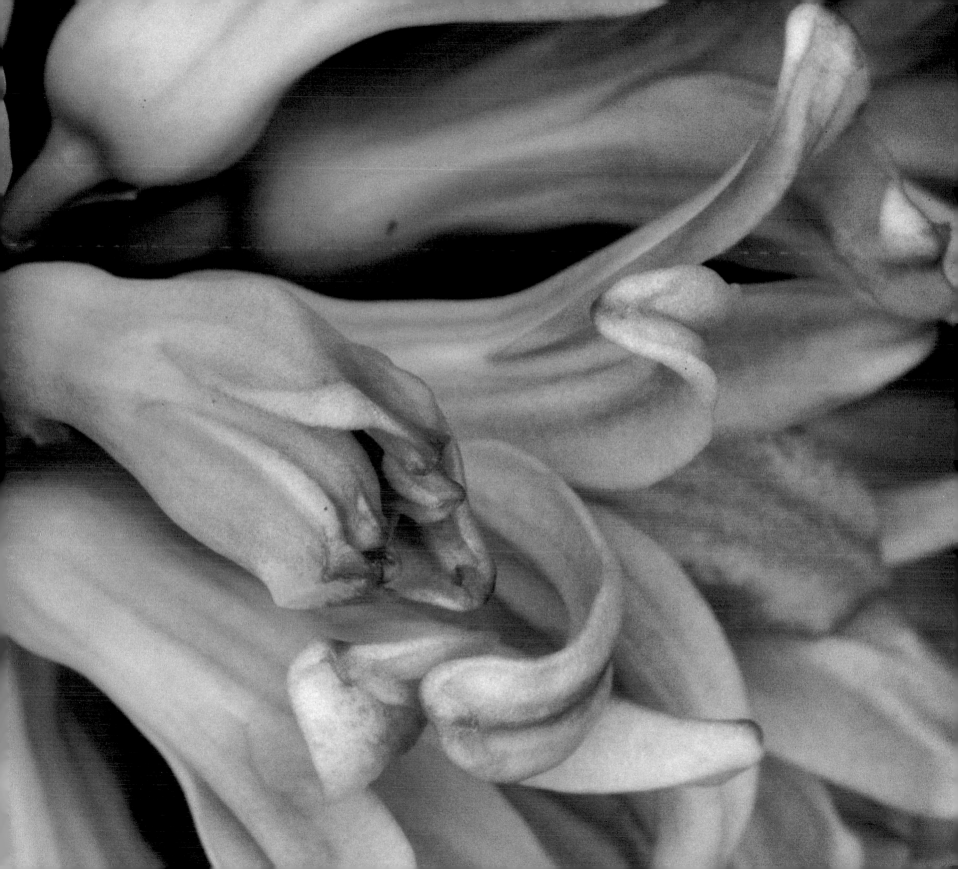

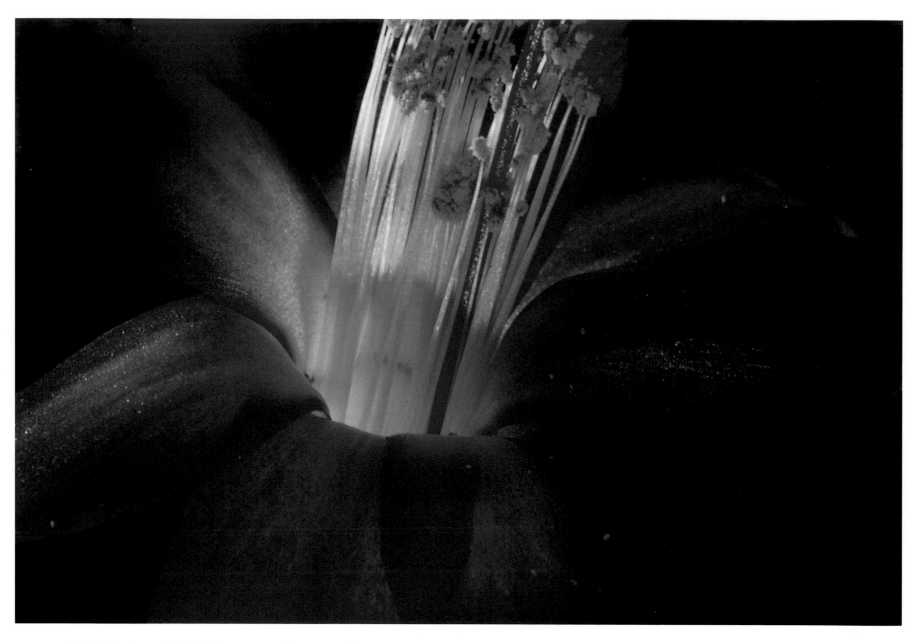

An interior close-up of a Christmas cactus flower was taken with two electronic flash units. One was positioned over the flower, its light funneled through an improvised aluminum foil cone. The other simulated backlight from below.

Adding light

It is virtually impossible to consider doing close-up photography seriously without learning how to use supplementary light sources. This necessity is dictated by the close-up photographer's wish to maximize sharpness by extending the depth of field as much as possible—something that can be achieved at such short distances only by adding light.

How much light must be added depends on several factors. First, remember that to achieve a natural look, the effect of the flash should not dominate the available light. Less than the optimum burst of light is generally advisable.

Light output is indicated on electronic flash units as the power level, calibrated according to guide numbers. Each unit has a different maximum; the most powerful units cost the most. Power can always be reduced from the maximum, but, of course, can't exceed it, so purchase the most powerful unit affordable. For moderate close-ups, a guide number of 100 is adequate. For extreme close-ups, a guide number of 40 should do.

Also, check how long the burst of light lasts. A very short burst of light effectively becomes the shutter speed, since the brief illumination freezes all movement.

For specific ways to set up electronic flash units for close-up work, see the appendix.

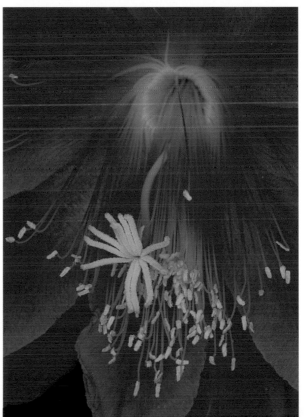

ABOVE. *Two flash units illuminate this close-up of a gloxinia. One unit was positioned to the left and above to create edge light and backlight; a weaker second flash was placed below and to the right to maintain detail in the calyx of the flower.*

FAR LEFT. *The ribbonlike swirl of internal filaments in this flower are captured with illumination from an electronic flash unit mounted on the lens.*

LEFT. *To portray this cactus orchid, a lens-mounted ring flash highlights the white starburst of pistil and stamens and retains detail in the flower itself.*

8
Photographing in the Wild

"The chance to find a pasque-flower is a right inalienable as free speech."

ALDO LEOPOLD, 1948

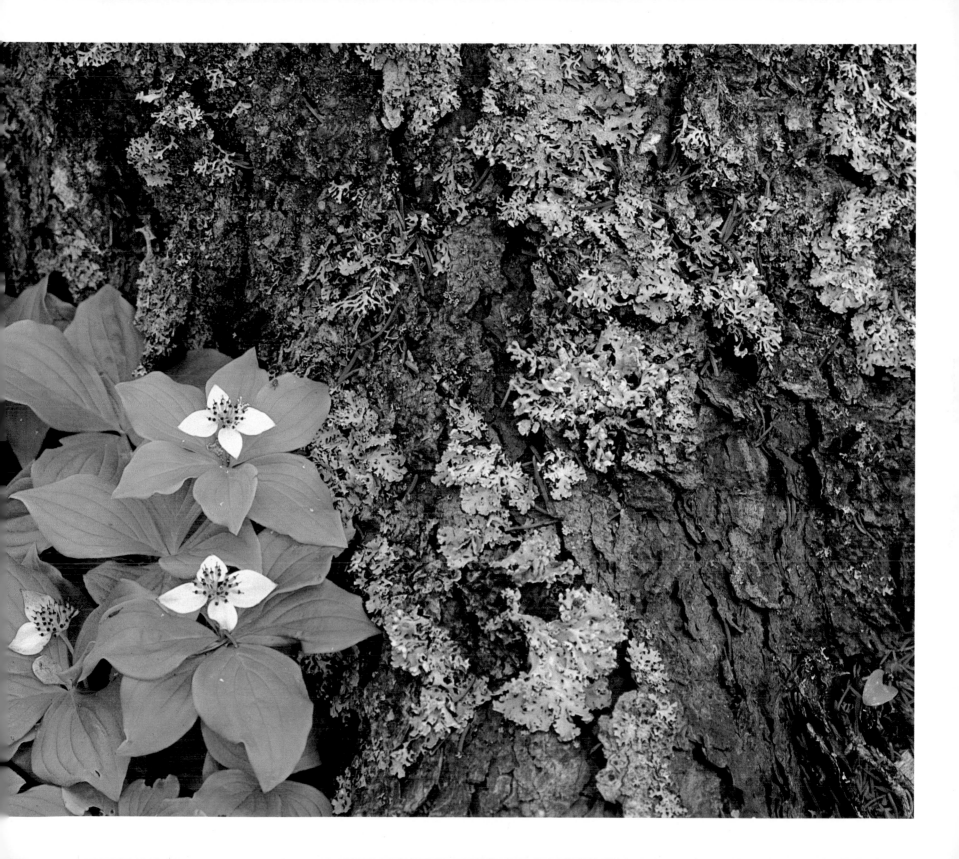

PAGES 154–155. *A Maine forest yielded this portrait of bunch-berry blossoms propped against a lichen-covered tree trunk. Diffused light permits proper exposure for details throughout the composition.*

ENVIRONMENTS

Photographing in the wild has a special quality of discovery. Because natural environments do not reflect the organizing presence of a designer—whether an amateur gardener or a professional landscaper—the photographer must rely much more heavily on a keen eye and an open mind to find photogenic subject matter.

One of the best ways to develop the ability to explore one's world visually is to think less about individual images and more in terms of producing a series of pictures, or a photo essay. Through a photo essay it is possible to recreate the essence of a particular environment with images that work together.

To make a photo essay as complete as possible, the nature photographer should pay numerous visits to the chosen site, returning at different times of the day and through the seasons. For this reason, it is best to begin by choosing the most ordinary and accessible spot, one that is close to home and easy to explore on foot.

By revisiting the same locations the photographer becomes thoroughly familiar with the place, so that even small changes in its flora and fauna are noticeable. Return visits also clarify which aspects of the site are essential and which are ephemeral, which are typical and which are unique. The final sequence of images may reflect both but should emphasize the ordinary made extraordinary by virtue of the photographer's vision.

Ideally, a photo essay might include shots of broad vistas, details, and close-ups, to convey the widest range of visual experiences. Each natural environment, however, presents specific photographic challenges that the photographer can anticipate and prepare for. The following pages suggest ways of approaching commonly found environments.

OPPOSITE. *Returning to the same environment and photographing with a variety of lenses yields a series of images that convey the richness of visual possibilities. This explosion of desert wildflowers occurred after an unusually wet winter in Israel. To compress and concentrate the blooms, a long lens was used.*

ABOVE. *A moderate close-up was taken of these poppies in the glow of late afternoon.*

LEFT. *A wide-angle lens captures the profusion of blooms and encompasses the surrounding terrain.*

Forests

Although we may associate woodlands and forests with trees rather than flowers and meadows there is, in fact, a wonderful interplay between the high-story vegetation and a host of ground-level species. It is important to learn about the kinds of plants found in a local woodland or forest. Each visit will then become more meaningful, as the photographer learns to look for specific flowering trees or shrubs and to discover native woodland flowers as they bloom over the seasons.

Many woodland flowers are early spring bloomers, pushing through the ground even when it is still covered by snow. In early spring the sun's rays penetrate most easily through the trees so such native perennials as the jack-in-the-pulpit and the lady's slipper orchid race to flower before the thickening canopy blocks out light. Early spring is also a time for the blossoming of woodland shrubs and trees, such as the witch hazel, the spicebush, and the dogwoods. Their delicate sprays of color are often set among a tangle of trees whose branches are still bare, so it is best to depict their subtlety and texture. Once azaleas burst into bloom, colors become bolder.

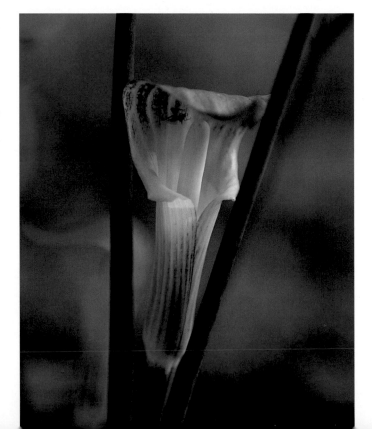

ABOVE. *A stand of white birches in a Maine forest forms the backdrop in a wide-angle portrayal of these ultra-sharp, long grasses.*

RIGHT. *This close-up of a jack-in-the-pulpit, taken in a New York State park, required a low perspective and a tripod. Despite the dim light, the flower radiates. A narrow depth of field blurs the background so the "jack" stands out.*

As summer approaches woodlands and forests, and the canopy fills in, the main problem the photographer will encounter is working with a limited amount of light. The understory of a forest is often in deep shade, making the use of a tripod mandatory, especially to maintain a maximum depth of field. In uniform deep shade, fast film is helpful for maintaining sharpness, because it enables the photographer to use a faster shutter speed or a smaller aperture. A fast film also simplifies overexposure, which is an advantage in the dim light of a forest. For close-ups and details, an electronic flash unit is essential, either for full illumination or for fill-in light.

Bright patches of sun often mix with deep shade in woodlands and forests, making metering and proper exposure a real challenge. The lovely dappled light, so attractive to the eye, is nearly impossible to capture well on film, which tends to exaggerate the difference between areas of light and shadow. This is a good time to aim for a dramatic effect, setting a well-lit woodland flower or a bank of ferns against a dark background. Look for flowers in marshy areas, along the banks of a woodland stream, and in spots where a tree may have fallen, creating an opening in the canopy. Or convey a mood of mystery by showing a forest in the fog or morning mist.

Winter is the time for emphasizing textures in bark and in the tangle of twigs. When snow covers the branches, it is a backdrop for interesting lines and designs. It is very difficult to expose snow properly. Generally, to keep snow truly white, it is necessary to overexpose film from one stop in diffused light to two stops in bright sunshine. Since judgment plays such an important role in exposing snow well, it is best to bracket liberally, keep accurate records, and then evaluate the results carefully.

TOP. *A telephoto lens creates an impressionistic image by portraying the autumn forest scene in terms of light, color, and shape.*

BOTTOM. *Bromeliads are common inhabitants of Amazonian rain forests. This close-up, taken with a 90mm macro lens and flash, reveals the plant's internal structures.*

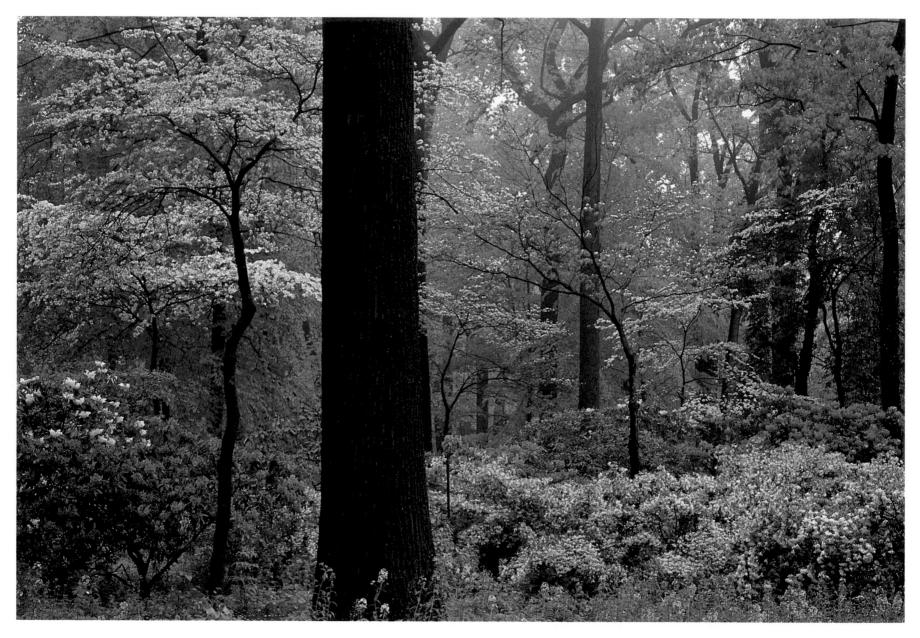

Forests and woods incorporated within estates or gardens are often planted with varieties derived from the wild. Tall, century-old trees at Winterthur, Delaware, mingle effortlessly with an understory of rhododendrons and dogwoods, just as in a natural woodland.

This stand of sugar maples in Westchester, New York, forms a wash of gold interrupted by the vertical lines of the tree trunks.

Meadows

Meadows and fields form wide open spaces, often in full, bright sunshine. Therefore, the situations they present contrast with those in woodlands and forests. While there is adequate light in meadows, there is the difficulty of setting the right exposure for full-color saturation. A polarizing filter is an indispensible aid, not just for removing unwanted reflections and glare, but for rendering the sky a deeper blue, so it serves as a strong foil to clouds as well as to the flowers themselves.

Summer is the main season for photographing in meadows and fields, especially for capturing the profusion of flowers that change the face of the terrain from one week to the next. However, fall and winter can be more than worthwhile, since grasses and flowers dry in place and provide a rich variety of textures. Against a somber winter sky, the brittle reeds and pods photograph quite effectively, particularly in fens, swales, and marshes, and at the extremes of the day.

The major challenges of photographing meadows is working with moving subjects, since field flowers are routinely tossed in the wind. On bright days, there is usually enough light for a fast shutter speed to freeze this movement. For details and close-ups, however, use a tripod and bring along an electronic flash unit just in case. Telephoto shots, which can be quite impressionistic anyway, are more tolerant of blurring due to motion than are close-ups, as long as some flowers remain reasonably crisp and sharp.

Composition is another concern. Meadows and fields can be almost endless in their breadth, offering little either in the foreground or background to delineate distance and scale or to serve as a visual reference point. Alpine meadows are an exception, of course, since a dramatic mountain backdrop can be incorporated. A forest or woodland at the periphery of a meadow is also an effective frame. A man-made structure, such as a fence or a house, can serve as an organizing element in the composition.

Alternatively, the photographer can emphasize the flatness of the terrain, either by filling the frame completely with flowers, or by using the horizon line to create bands of color below and above it. A tree or an isolated farm on the horizon helps emphasize a mood of loneliness in such a scene.

ABOVE. *A meadow of Texas bluebonnets and Indian paintbrush fills the frame with an abstract swirling of cheerful colors.*

RIGHT. *Meadow flowers attract a variety of fascinating insects. Here a yellow swallowtail butterfly alights on the upturned head of a black-eyed Susan in a New York meadow.*

An expanse of "elephant ear" blankets this mountain meadow in Colorado. The gentle hills along the horizon frame the field and provide a glimpse of the setting.

Deserts

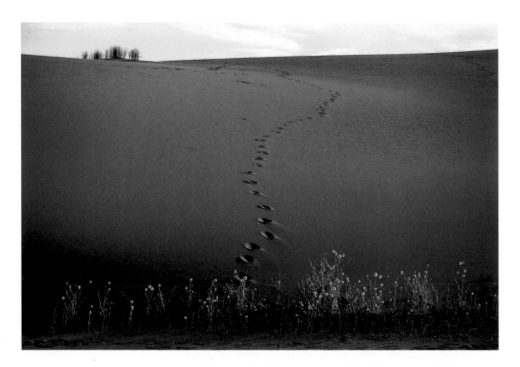

Despite the popular notion that deserts are barren wastelands, they offer some of the most captivating portraits of flowers in nature. Brightly colored desert poppies dot the arid landscapes of regions around the world. And the range of other plants from tiny anemones to gorgeous cactus flowers, are fascinating photographic subjects.

In addition to the desert's reliable perennials, other desert flowers can patiently wait out several dry years, only to have their tough seeds activated by a season of heavy rain. Such desert blooms, with their riot of colors, are as short-lived as they are miraculous, however.

While not always found in deserts, dunes are dry by virtue of the porousness of sand and form wonderful vistas to photograph. The few flowers that grow on dunes stand apart, evoking a romantic aura with their delicate forms and subtle colors and their juxtaposition to the waves and ripples of the sand in which they live.

In a desert environment the photographer will need to make several important adjustments. The first is to keep the camera and other equipment as clean as possible. A skylight filter—1A or 1B—should be placed on each lens. In addition, remove the lens from the camera body at the end of the day, and using a camel's hairbrush, carefully clean out any grit and sand that may have become lodged in the mechanisms. Pay special attention to areas with threads for screwing on filters. Coastal dunes are salty and wet, as well as sandy, and so require even greater maintenance of one's equipment.

An adjustment to desert light is also needed. It is wise to take along a polarizer to remove glare and reflections, and to compensate for the extreme brightness of desert areas by underexposing slightly. A slow film makes such underexposure easier and will maintain rich color saturation.

While desert blooms can be abundant, they are rarely dense, and the photographer will probably want to increase the impact of the flowers by using a telephoto lens. The contrasts of light and shadow, soft and coarse textures, and delicate forms against massive ones are just some of the photographic ideas to explore in the desert.

ABOVE. *A row of wild Heliopsis catches the last rays of light as the sun sets on the Great Sand Dunes in Colorado. The massive dune, broken by a line of footsteps, forms a stark, barren backdrop to the sunflowers, which have found a niche in this seemingly hostile environment.*

OPPOSITE TOP LEFT. *Early morning light delineates these Saguaro cacti in Arizona.*

OPPOSITE CENTER LEFT. *A flicker is perched between the spines of a Saguaro cactus in an Arizona desert.*

OPPOSITE BOTTOM LEFT. *Bright sidelight sharpens each needle on these cacti in Organ Pipes National Monument in Arizona.*

OPPOSITE RIGHT. *To document these wild sunflowers in their natural habitat, a vertical format was chosen to incorporate the ridges and hillocks of the Great Sand Dunes National Monument in Colorado.*

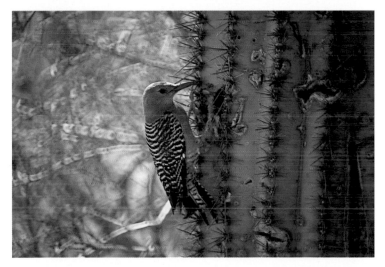

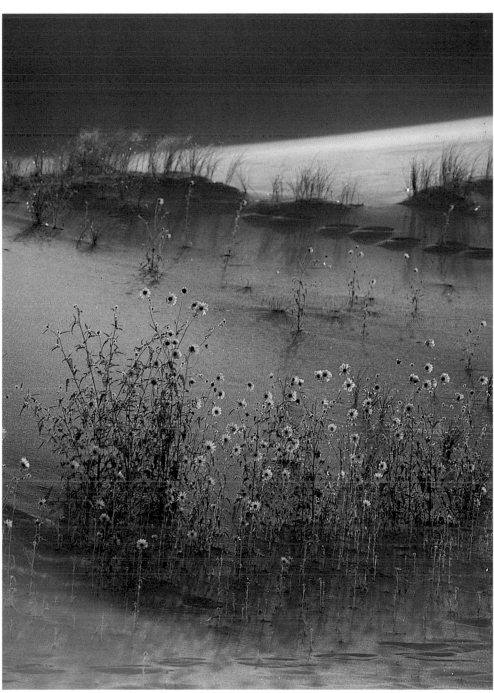

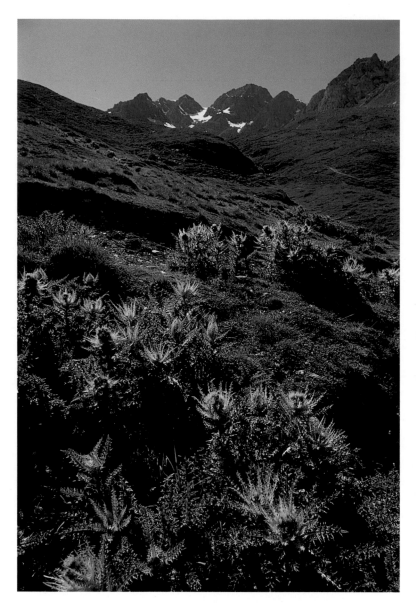

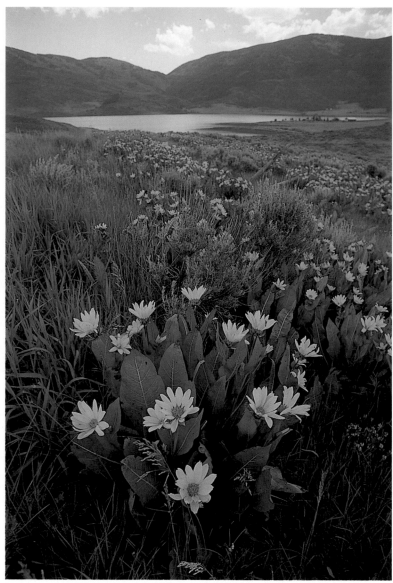

Thistles are typical of the hardy, clinging vegetation found at high mountain altitudes, such as this one, in the Swiss Alps. A wide-angle lens enlarges the coarse wildflowers in the foreground while retaining the mountain scenery in the background.

A wide–angle lens exaggerates "elephant's ears" in the foreground of this meadow in the Colorado Rockies, caught in the misty blue light, often found at high altitudes.

Mountains

Mountain vistas are the mainstay of many landscape photographers, yet juxtaposing grand panoramas with flowers is a feat that requires some planning.

Since alpine flowers are found at high elevations, the photographer should be prepared for some climbing and exertion to reach them. It is best to take only what may be handled comfortably and carry the equipment in a backpack or bellypack, leaving hands free for the rigors of the ascent. Lightweight and sturdy equipment is recommended as is high-speed film for overcast light, especially if carrying a tripod is too burdensome.

Because of their high-altitude habitats, mountain flowers usually bloom during two periods. The first, during late spring and early summer, occurs on the lower levels of a mountain, and the flowers are often small and delicate. The second period, during late summer, takes place at the higher elevations and includes larger showier flowers in alpine meadows but also scrubby, highly textured flora, typical of the shallow soil conditions found above the tree line.

It is not easy to show alpine flowers against a mountain backdrop. A moderate wide-angle lens (35mm to 28mm) can be helpful for encompassing both subjects, but sometimes at the price of diminishing the impact of the mountainous setting. Coping with the wind, which can be quite fierce at high altitudes, is another dilemma, requiring a fast shutter speed even in bright light and a fast film on overcast days.

Mountain light can be very evocative. The blue mountain light in the early hours of the day is lovely for scenics, but it may distort the color of flowers, so use a warming filter (81A) to restore the true hues to yellows, reds, and oranges.

The bright light of an open mountain scene often causes glare and glints, especially where flowers are growing in rocky areas that contain reflective minerals. Look carefully for such points of light, since they can be quite disturbing in the final image. Try polarizing to remove the glints, or frame the shot to avoid them.

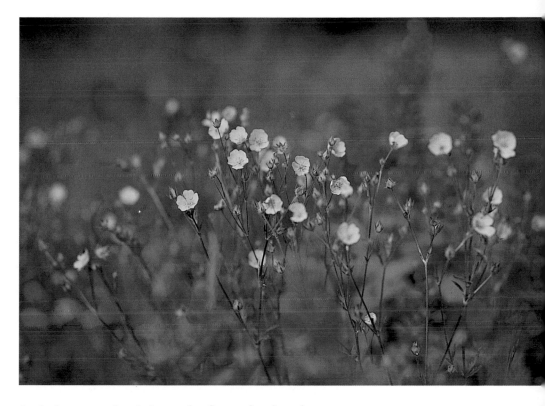

A telephoto macro lens isolates a few flowers sharply and compresses the foreground and background into a fuzzy, colorful setting in this detail of a Colorado mountain meadow.

Overcast days, while kinder with respect to light than sunny ones, may lead to a typical mountain thunderstorm. Prepare for such possibilities by carrying plastic bags to protect photographic equipment. Cloudbursts usually don't last very long, and they offer unusual opportunities for capturing the rapidly changing qualities of light and weather. The dramatic thunderclouds that can envelop mountain peaks are especially effective with colorful flowers in the foreground.

Wetlands

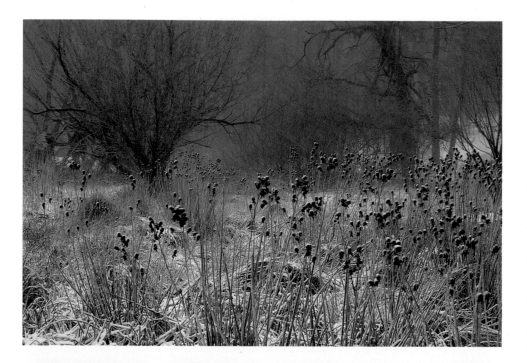

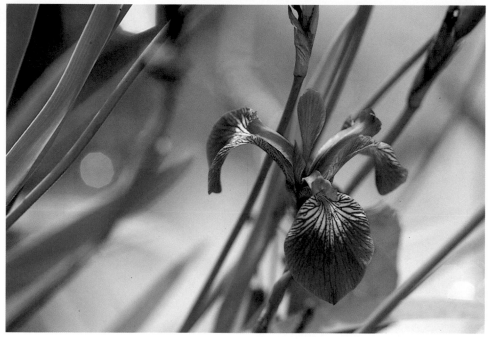

Wetlands, such as marshes, swamps, fens, bogs, streams, and swales, are often neglected as environments rich in photographic possibilities. This may be because this habitat is generally flat and lacks dramatic topographical features. Even for photographers of flowers, wetlands do not seem promising since the flowers are often at a considerable distance from dry land or are among dense vegetation.

Nonetheless, wetlands will reward those who venture forth with a spirit of discovery and exploration. For here, among the reeds and rushes, one can find a wealth of birds. And as the muted colors and coarse textures of the vegetation become familiar, they yield images that can be both arresting and intimate.

Photographically, there are opportunities and difficulties in portraying this watery habitat in every season. Reflections can be combined effectively in a composition or can be minimized with polarization. Grasses mirrored in the water form fascinating patterns and designs. With so much sky showing, use interesting cloud formations to create contrasting shapes to the lines of the grasses and the horizon. Reflections of billowing puffs of clouds, or threatening stormclouds, can transform an otherwise tranquil setting into a highly dynamic one, even with a symmetrical arrangement of sky and water.

Fujichrome and Ektachrome film give a bluish purplish cast to water, a benefit when water seems murky or brownish. The movement of water, especially around streams, can be portrayed as a blur using a slow shutter speed (1/4 to 1/15 of a sec.), or can be frozen with a fast shutter speed. Flowers that lie on or across the water, such as waterlilies and irises, require a telephoto lens to fill the frame, unless the photographer can approach them by boardwalk or boat.

Because most wetlands are in wide, open areas, the best light for photography there is not bright sunshine. Use the extremes of the day to catch the glow of sunrise or sunset. And take advantage of bad weather and cooler seasons, when wetlands take on a special beauty. For example, dried reeds and pods photograph as stark, black filigree especially with a dusting of snow.

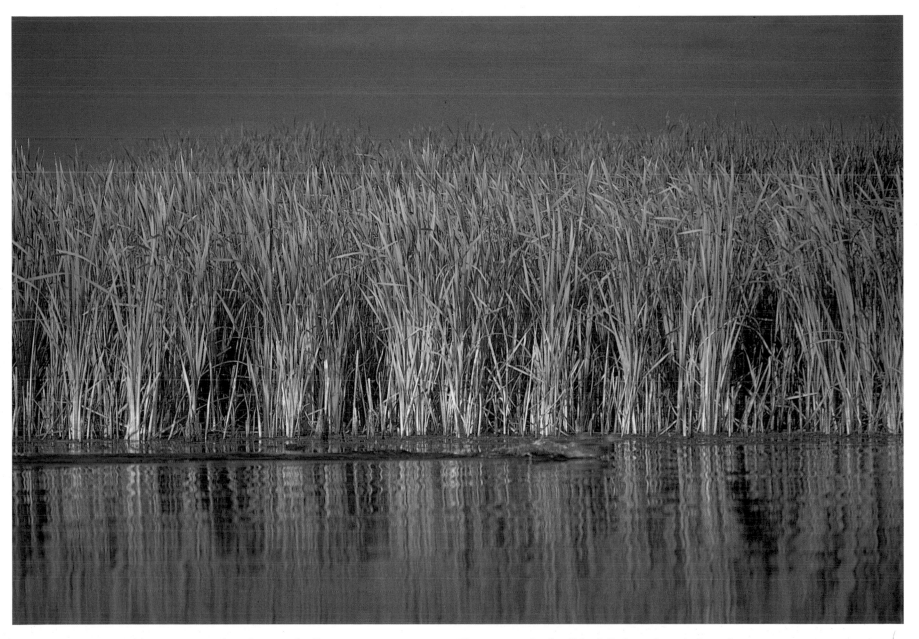

OPPOSITE TOP. *The gentle, muted earth tones of willow trees, oaks, and marsh mallows are held in relief against a dusting of snow.*

OPPOSITE BOTTOM. *Close-ups taken in wetlands often require magnification. This Siberian Iris was photographed at a pond in Maine with a 100mm macro lens.*

ABOVE. *The grassy wetlands of North Dakota gleam in late afternoon light. The composition emphasizes horizontals of varied colors and textures with elements of air, vegetation, and water. The blur of a mallard reveals that this is a habitat for water fowl.*

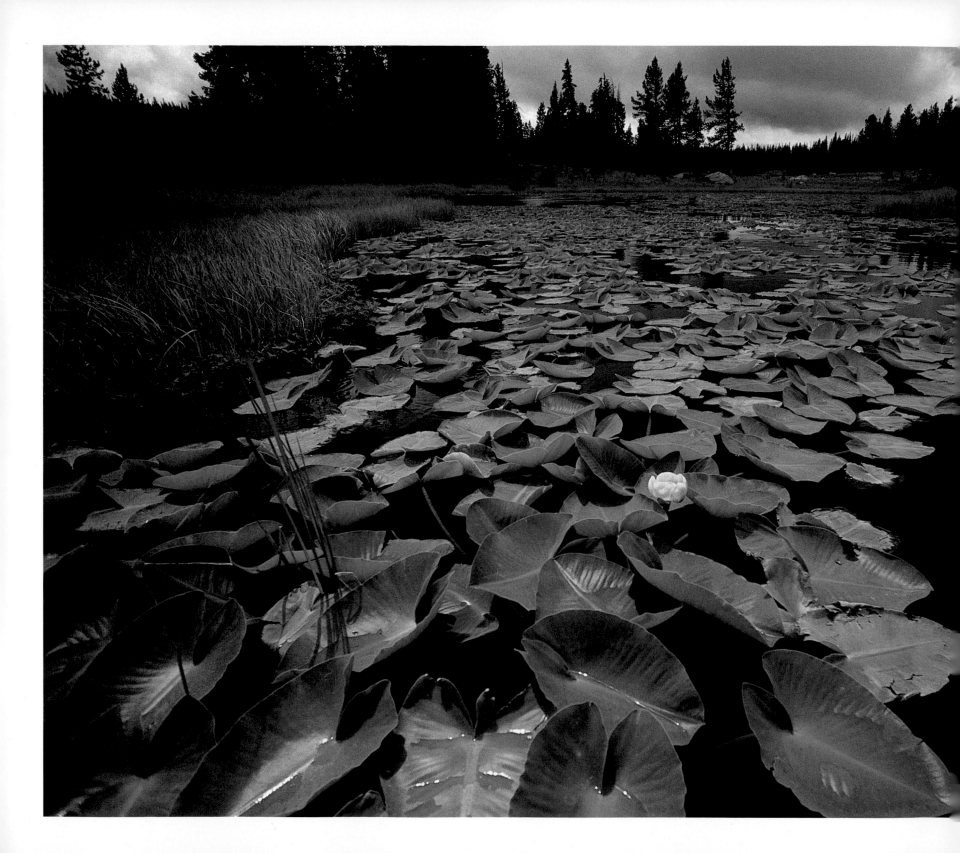

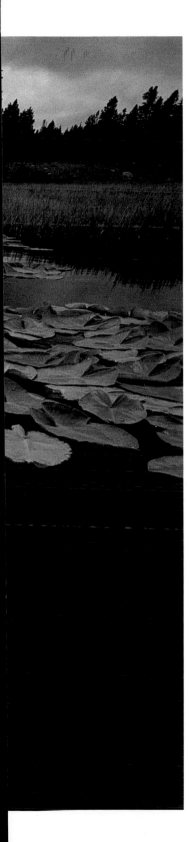

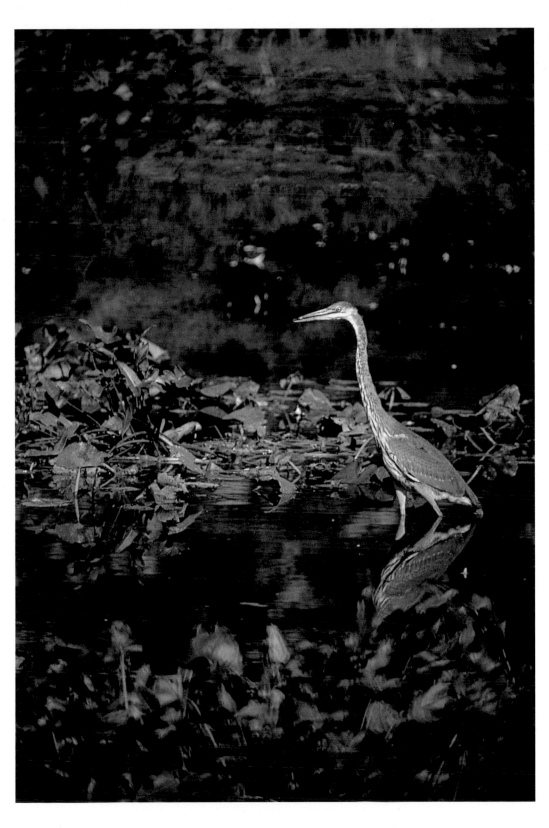

FAR LEFT. *Water lilies and cattails have found a niche in this mountain pond in Colorado. An extreme wide-angle lens enlarges the foreground and retains the setting in the background.*

LEFT. *Wetland areas, such as the Everglades in Florida, are prime habitats for birds. Here, a Great Blue Heron is shown in late afternoon sidelight wading through the shallow waters toward its prey.*

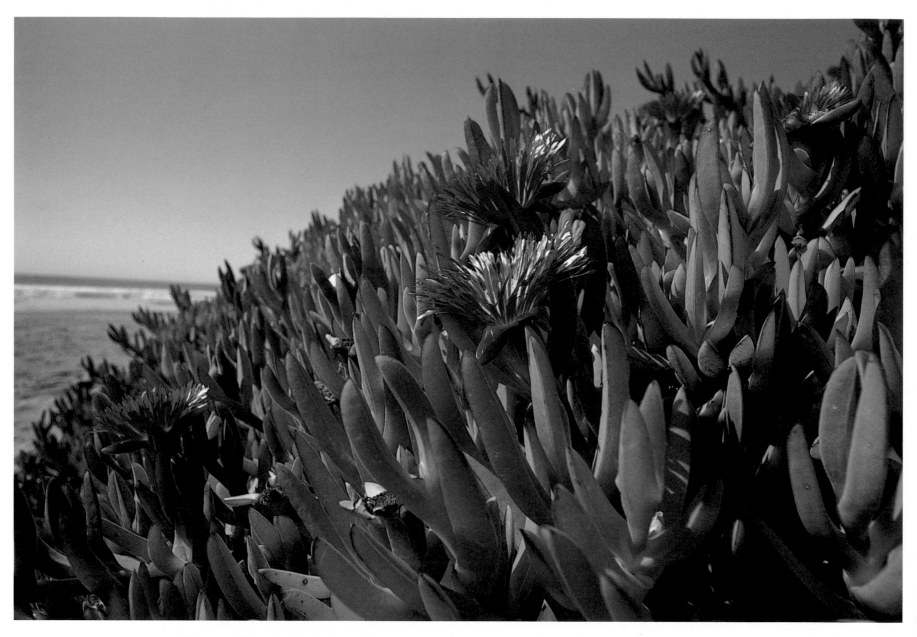

ABOVE. *Blossoms of the succulent Lampranthus, typically cling-ing to sandy hills, are documented here with a suggestion of the nearby California coastal beach.*

OPPOSITE LEFT. *These dainty, climbing beach peas are composed to include the rocks along a Maine shore.*

OPPOSITE RIGHT. *The geometric, solid shapes typical of the coast of Maine are softened by the brilliant green seaweed and the sprays of crashing waves, caught at a slow shutter speed.*

Coastal areas

There are two main varieties of coastal areas, each with quite different flora and photographic conditions. First, there is the rocky coastline, whose craggy terrain includes windswept trees and scrubby, earth-clinging vegetation. Then there is the sandy coastline, often with some dunes, and typically dotted with seaside roses, goldenrod, and other hardy wildflowers. Both offer numerous possibilities for portraying the meeting of land and sea, sometimes with the added charm of coastal towns and fishing villages.

The major challenge in photographing sandy and rocky coastlines is finding ways to combine flowers or trees with the setting. Along a rocky shore, this may require the added depth of field and broader field of vision of a wide-angle lens. At a beach, the problem may be compounded by the tremendously bright background which causes the foreground to become a silhouette. However, since coastal light ranges from brilliant sunshine to mist and fog, use early or late light to reduce the high contrast and take advantage of the opportunity to create an interesting mood.

Wherever there is sand, wind, and splashing water, it is important to protect camera equipment. Keep all gear in closed plastic bags until it is needed. Use a 1A or 1B skylight filter over lenses, and clean all equipment thoroughly at the end of each day.

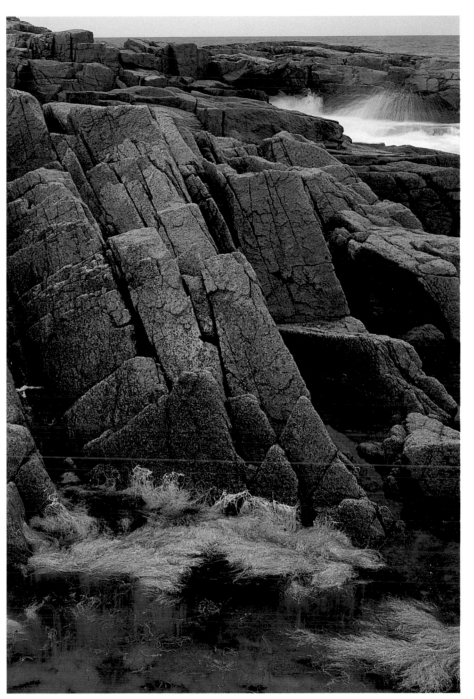

9
Pleasures of Garden Photography

"A garden is a lovesome thing."

THOMAS EDWARD BROWN,
1830–1897

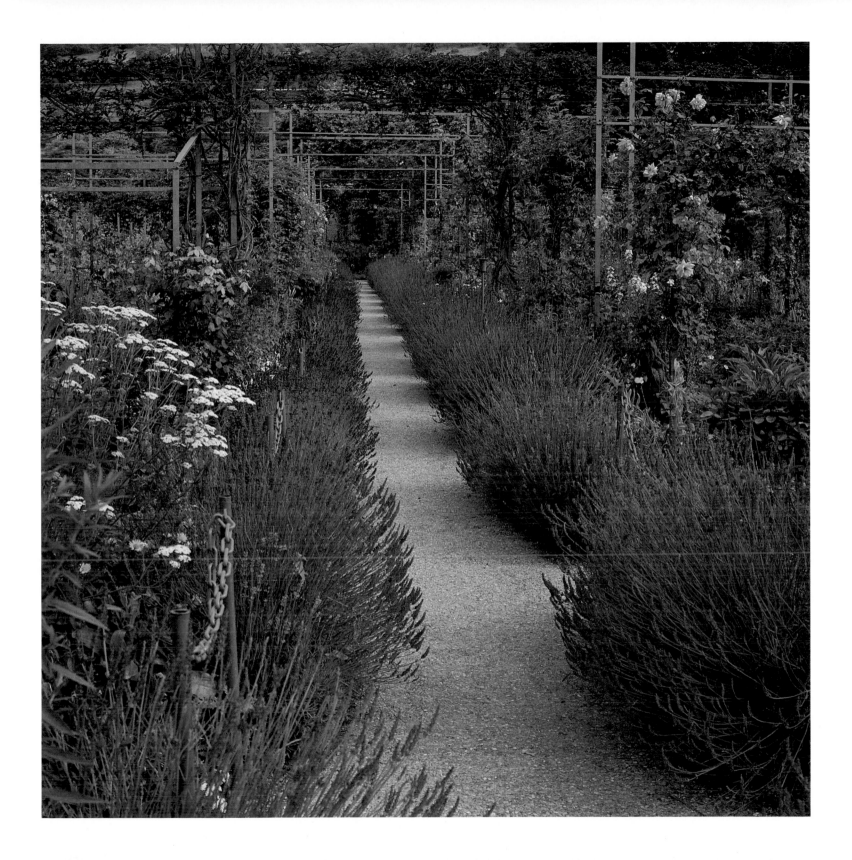

UNDERSTANDING

A visit to the gardens of Giverny created by the great French Impressionist, Claude Monet, is an incomparable lesson in the precepts of garden design. At its best, a garden reflects the values of its owners and inhabitants. At Giverny, there is no doubt that Monet loved light, color, and the totality of visual experience with unbridled passion. Painstakingly, he made the gardens into a laboratory in which he could continuously test his artistic theories. No matter what time of day, the kind of weather, or the season of the year, Giverny offers a feast to the imaginative eye.

Not all gardens are designed with this exacting level of attention, but the better ones pay homage to the same spirit. Russell Page, the preeminent English designer of gardens, spoke of his approach as that of an artist working with living materials. The selection of plantings and their arrangement over the entire garden space was created with the expectation that the results would retain visual vigor throughout their growing cycle: the moment-to-moment changes of light; the day-to-day variations in weather; the season-to-season evolution of growth, flowering, and decline; and the year-to-year maturation of plantings in relation to each other and to the permanent structures they surround.

A well-designed garden is a great boon to a photographer with an understanding of its rudiments. The photographer can reflect upon the order and organization intended by the design and can utilize that knowledge to portray the visual images of the garden. Moreover, a sensitive photographer can recreate and evoke the feel of each garden. For beyond the technical dimensions of any garden lies an emotional realm, a powerful call to loveliness which every garden aspires to.

While each designer has an individual perspective on what works, the elements to look for are shared by all. These begin with the broadest strokes—the conception of the garden as an evolving space over time; the delineation of recognizable shapes and vistas with paths and walkways; and the role of a garden's most permanent living inhabitants, its trees. Then comes an appreciation of the relationship between the hard surfaces represented by architectural structures and the softer, more fluid plantings. Finally, there are the incidental and moveable ornamental features, which add personality and identity to a garden.

Photographing in gardens is immeasurably enriched with a clear perception of how they are designed, both in their technical dimensions and for their intended effect on visitors. No single photograph can encompass all that a garden represents. Nor can a garden be fully appreciated in a single visit. Because a garden is a living, changing space, a true portrait can result only from a composite built over time or during many "sittings." And, similar to a good portrait, its success depends not only on depicting an accurate likeness but on revealing its personality.

PAGE 175. *A simple path winds through Monet's perennial garden at Giverny in France, past mounds of lavender laced with bright turquoise links of chain, through rose trellises painted the same bright turquoise, and along a seemingly casual array of many colors. This informal yet carefully structured approach to gardening was a favorite for Monet.*

OPPOSITE. *A Garden design can be as intricate and formal as this one at Villandry in France, with its ornamental boxwood and shaped linden trees.*

GARDEN DESIGN

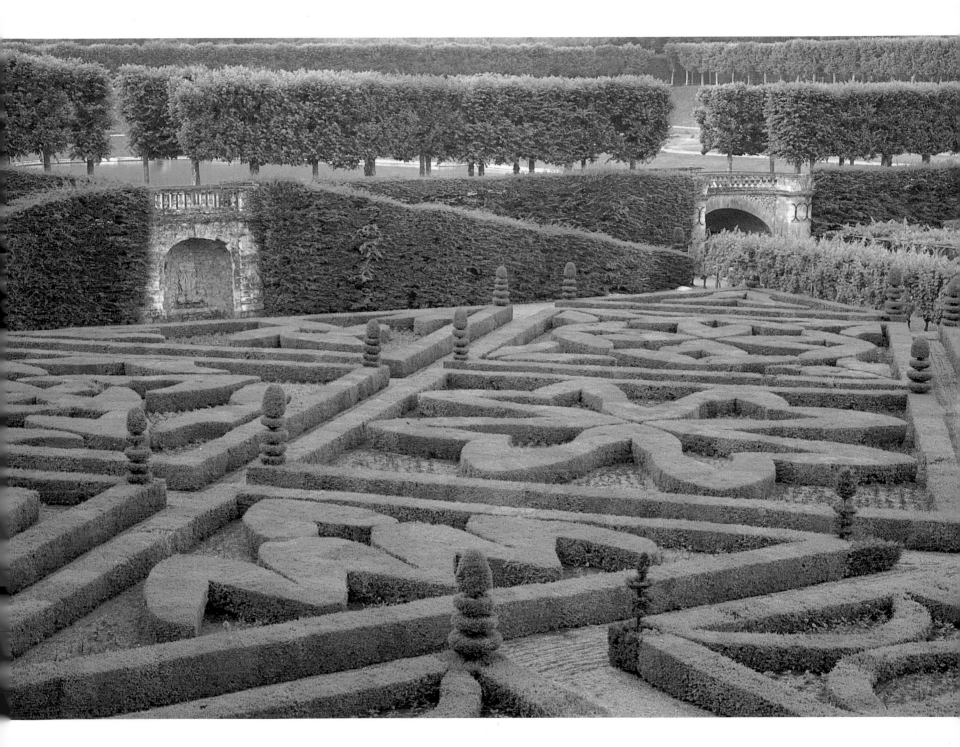

Seasons

Although we may think of gardens as places of spring and summer beauty, the ideal garden is planned for enjoyment throughout the year. The cycle of seasons, with its gradually unfolding changes, is very much in the mind of the garden designer or landscape architect.

Each season brings new visual delights. Spring is heralded by the bulbs, such as crocuses, narcissuses, and tulips, and by early flowering trees, such as cherries, magnolias, and crabapples. Rock gardens have their showiest moments in spring; woodland wildflowers emerge before the leaves above them deprive them of light, and a fresh, inviting green emerges everywhere, rejuvenating our spirits. As spring matures, such flowering shrubs as azaleas and rhododendrons follow both in gardens and in natural environments.

As spring turns into summer, roses gain the spotlight, and perennial gardens start to fill out with peonies and irises. While the perennial border continues to blossom with new groups of flowers—lilies and daylilies, for example—water gardens reveal the beauty of water lilies. Meadows and natural gardens display thick tufts of grasses and wildflowers. Framing the garden, trees unfurl their leaves, providing welcome shade, which is also part of the planned design.

New blooms emerge in autumn that are worth waiting for. The centerpieces of fall flowers are chrysanthemums, which cascade in broad sweeps of color and intrigue us with their carefully orchestrated shapes. The magnificent foliage of the maples is always a spectacular treat. As leaves are shed, barren branches take on a lovely delicacy; and the grasses and wildflowers in the natural garden ripen to a warm pattern of textures and shapes that remain for our contemplation through the winter months.

With each generation of blooms, the astute photographer can capture the cycle of life in a matter of days or weeks. There are poignant moments to see, as a perfect flower drops a petal or two, as it stands disrobed, and as it finally turns to its true reproductive purpose. Flowers afford us the chance to witness and record such moments, which would take years or decades in the lifespan of man.

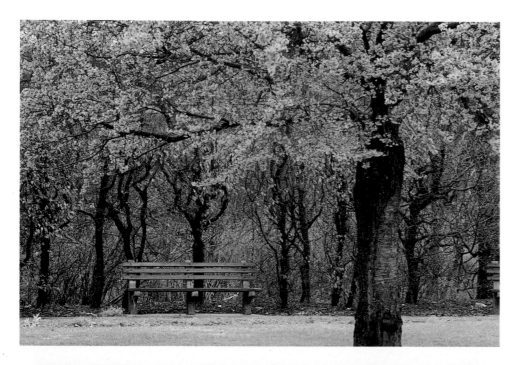

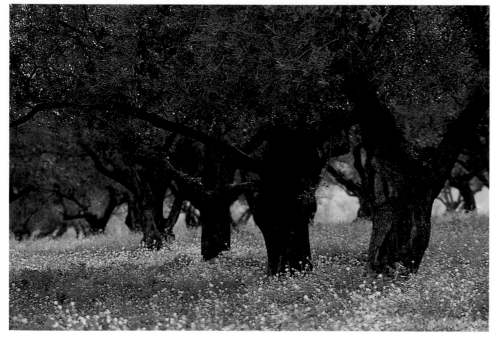

ABOVE. *Gardens in winter are often neglected as worthy of visual exploration. In fact, the forms of trees are more clearly delineated, and the mounding of snow on branches is as unique to each species of tree as are its leaves. This snow-covered magnolia tree at The New York Botanical Garden is just as lovely under a fresh dusting of snow as it is in spring.*

LEFT. *The change of season to autumn, and its photographic possibilities, is seen in this photograph. The colors of vibrant yellows and oranges give this image its own identity.*

OPPOSITE TOP. *This early spring flowering cherry tree at The New York Botanical Garden is not shown in its entirety. Instead, its delicate pink blossoms are set above a bare scene. Horizontal lines of color, echoed by the slats of the bench, contrast with the vertical lines of the trees. The film was chosen to emphasize grain and capture the pink tonalities.*

OPPOSITE BOTTOM. *A grove of mature olive trees in Israel sparkles with life and color, as summer light shimmers across the mustard flowers at their base.*

This path at The New York Botanical Garden curves from the corner, behind the maple tree, and up a slight grade before it vanishes around a corner. Such visual movement, compressed by a moderate telephoto lens, carries the viewer's eye into the experience of strolling along the path.

Paths

Garden designers consider paths so important in their overall planning that photographers must understand their function. Russell Page referred to paths as "the bones of the garden." His paths brought the viewer from one point of interest to another. Plantings, which fleshed out the skeletal structure, were installed to be best appreciated from the path. Similarly, paths guide the photographer along a continuous tour through a garden.

Since paths are two-way lanes, a well-designed garden provides equally pictorial effects from either direction. The garden photographer should keep that in mind, remembering to look forward and backward along a path.

Garden designers try to achieve a balanced picture on both sides of a path. In some cases, the balance is symmetrical; in most, however, the balance is achieved through a more complex arrangement of plantings. The photographer can discover and emphasize these compositional elements in the garden's design, with the path as a point of departure.

In larger gardens, the paths often wind past a variety of vistas, from broad, open views to more intimate enclosures. The alert photographer will note such changes and look for transition points. For example, a screened-off enclosure is often entered through an arch of shrubbery or a trellis. Such architectural elements along the path add visual impact.

Finally, here are a few suggestions for improving photographs that include paths:

1. Walk up and down the paths before starting to compose photographs.
2. Some paths are sufficiently interesting to warrant being photographed for their own sake. Look for distinctive brick or stonework.
3. Although a garden is meant to be viewed from the path, the photographer may stray off the path to include it as a graphic element within the composition.

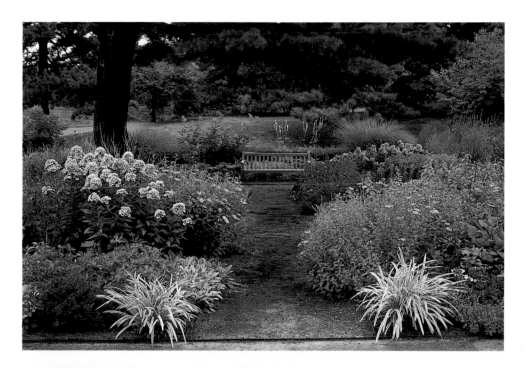

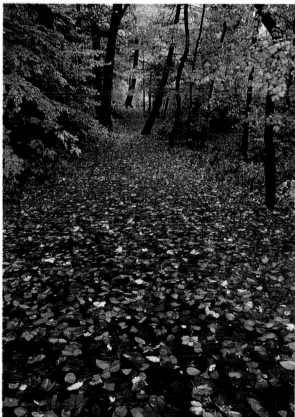

ABOVE. *A peaceful resting stop beckons the visitor down this path at The New York Botanical Garden. The grasses and other naturalized perennial plants that line this path add to its inviting quality.*

LEFT. *Fallen leaves along an ordinary path at The New York Botanical Garden add enough color and texture to make it a worthy focal point. The converging lines from the sides give depth and direction.*

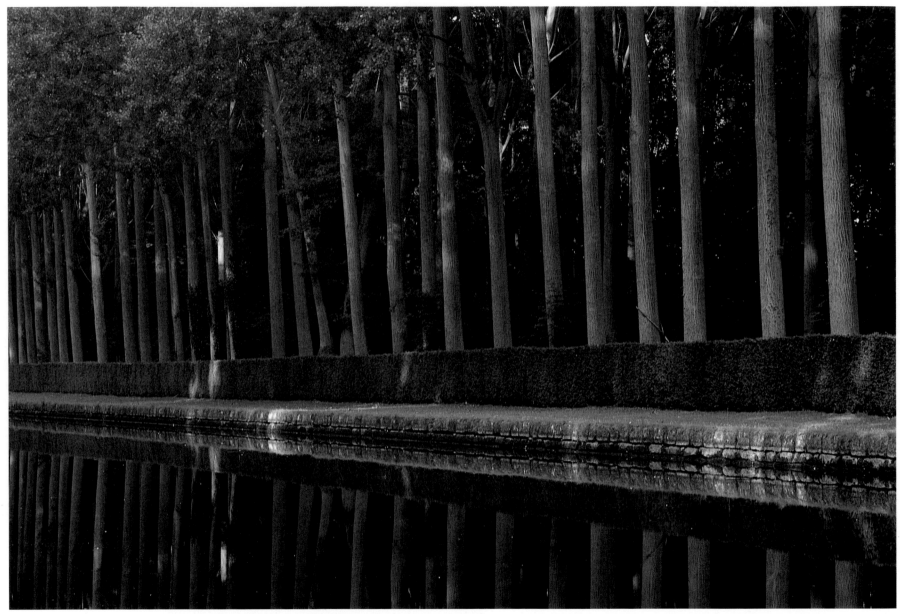

ABOVE. *The meticulous arrangement of poplars along the banks of the water garden in Courrances in France, is cast in velvety early morning light. The dreamy mood is enhanced by including a hint of reflections in the water.*

OPPOSITE TOP. *This row of flowering cherry trees at the Brooklyn Botanic Garden was photographed at a slow shutter speed to show the movement of petals falling like snow from the branches.*

The diagonal receding line adds depth, while the repeating parallel forms of the trunks provide an interesting graphic dimension.

OPPOSITE BOTTOM. *The drooping fronds of a weeping willow in early spring seem deliberately to frame the magnolia bush below. The combination of pastel shades is complemented by overexposing the soft backlight of late afternoon at the Donald M. Kendall Sculpture Garden in Purchase, New York.*

Trees

Trees are the most permanent features of a garden, outlasting not only the other plants, but many of its manmade structures as well.

Because of their relatively large size, trees give a garden scale and a sense of the third dimension. Of all the plantings in a garden, only trees can be seen and identified reliably from a distance. They can be arranged in neat parallel rows, forming a living colonnade, and further enhancing a feeling of depth.

Trees are also important to the enjoyment one feels in a garden. They enhance the visual beauty of a garden in spring with their profusion of flowers. In summer, trees provide refreshing shade for visitors, and they hide unpleasant views and muffle the sounds of the city. In autumn, they enrich us with their brilliant foliage and a harvest of fruit. And in winter, their outstretched branches gently cradle snow and hold it up for our further delight.

In all seasons, the shapes, forms, and textures of trees are a source of pleasure. It is surprising, therefore, that more people do not consider trees as photographic subjects in the garden. In fact, images of trees can be just as fascinating and evocative as those of flowers.

To emphasize the shape of a single tree, it is best to use a telephoto lens—100mm to 200mm—and shoot at a distance. This will separate the tree from its surroundings and compress its foliage, emphasizing color in spring and autumn.

Look for unusual angles, not just from eye level. Shoot from below or from a vantage point above the tree. Shoot such details as a tree's flowers, its leaves, or its fruit. Combine textures, such as pinecones, with the needles of evergreen trees.

Whether for a single tree or a grouping, it works well to accentuate the three-dimensional roundness and the textures of leaves and bark by paying special attention to the direction of light, favoring sidelight. When trees are planted in rows, sidelight also helps delineate the individual trees within the group and casts shadows which add to the dynamics of the photograph.

Trees are the best focal point for depicting the effects of weather in a garden, especially to create subtle moods. Their presence is noticeable even if they are shrouded in mist and fog, or partially obscured by rain or snow.

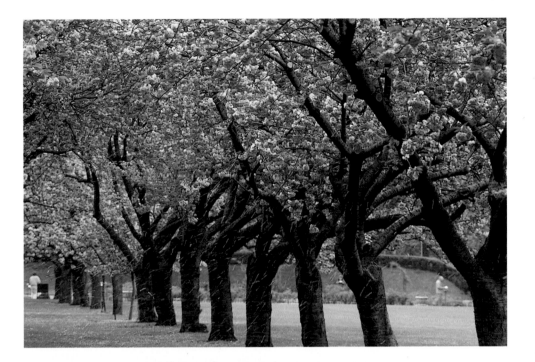

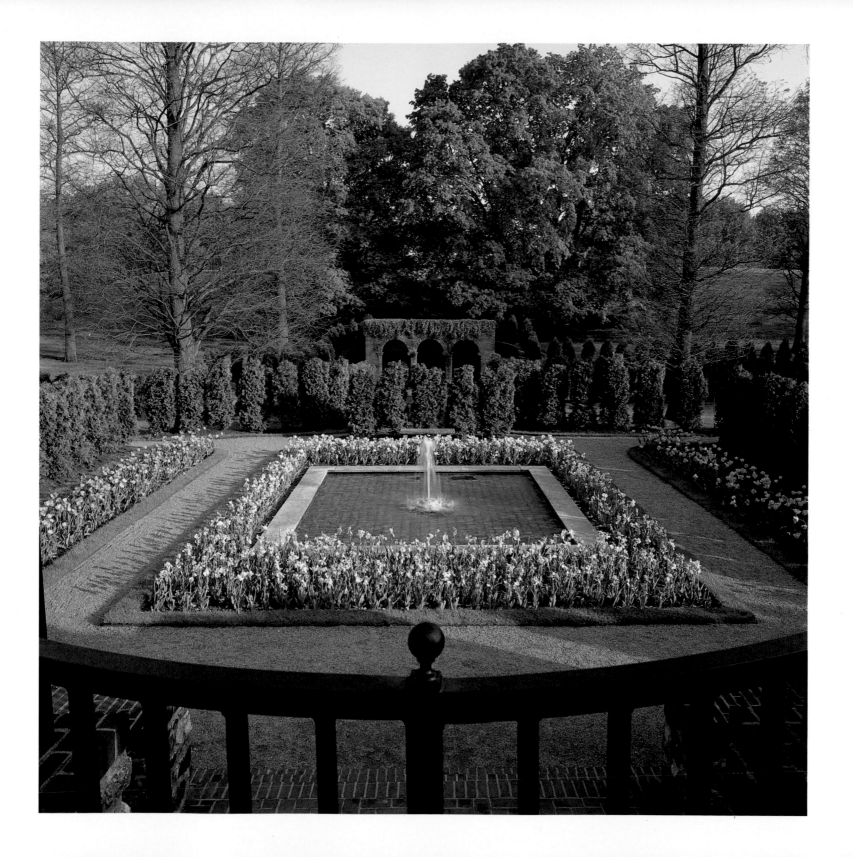

Walls, hedges, and fences

A garden is a defined space, and the limits of that space are often marked by walls, hedges, or fences. Garden designers often refer to Andrew Jackson Downing's idea—which he imported from Europe in the late 1800s—that exterior areas need organization into "outdoor rooms" much as interiors do.

What makes these boundaries interesting is the variety of materials from which they can be assembled, and the backdrop they provide for the plants and other garden elements they contain. Often built of stone or brick, walls are the most imposing of the available options. Their construction out of hard substances contrasts well with the softer, more pliant vegetation of the garden.

Hedges are essentially walls of plants that are grown, sometimes reaching extraordinary heights. They project an architectural quality and formality suitable for public or estate gardens, but less appropriate in the more intimate surroundings of a family garden. Less geometrically austere than the familiar box hedges are those created by pleaching trees—trimming a row of short trees into a flat presentation.

Fences, mostly made of wood, are less formal than either walls or hedges. They are interesting for their form, color, and texture and often serve as quaint or clever supports for some lovely climbing and trailing floral shrubs. Because some fences do not form an impenetrable barrier, they can be well utilized by the photographer as lines within a larger space.

TOP. *This photograph documents the regal symmetry of a stone bench placed against a shaped hedge the size of a wall, with carved-out "doorways" at each end. Slight overexposure in the rain brightened the scene.*

BOTTOM. *The vertical lines of this simple wooden fence in a private Long Island garden form a visual contrast to the masses of annuals in the foreground.*

OPPOSITE. *The Italian water garden at Longwood Gardens in Pennsylvania is surrounded by hedges and fences, that help underscore the contained, formal quality of its design. A wide-angle lens with a square format camera was chosen to expand the angle of view without sacrificing the parallel lines.*

Gardens and architecture

Well-designed gardens complement the houses they adjoin, both in scale and in style. Their pleasures should be apparent from ground level and from the interior of the living quarters. Ideally, there should be an easy coexistence between the hard architectural structures and the living elements, with their ephemeral, soft, and fluid aspects. Whether it is a grand château surrounded by a vast, formal landscape, or a simple cottage, adorned by window boxes, the garden forms a strong bond with its neighboring buildings.

By juxtaposing gardens with architecture, the photographer enters the designer's imagination, revealing intended—or accidental—combinations of color, texture, and form. In addition, the photographer imposes a second vision on the scene, discovering details that are especially evocative and pleasurable.

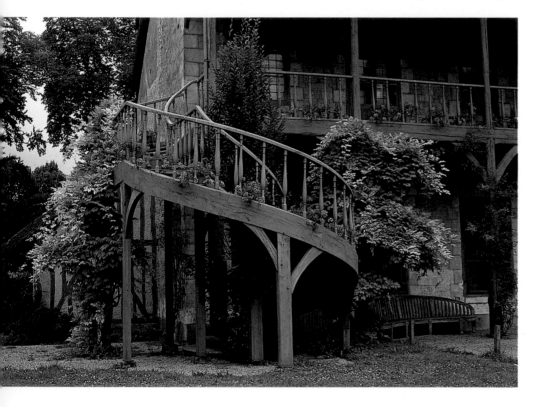

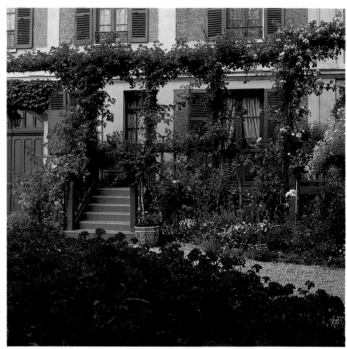

ABOVE LEFT. *The spiral staircase and balcony outside this auxiliary house at Versailles is decorated with an array of potted pink geraniums. Diffused light accentuates the tawny tones of the 18th century wooden structure and the soft pinks and greens of the plants.*

ABOVE RIGHT. *The interplay of architecture and gardening is evident in this view of Monet's house at Giverny. The repetition of the favorite colors—a bright teal with a muted pink—is even on the stairs. A massing of red geraniums hides the gravel drive.*

Ornamental structures

Ornamental structures such as benches, gazebos, arbors, and furniture, endow a garden with personality and perspective. They are both a focal point within the setting, and just as often, the vantage point from which to view the surrounding scene. They reflect the style of the owner as well as the designer. They reveal how the garden is meant to be used as well as enjoyed. Most of all, they suggest the need to pause and contemplate the garden's special features.

Before photographing, take the time to walk around the ornamental structures to become familiar with their purpose and their form. Perhaps a scene taken from within a gazebo or from beneath a pergola, with the structures providing a framework, will capture a special view of the garden. Or a shot of a bench overlooking a reflecting pool will capture an area of serenity. Remember that no single picture will encompass all the vantage points that prove to be photogenic.

In general, the low-angled sidelight of early morning or late afternoon is best for bringing out sculptural details. The diffused light of overcast days is also flattering to many ornamental structures, especially if there are distracting shadows cast by framework or grills. Bright sunshine is probably the least effective light for showing off such structures.

Because ornamental structures are architectural, and because they may be the only fully stationary elements within a composition, it is crucial that they are extremely sharp. Therefore, use a tripod, set the lens at a small aperture, and focus with great care.

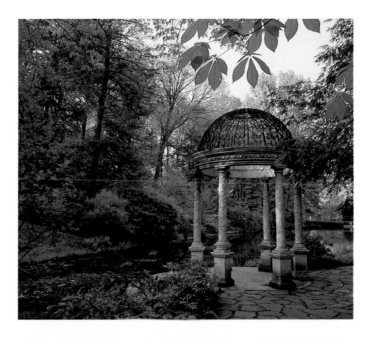

TOP. *This Victorian gazebo at Longwood Gardens is in a wooded setting beside a stream. A branch of overhanging leaves camouflages a dull sky.*

RIGHT. *A frontal perspective of this pergola at the Brooklyn Botanic Garden was taken to maximize the sense of depth made by the converging lines.*

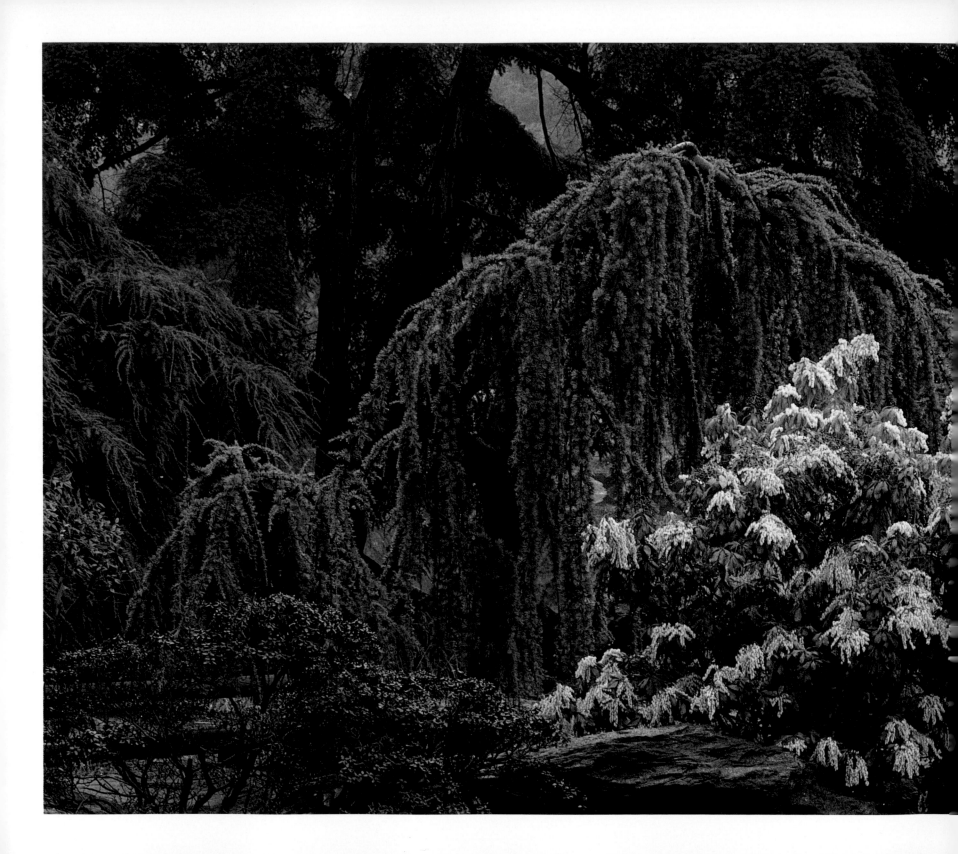

SPECIALTY GARDENS

The elements of garden design are evident in most, if not all, well-planned gardens. The specifics of how they are combined, however, vary tremendously. To some extent, the choices are based on the nature of the terrain, the type of soil, the amount of sun, the limits of space, and the plants that adapt best to those conditions. Decisions are also based on the preferences and needs of the owners or designers. And finally, they reflect a philosophy about gardening and a sense of a garden's purpose and promise.

Each of the specialty gardens shown on the following pages represents a response to these considerations. A few may not be gardens in the truest sense of the word, but since they are of interest to lovers of flowers and gardens, as well as to photographers, they have been included here. After all, flower shows, conservatories, and greenhouses are sources of inspiration for many gardeners. Flower markets can be found around the world, and are a fascinating way to learn about local customs and cultures. Sculpture has been important to gardens for centuries, and many parks are landscaped for the express purpose of showing off the statuary. Window boxes, too, are becoming an increasingly vital way to create a garden, especially in urban settings where space is so limited. Whatever the specialty, each garden can be portrayed more effectively with a bit of knowledge about what makes it so distinctive, horticulturally and photographically.

A Japanese weeping yew and mountain laurel against a background of pines simulate the atmosphere of a rocky mountainside in the T. H. Everett Rock Garden at The New York Botanical Garden. The mist reduces the contrast between the whites and dark greens, and mutes the coarse textures of the plantings.

Rock gardens

Rock gardens are designed to simulate a naturally rocky landscape. Contemporary examples strive for a much less formal effect than those of the last century. Ideally, rock gardens should give the appearance of simplicity, such as a Japanese garden does, rather than one of excessive grandeur or fussiness.

Although they are usually installed in temperate zones, they emphasize plants that grow above the tree line in alpine regions. Generally these are creeping plants that hug the ground, since at high altitudes they must withstand powerful winds. The flowers tend to be small and delicate (so tiny that they have been nicknamed "belly plants," since the only way to see them is to sprawl on one's belly) and usually tend to bloom early in spring, because in colder climates, only a few weeks are warm enough to be safe for blossoms.

Since these flowers are so tiny and short-lived, rock gardens are of the greatest interest for their textural variety and for the way plants and rocky outcrops are interwoven.

A normal lens is fine for general scenes of rock gardens and for accessible details. For details that can't be reached easily, a telephoto lens is recommended, and for close-ups of some of the small flowers a macro lens is crucial. Since texture is a major focus, try to shoot details under the directional light at the extremes of the day, or in overcast light. Bright midday sunshine will flatten texture and create too many shadows for an effective photograph.

ABOVE. *Tufts of Basket–of–Gold push between the rocks to reach the sun in the T. H. Everett Rock Garden. The bright yellow color of these tiny flowers is emphasized by the overcast light and concentrated by a telephoto lens.*

RIGHT. *This close-up taken in the T. H. Everett Rock Garden at The New York Botanical Garden documents ground-hugging plants that are widely found in rock gardens.*

FAR RIGHT. *Spanish bluebells carpet the ground in the T. H. Everett Rock Garden. The soft, misty light saturates the purplish-blue color.*

Perennial gardens

While perennial gardens are increasingly popular today, traditionally they are associated with the English herbaceous border. Prime examples can be seen at Sissinghurst, in Kent, at Gertrude Jekyll's home at Munstead Wood, in Surrey, and at The Royal Botanic Gardens at Kew. The British model is typified by a romantic billowing of blooms overflowing onto pathways in an interesting arrangement of heights and textures.

The French approach, mastered by Monet in his gardens at Giverny, emphasizes movement and the blending of plants and colors, rather than the discreet massing of similar plants typical of the British plan. It is interesting to note that two of the major proponents of perennial gardens—Gertrude Jekyll and Claude Monet—both came to gardening from a lifelong involvement in art. Some have even speculated that Jekyll adopted gardening because her eyesight was failing and she was no longer comfortable working on the small palette provided by a canvas. While Vita Sackville-West originated the monochromatic perennial garden at Sissinghurst, both Jekyll and Monet brandished color with great enthusiasm.

One of the essential conceptual underpinnings of the perennial garden is that the border blooms throughout the growing season. The designer must be able to orchestrate a succession of plants in flower that are strong elements of the overall effect even when it is only their foliage that remains.

For the photographer, the perennial garden presents a changing vista every week or two. The billowy feel and massing of plants is conveyed best by photographing at a distance with a telephoto lens. There are also numerous possibilities for grouping small vignettes and for shooting close-ups.

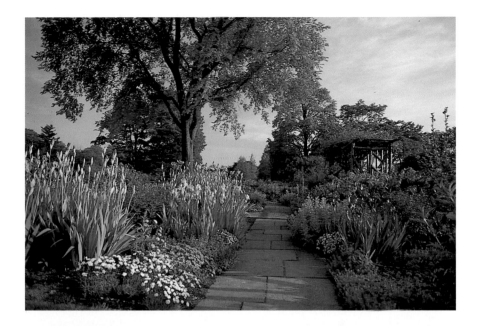

TOP. *The structure of this well-planned perennial garden at Wave Hill in New York is shown in its spring presentation. Masses of irises, some still in bud, tower over the low lying plants, which tumble onto the path.*

RIGHT. *Unlike an English border with its masses of the same flowers, this French perennial border at Giverny is dotted with brightly colored daylilies, hollyhocks, blue salvia, flowering tobacco and tansy.*

A monochromatic perennial garden at Wave Hill emphasizes light pastels and interesting textural contrasts in juxtaposing irises, clematis, artemisia, and peonies. Diffused overcast light retains some color in the pale tones.

The wall on this private Long Island estate forms a parti-
tion creating space for a perennial garden on each side. In-
stead of being set along a path, this one forms an undulating
border against a lawn. This late summer presentation shows
the garden at its fullest and features sedum 'Autumn Joy,'
New England aster, and sweet autumn clematis.

Water gardens

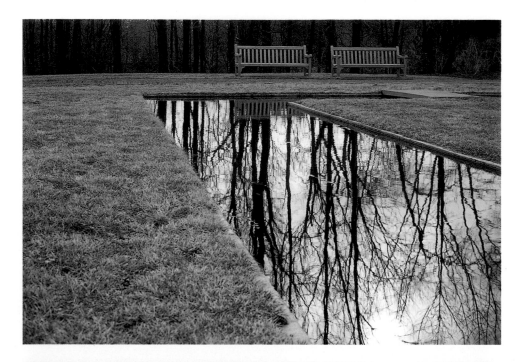

Water has long played a significant role in garden design. Whether it is moving or still, water's presence tends to have a mesmerizing effect on the viewer. The magnetism of water contributes to feelings of restfulness, and tranquility, which also echo the purpose of the garden as a whole.

Photographing moving water usually means thinking about how that movement should be rendered—as a soft blur or as a moment in time. In general a soft blur, using a slow shutter speed of 1/2 to 1/15 of a second, is preferable. However, if the fountains are part of a choreographed water show, a fast shutter speed will capture a particular configuration.

Still water gardens include natural or artificial pools or ponds, sometimes with plantings within or around the water. The reflections in the water effectively double the impact of any such plantings. Many French gardens incorporate reflecting pools as a way of adding brightness and light.

A careful analysis of the reflections should be made. A polarizer can eliminate them and turn the water surface so dark that flowers, such as water lilies, are clearly visible. But reflections can also be desirable, either as mirror images of waterborne plantings, or to create balance and interest in the watery portion of the composition. If reflections are included, remember that they are generally darker than the scene, so bracket towards overexposure. For details of flowers in the water use a telephoto lens. Most of all, keep in mind the mood of the water garden and try to re-create those feelings in the composition.

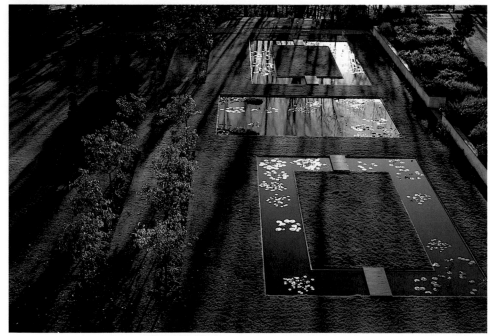

TOP. *The starkness of the pond in winter, bordered by empty benches and dormant lawns, is enlivened by reflections in the pond at the Donald M. Kendall Sculpture Garden in Purchase, New York.*

BOTTOM. *A high perspective was taken to reveal the scale and shape of the water gardens at the Donald M. Kendall Sculpture Garden, in Purchase, New York. Low sunset light highlights the autumn colors and casts a sheen on the man-made ponds containing water lilies.*

OPPOSITE. *Since the reflection of this close-up of a water lily was crucial to the composition, exposure was based on its meter reading, resulting in slight, but acceptable, overexposure in the flower itself.*

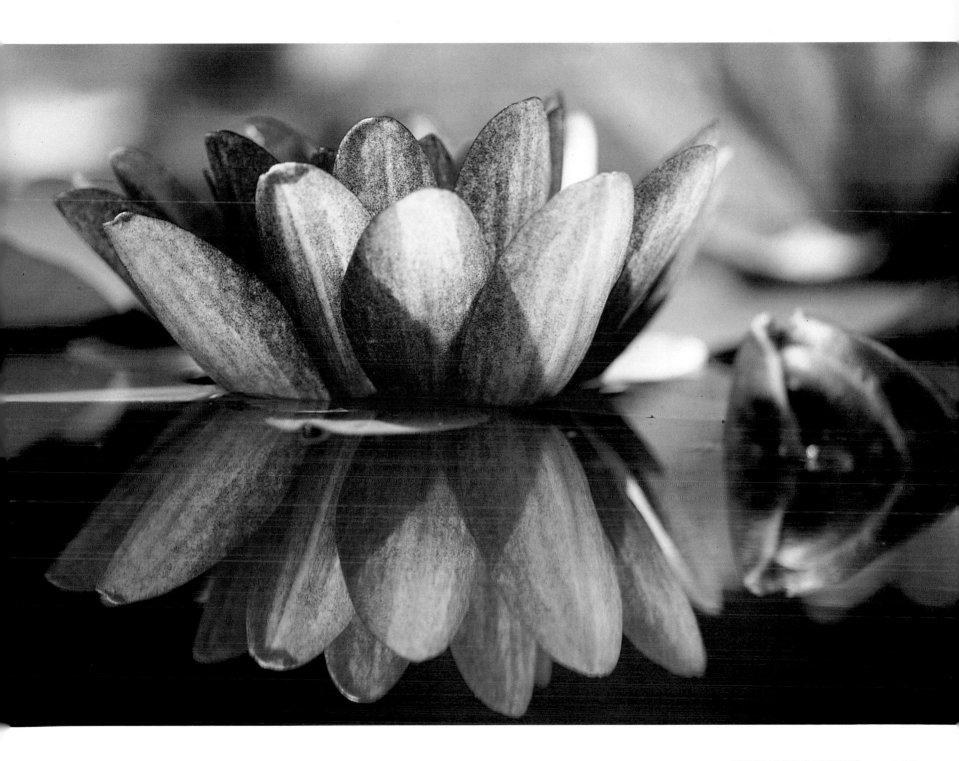

Natural gardens

Because nature and the environment are important concerns, there has been a growing interest in creating gardens that simulate woodlands or meadows. Philosophically, natural gardens are respectful of the land. Hilly spots, rocky outcrops, or stands of trees are left in place, with plantings arranged to accommodate and complement them. For perspective, if space permits, an effort is made to include open areas similar to meadows.

Plants are selected according to their natural occurrence in the local environment, with special emphasis on decorative grasses and flowers adapted from the wild, such as black-eyed Susans, sedums and daisies. These are allowed to take nature's course, flowering from summer to fall and remaining as a highly textured winter garden, with only one mowing needed at the end of winter to prepare for the next blooming cycle.

Photographically, natural gardens are marvels of texture and subtle coloration. They invite attention to the interplay of neighboring plantings rather than to close-ups of individual flowers.

TOP. *The late afternoon light brings out the extraordinary warm earth tones in these naturalized plantings of sedum 'Autumn Joy,' Purple-leaved smoke tree, oak leaf hydrangea, zebra grass and* Boltonia asteroides *at The New York Botanical Garden.*

BOTTOM. *The low diffused light brilliantly sets off the pale variegated grasses, the variegated dogwood, and the astilbe against the foliage in The Jane Watson Irwin Perennial Garden.*

RIGHT. *Low-angled, late afternoon light complements the delicate textures and pale colors of these sturdy grasses in the Donald M. Kendall Sculpture Garden.*

Food gardens

Once relegated to the less visible backyard areas, food gardens are increasingly recognized as attractive in their own right. Their contrast of colors—lettuce that is gold or green, or even purple—and textures—the use of savoy cabbage or curly kale—has even made vegetables appropriate inhabitants of traditional flower beds. Besides their aesthetic value, many vegetables, especially herbs, help control insects that invade the garden.

The French, with their love of good food, have long treated their food gardens with respect. Their formal rows of vegetables, in neatly bordered beds, look more like elaborate geometric puzzle pieces than anything resembling a farm. They have, in essence, turned the kitchen garden into a work of art.

To show the geometry and plan of a vegetable garden, it is usually best to photograph it from above with a telephoto lens. This perspective—taken from a roof, a window, or by standing on a ladder—reveals the lines and patterns made by paths and planting rows. This elevated view also enhances details that combine a few individual plants into a still-life composition.

However, ground-level perspectives with a wide-angle lens can also be successful, especially to portray the massing of rows. This low vantage point emphasizes depth and is ideal for views that include trees or houses at the periphery or on the horizon.

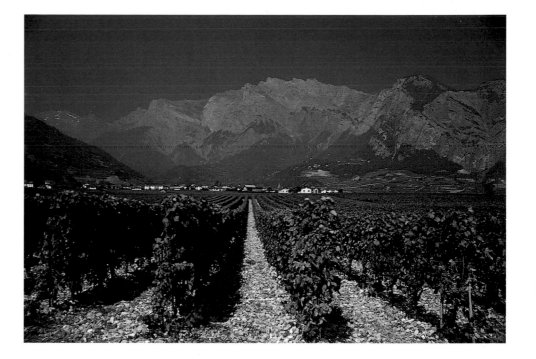

TOP. *A low angle was chosen to document the rows, paths, and stakes within this Swiss vineyard and to show its setting. While the scene is in bright sunlight, a mass of thunderclouds on the horizon produces a dramatic gray sky in the background.*

RIGHT. *The mission of this photograph was to document the enormous vegetable garden at Villandry in France, probably the largest in the world. To include a portion of the majestic château and to maintain parallel lines, a moderately high vantage point was taken.*

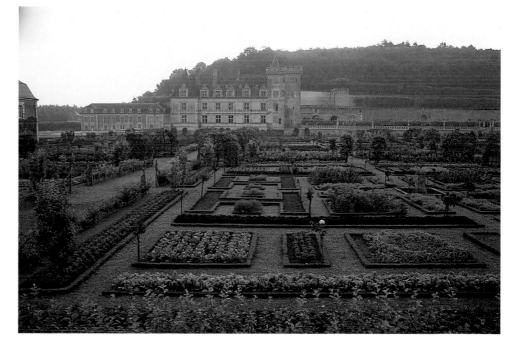

Sculpture gardens

Sculpture gardens are a marriage of art and plants, a landscape designed to complement sculpture. Although a piece of sculpture or statuary can be a focal point in any garden, there has been real interest in creating park-like spaces as outdoor museums for sculpture.

The trend in contemporary sculpture gardens has been to move away from the formal arrangement of statuary in niches to an informal placement of works that are often enormous in an open vista, with plantings judiciously placed to set them off well through all the seasons.

A major challenge in photographing sculpture gardens is recognizing the best light both for the artwork and the plantings. Since outdoor pieces are not illuminated with studio lights, the photographer must exercise extreme patience and ingenuity in finding the ideal lighting conditions.

Another consideration to bear in mind is that the color, texture, and patina of sculpture, as well as its form and scale, must be well represented. These constitute the aesthetic criteria by which sculpture is judged, so their depiction must be true to the original.

Sculptors whose works are created for outdoor display understand that their work will look different at various times of day, in all kinds of weather, and through the seasons. The photographer who returns to shoot the same works can show how the sculpture and the surrounding gardens are transformed by different light and seasons.

TOP. *A 200mm lens makes it possible to set Rodin's* Eve *in between a bush heavy with red winter berries and a bare cherry tree in the Donald M. Kendall Sculpture Garden.*

BOTTOM. *This photograph of Moore's* Double Oval *combines natural light, just after sunset, tungsten light illuminating the sculpture, and sodium vapor lights which turn the background trees a garish green.*

OPPOSITE. *Russell Page set Graetz's sculpture within a billowy grass garden that is at its peak in late autumn.*

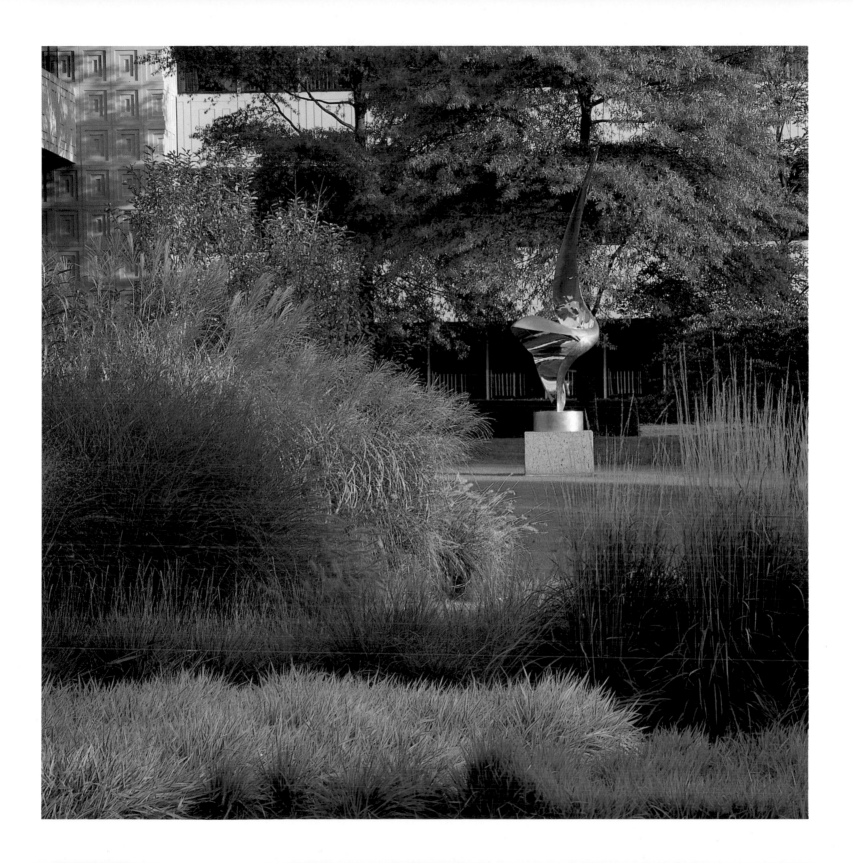

Topiary

Topiary can be thought of as sculpted plants. Like the intricate hedges of a maze, topiary is a highly formal planting, requiring a great deal of maintenance. There has been a revival of interest in topiary in connection with Georgian and other classic styles of architecture. The shapes of topiary are limited only by the creator's imagination. Everything is possible, from precisely groomed studies in solid geometry to fanciful animals. These shapes are highlighted by photographing topiary with sidelight, backlight, or against a contrasting background.

Since topiary is usually green, it is a challenge to present the color with richness and freshness. The choice of film may make a significant difference in how green is rendered. Experiment with a variety of color films—Kodachrome, Fujichrome, and Ektachrome—to find the most appealing one. The most suitable film is a matter of individual preference; even professionals in the photographic community argue over the relative merits of color rendition in various films.

Moreover, all greens are not the same. Differences in the level of chlorophyll account for the enormous range of greens in plants—from a yellowish color to gray to deep blue. The various colors of light, due to the time of day or kind of weather, may also influence the exact hue of the green. Be aware of the exact tonality when photographing topiary and other "solid green" subjects. Use an 81A warming filter if the green seems unnaturally blue.

Generally topiary tends to run toward the darker green hues. To reproduce those dark tonalities on film, and achieve full-color saturation, it is often necessary to underexpose from 1/2 to one full-stop, depending on light conditions.

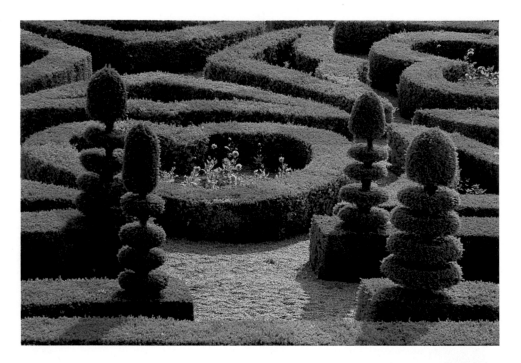

TOP. *Low-angled, late afternoon light warms the greens of these topiaries and hedges at Villandry, France. It also softens the glare of the gravelly parterre and creates a play of shadows which sharpens forms as seen from above.*

BOTTOM. *When rain wet this stone wall at Longwood Gardens, Pennsylvania, glistening textures and colors emerged. The sky was sacrificed to overexposure in order to brighten the grays of the stone and the greens of the topiary above.*

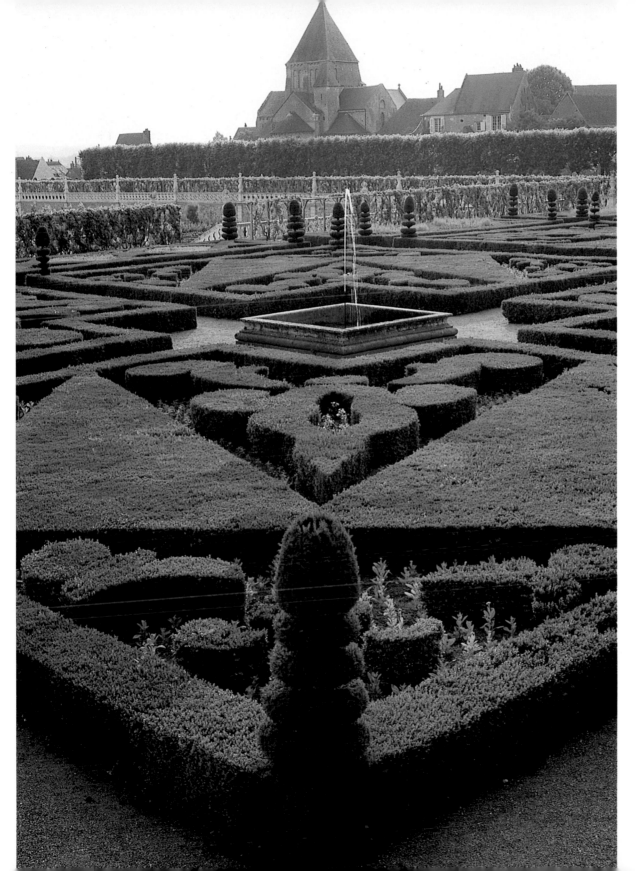

Although the topiary in this garden in Villandry in France is the focal point of this composition, the lovely setting, including a 12th century church, was also important. To combine both and capture the symmetry of the garden, a high angled perspective was chosen. Dim sunset light required overexposure to brighten the greens.

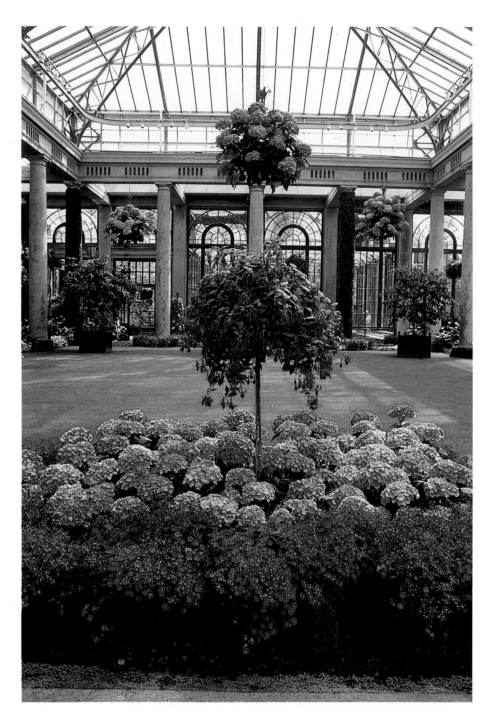

Conservatories and greenhouses

While they are not technically gardens, conservatories are indoor showcases for new—or revived—ideas about outdoor gardening. Their permanent exhibits often re-create natural habitats around the world and inspire gardeners with the highly theatrical qualities of seasonal displays. Greenhouses, especially those used for propagation and growing, are, in a sense, indoor farms.

Both conservatories and greenhouses offer the photographer a chance to practice in a protected environment, with a generous supply of daylight, and without the frustrations associated with wind and weather. When the structure's glass is frosted, there is an added benefit, as the penetrating light can be softened nicely.

This is the time to practice close-ups and floral portraits, using a tripod or monopod. If the perfect specimen is a bit off the path and can't be approached, a close-up can be taken with a 200mm telephoto macro.

The structures themselves can add interest behind the floral subjects. However, on very bright days, the shadows cast by the grillwork can spoil an otherwise lovely composition. Look carefully to be sure such shadows are avoided. Interiors of conservatories and greenhouses are also often lined with pipes, water sprinklers, and fans. Take care how these may intrude on a composition.

LEFT. *The symmetry and formality of this conservatory at Longwood Gardens in Pennsylvania is underscored by the frontal presentation. Overcast skies bring out the rich pinks, purples, and reds of the hydrangea, agaretum, and fuchsia.*

OPPOSITE. *A 28mm lens was chosen to avoid distorting the straight lines of the palms while showing a comprehensive view of the interior of this Longwood Gardens conservatory. And, a point of view was found, from which the potentially distracting shadows complemented the grillwork.*

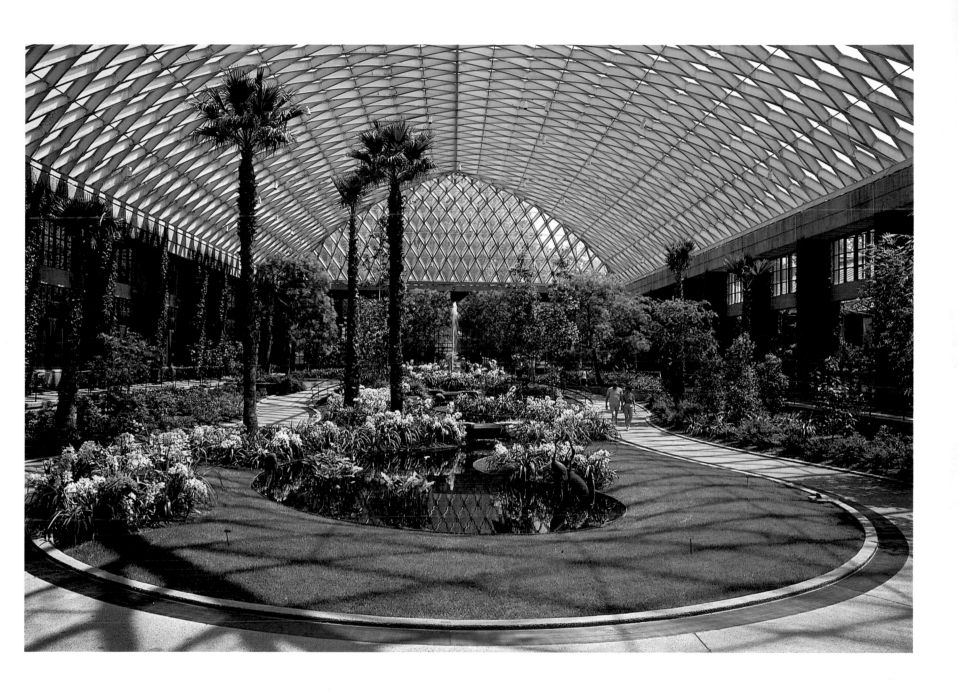

Flower shows and markets

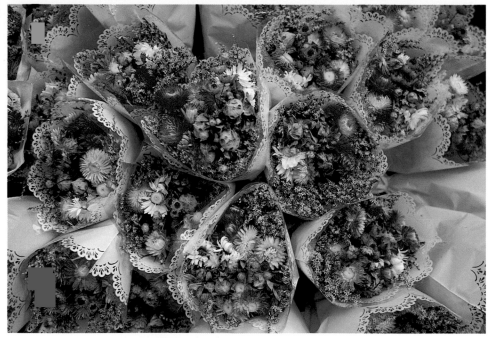

Indoor flower shows are popular events for discovering new developments in gardening, horticulture, and floral arrangement. They can be quite lavishly staged, dramatically lit, and well attended. However, many inexperienced photographers are not aware that taking successful pictures under these conditions requires special adaptations.

The most important adjustment is working with interior light. Daylight film is not balanced for tungsten or fluorescent lights, and colors will be noticeably distorted unless special films or filters are used. (See the appendix for details.) For shooting close-ups and details, an electronic flash will substitute its white light for the available indoor light and will provide enough illumination so that a tripod—usually not permitted in major flower shows—is not needed. However, a small flash unit will not illuminate a large display. Such display shots can only work with color correction filters or with film balanced for the available light. One advantage of using filters is that they can be combined with one of the new ultrafast films, so that hand-held exposures can be taken under the low light conditions present at most flower shows.

Outdoor flower markets have the benefit of displaying the freshest flowers in an attractive way. They also offer a variety of specimens, masses of color, and unusual juxtapositions, often combined with picturesque settings.

ABOVE. *An extreme wide-angle lens (18mm) exaggerates the tulips, in the foreground while incorporating much of the background in this scene at the New York Flower Show. A very slow shutter speed of ⅛ of a second makes an inconspicuous blur of the crowds, nearly erasing them from the image.*

LEFT. *This Dutch market display of dried flowers was shot from above producing an unusual perspective and an interesting composition of circles.*

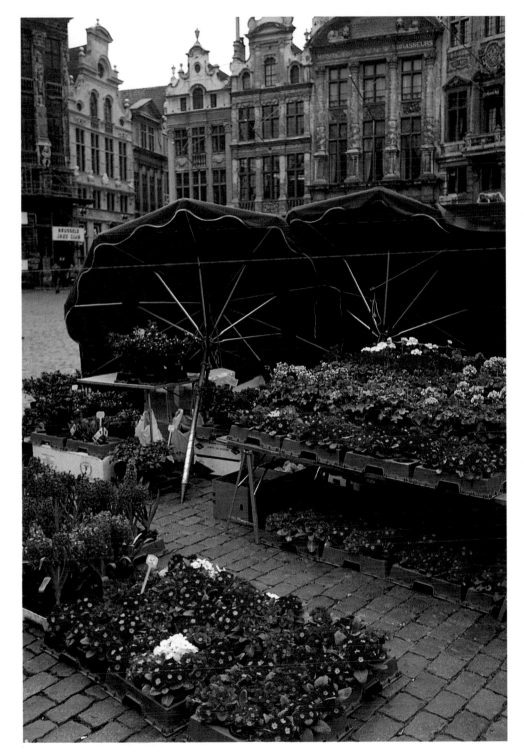

ABOVE. *Fill-in flash was used on this arrangement of lil- ies at the New York Flower Show to soften the high contrast light of the spots and to brighten the lower portion of the frame.*

LEFT. *By crouching low, it was possible to combine this Belgian flower market scene with the architectural background. Full-color saturation in the flowers and umbrellas is the result of the overcast light shot at the meter reading.*

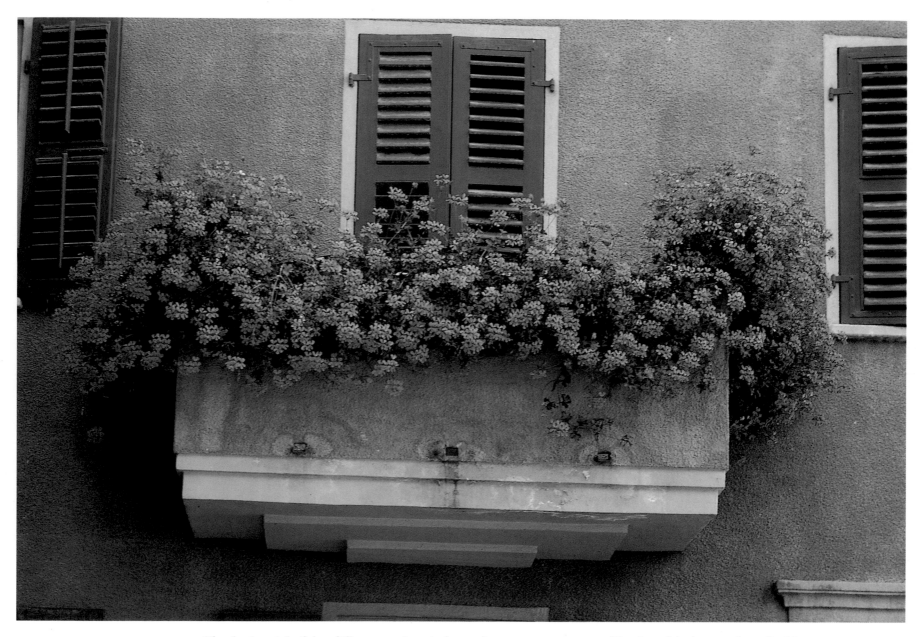

ABOVE. *The glowing pink of these billowy geraniums is due to the soft light of an overcast day. A 200mm telephoto lens was used to magnify the window boxes along the edge of this balcony and frame them tightly.*

OPPOSITE RIGHT. *The play of shadows on the wall adds texture and compositional interest around the pink geraniums in this stark window.*

OPPOSITE FAR RIGHT. *The red geraniums in the box provide just the right touch of color to brighten the dull gray of the concrete wall. To encompass both the box and its architectural setting a 35mm wide angle-lens was used.*

Window boxes

The miniature garden contained in a window box is available even to urbanites. The art of arranging flowers in window boxes, a European tradition, is now gaining in popularity around the world.

Because they are not meant to last, window boxes lend themselves to highly personal expression and experimentation. As a result, there are no rules about how plants are to be combined. They can be all of one kind and color, or a gaudy, irreverent mix. Generally, the plants in window boxes offer some contrast in flowers and foliage—for example, vertical plants combined with cascading ones.

But generalities, like rules, are meant to be broken, which is why photographers are so taken with window boxes. Their charm lies not only in the skill with which each example is made, but in the form itself. Here is a garden that can be totally encompassed within a single frame, with justice done to all the elements. The entirety of the gardener's art can be shown.

Since window boxes adjoin buildings, they also give the photographer a chance to include points of architectural interest. And, of course, there are the windows, which suggest so much with their curtains and shutters, and an occasional cat or human face peering through. The window box can reveal much more about the world and the nature of things than its simple form would lead us to expect. To capture not just what is seen, but the hidden dimension beyond, is the real task in photographing window boxes.

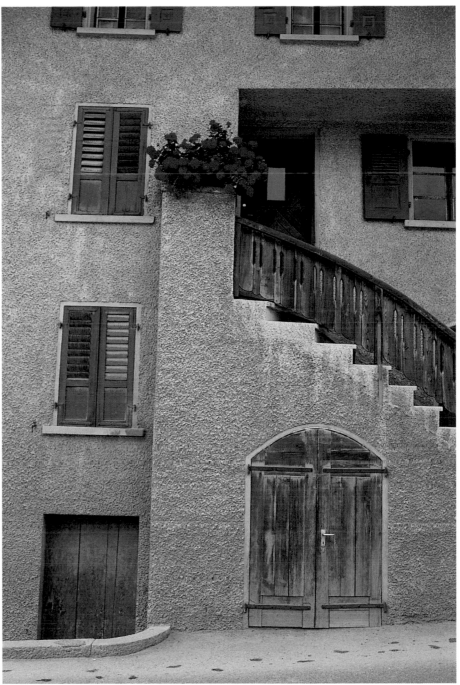

10
Great Flower and Garden Photographs

"Photography can never grow up if it imitates some other medium. It has to walk alone; it has to be itself."

BERENICE ABBOTT, 1951

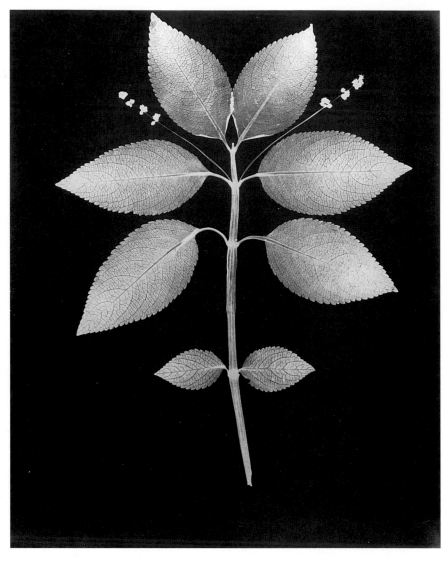

In the 150 years since the invention of photography, flowers and gardens have been recurrent subjects for professionals and amateurs. The history of these images reflects a wonderful and curious confluence of purposes: an amalgam of developments in an experimental visual medium; an application to that medium of precepts derived from the fine arts and the field of design; a desire to produce visual records, of specific gardens or floral species; and a wish to infuse the viewer with an appreciation of a vanishing world of natural or man-made beauty.

The number of photographers who have turned their eyes to flowers and gardens has been legion. While flowers and gardens have been almost universally portrayed, they have not been accorded recognition as the focus of a photographer's body of work, such as portraits or landscapes have been. The large body of floral images that has emerged has not developed apart from the rest of an individual photographer's opus or from the general evolution of photography.

Nevertheless, there are outstanding images of flowers and gardens, and several criteria were important to us in selecting photographs for this sampler. First, each image should represent the photographer's overall direction, in terms of aesthetics, philosophy, and technique. We did not want a single magnificent picture that stood apart from the photographer's other work.

Second, each image should mark a new benchmark in the development of the photographic medium. Portrayals of flowers and gardens have always reflected the evolution of photography as a whole, and as the concerns of photographers changed, so did the way they depicted floral subjects. We looked for the visual pioneers in that evolution.

Finally, each image should have had a lasting influence on later and contemporary photographers of flowers and gardens. We believe these selections have stirred the imagination, inspired the heart, and challenged the concepts of many who followed.

ABOVE. *William Henry Fox Talbot, "Botanical Specimen," England, 1839. Talbot pioneered the medium of photography in the 1840s', and he promoted the potential of his negative process by turning his camera to readily available objects around his family's estate. These early experiments set a high standard for an emerging medium.*

OPPOSITE. *Adolphe Braun, "Still Life of Flowers," France, ca. 1854–56. A textile designer by trade, Braun utilized photography to create images of floral arrangements.*

PAGE 209. *David Muench, "Blue Columbine," 1988. Muench's photographs of the American landscape are quintessential examples of how to capture a sense of place with clarity and purpose, combining typical details such as flowers with equally typical scenery, all photographed with precise composition and utmost sharpness.*

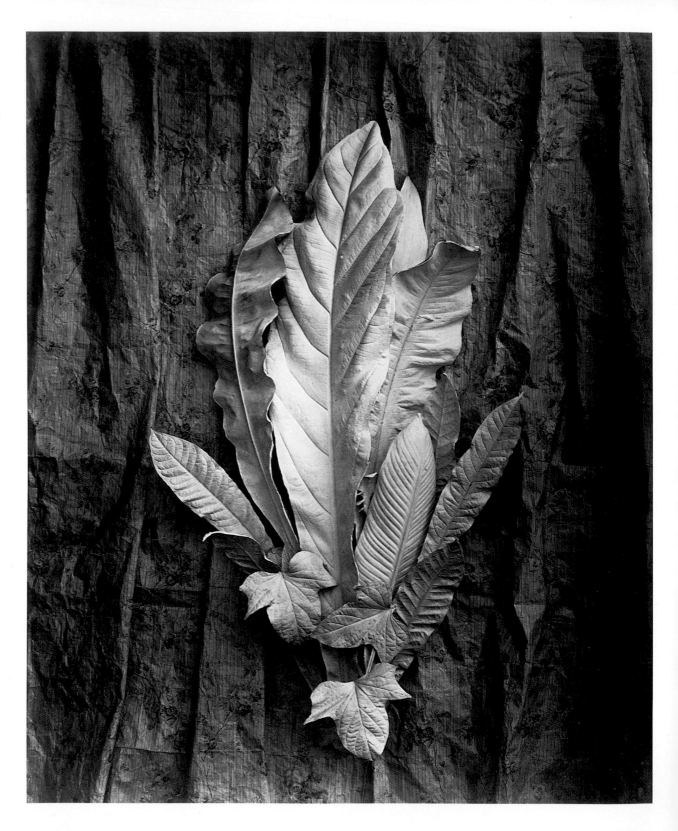

Charles Hippolyte Aubry, "Study of
Leaves," France, 1864. The painter's
tradition of still-life composition and
the textile artist's interest in design
are combined and extended in this
photographic study, which realizes
the camera's potential for depicting
textures of all varieties.

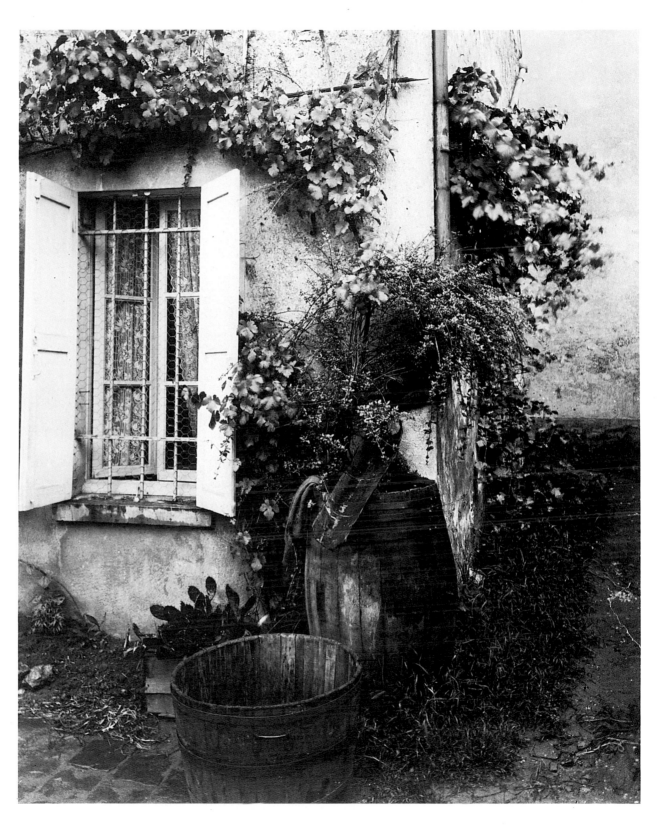

Eugène Atget, "Verrières, coin pittoresque," France, 1922. Atget loved gardens and brought to them many of the ideas he explored in his other works. His interest lay in the photogenic quality of the "threadbare," the beauty revealed in the ordinary, as in this image. He emphasized mood, particularly the loneliness and isolation of gardens, by photographing at the extremes of the day or bad weather, when no people were around.

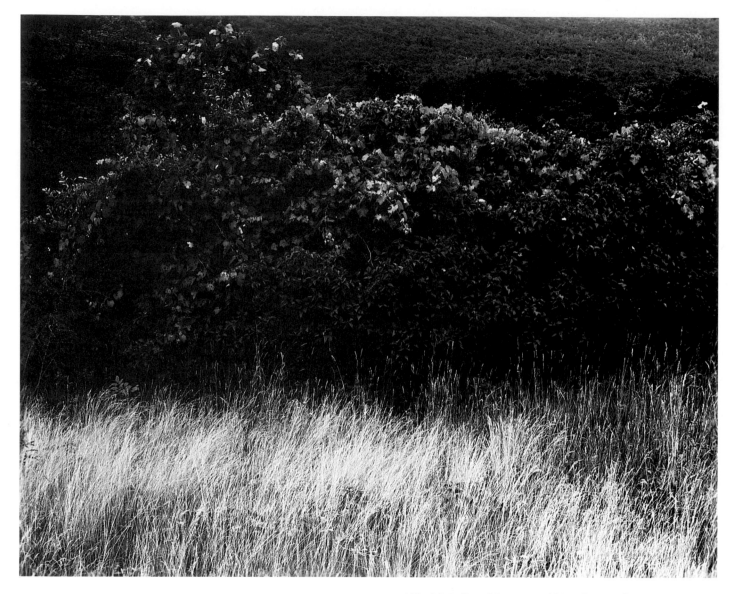

Alfred Stieglitz, "Grapes and Vine," United States, 1933. Primarily a photographer of cityscapes, Stieglitz brought the same discipline and concern for abstraction to this rural image. Stieglitz viewed objects as formal elements—shapes, textures, shades of gray—to be synthesized and organized through the artist's aesthetic.

André Kertész, "Melancholic Tulip," 1939. Kertész brings a highly individualistic vision, and a touch of surrealism, to the formal elements in his works, always seeking a different way of looking at familiar things. While few of Kertész's images include flowers, this one of a single, downhearted tulip has become a classic.

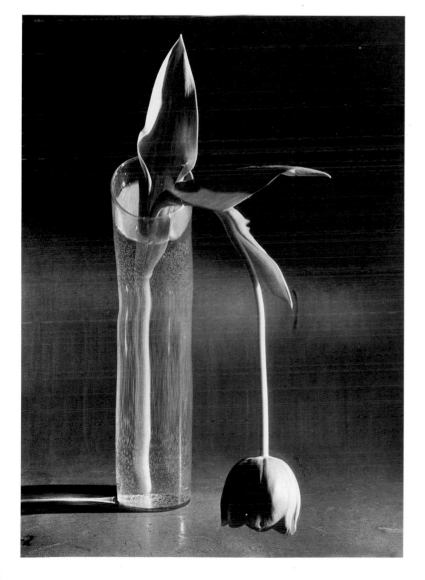

Robert Mapplethorpe, 1983—Mapplethorpe's classical compositions, his high technical quality, and his fascination with sexuality are as evident in his flower photographs as in his other works. Flowers, to Mapplethorpe, were seen as sexual organs, and he portrayed them in a sensuous and disingenuously forthright manner.

Eliot Porter, "Black-eyed Susans and Sumac in Grass," New Hampshire, 1956. Porter's most remarkable contribution to photography has been his ability to depict the sense of wilderness, not as something to conquer or master, but as something to revere, preserve, and appreciate. His portrayals of wild places eschew the extraordinary and magnificent in favor of the exquisite beauty of nature's randomness.

Ernst Haas, "Rose," 1970. Haas viewed photography as a means toward high philosophic and mystical interaction. He imposed his inner being on everything he photographed, transforming the outer world through his personal vision. This extreme close-up conveys the energy of Haas's imaginative powers and his absolute mastery of technique.

Marina Schinz, "Rose Garden," 1985. Schinz evokes the sense of place in gardens, not through any single portrait, but through a series of telling, intelligent images. Her knowledge of garden design, and her uncanny eye for elements of charm, mood, and humor are evident in this wonderful depiction of a formal rose garden.

Sonja Bullaty, "Iris Siberica" 1985. With a camera Bullaty is a poet, creating delicate images with soft edges and romantic pastel colors. In this photograph, the common name for the flower, "Flight of the Butterfly," is interpreted visually, so the iris seems to float over a cloud of mauve.

Larry Ulrich, "Datura," 1986. Clarity is the hallmark of Ul-rich's approach to flowers, which he portrays with classic simplicity within their natural setting.

APPENDIX

Fill-in flash

For eliminating or softening shadows on flowers, an electronic flash unit is a versatile accessory for the outdoor photographer. The flash unit may be set to provide just enough fill-in light to give detail to the shaded areas without eliminating shadows, or the flash may be set to avoid shadows entirely. Fill-in flash is best used between 3 and 15 feet from the subject.

There are so many camera and flash systems on the market that it is not possible to give specific instructions for each. However, the principles and steps listed below provide a general guide to the effective use of fill-in flash.

For flash units with variable power ratios:

1. Set flash unit to proper ISO designation, for example, 100.
2. Set camera shutter speed to designated flash synchronization speed. Most cameras synchronize at 1/60 of a second or slower.
3. Carefully meter the highlights, that is, the brightest parts of the flower, with the camera's shutter speed set at the synchronization speed for flash photography.
4. Focus on the subject to determine the flash-to-subject distance. This distance is found on the focusing scale of the lens barrel.
5. To determine flash output for this distance, set the flash unit for manual operation. Turn the dial on the flash unit so the flash-to-subject distance and the highlight meter reading are aligned. An arrow or indicator will point to the suggested power level.
6. This power level should be reduced by 1 f-stop for purposes of fill-in flash. Therefore, use the next lower power level from the one suggested. For example, if the meter reading is f/11 and the flash-to-subject distance is 9 feet, the recommended power level may be ½ of power. For fill-in flash, set the flash unit at ¼ of power.
7. Take the photograph. Bracket by changing the f-stop at ½-stop intervals.

For flash units with constant power output:

1. Set flash unit to proper ISO designation, for example, 100.
2. Set camera shutter speed to designated flash synchronization speed. Most cameras synchronize at 1/60 of a second or slower.
3. Carefully meter the highlights, that is, the brightest parts of the flower, with the camera's shutter speed set at the synchronization speed for flash photography.
4. Focus on the subject to determine the flash-to-subject distance. This distance is found on the focusing scale of the lens barrel.
5. The dial on the flash unit will recommend a particular f-stop at this flash-to-subject distance. Compare the recommended f-stop to the meter reading.
6. If the meter reading and recommended f-stop are the same (e.g., 1/60 of a second at f/8), or if the meter reading calls for a higher f-stop than the one suggested on the flash unit dial (e.g., a meter reading of 1/60 of a second at f-16 and a recommended f-stop of f/8), then the power output of the flash unit can be reduced in one of two ways:

 a. by covering the flash unit with layers of lens tissue to achieve the desired reduction of light output.
 b. or by removing the flash unit from the camera and placing it at a greater distance from the subject.

7. If the meter reading calls for an f-stop that is 1 stop lower than the one recommended on the flash unit (e.g., the meter reading is 1/60 of a second at f/11 and the recommended f-stop is f/16), then no compensation is needed, and the photograph can be taken.
8. If the meter reading calls for an f-stop that is 2 or more stops lower than the one recommended on the flash unit (e.g., the meter reading is 1/60 of a second at f/11 and the recommended f-stop is f/22), then move the flash unit closer to the subject.
9. Another way to reduce power with fill-in flash is to increase the ISO number on the flash unit or on your camera if it controls the flash output. This change fools the built-in computerized electronic mechanism into producing less illumination based on the assumption that a faster film is being used. Doubling the ISO number is equivalent to a reduction of 1 full f-stop. Intermediate reductions can be made proportionately.
10. It is also possible to reduce light output by covering the flash head with two sheets of lens tissue. The loss of light will be approximately 1 f-stop. The resulting image will show little change in the background lighting, but the shadows in the foreground will be brightened.

Flash test

The flash test below is designed to help photographers control the light output on an electronic flash unit for proper exposure in close-up photography. Since most flash units are too powerful at close range, or at a distance of less than 3 feet, light output needs to be reduced. This is achieved by the application of layers of lens tissue over the flash head. The flash test will guide the photographer as to how many layers are needed with the flash unit at hand, and is meant only for magnifications of 1/6 of life-size to full life-size.

Equipment and Materials

1. A 35 mm SLR
2. A macro lens or extension tubes with automatic diaphragms.
3. A flash unit with manual controls. The ideal flash unit should be light, inexpensive, accept interchangeable batteries and have a guide number ranging from 30–50. Larger, more powerful units used for fill-in flash are not recommended for this test or for close-up photography.
4. A tripod.
5. A package of lens tissue and rubber bands.
6. Any slide film in the ISO 25–100 range. Kodachrome 64 and Fujichrome 50 work best. Slide film is best for this test because it records accurately the minor changes in exposure that are critical for this test. With negative film, after the test is done as described, the film must be processed by a professional lab and a color contact sheet made of the test roll. Normal 3 × 5″ commercial prints should *not* be made, because they will not show the exposure variations necessary to get the proper exposure.
7. A power cord (PC) which permits the flash unit to be removed and fired off the camera.
8. A chart to record exactly what you will be doing for future reference. On the chart you should identify the type of film and list numbers from 1 to 24 or to 36 that match the number of exposures on the roll of film. Next to each number, record the general color intensity of the flower—light, medium, or dark— and the number of sheets of lens tissue on the head of the flash unit. See sample chart below:

Film: Kodachrome 64	Flower color	Number of sheets of lens tissue
1	light	0
2	light	1
3	light	2

Procedure

1. Place the camera on a tripod and select three flowers for the exposure test: A light-colored variety (for example, a lily), a dark-colored variety (for example, a red rose), and a medium-colored variety (for example, a morning glory). A series of test exposures will be shot for each flower.
2. Be sure that the flower to be photographed is at a magnification of ½ of life-size, which is the maximum magnification on most macro lenses. Focus very carefully on the part of the flower that is most crucial for sharpness.
3. Set the lens aperture at f/16 or 1 stop down from the smallest aperture. For example, if the smallest aperture is f/22, use f/16; if it's f/16, use f/11.
4. Connect the flash unit to the camera using the PC cord. Holding the flash unit off the camera, position it so it is parallel with the front edge of the lens, and is angled at 45 degrees to the flower. (A number of manufacturers— Olympus, Spiratone, Novoflex—make special brackets for mounting the flash to the front of the lens, simplifying such close-up flash work.) Positioning the flash at exactly the same place is *not* critical, as a slight movement off the mark will still result in proper exposure. What is very important is that the flash be pointed directly at the flower.
5. Release the shutter to fire the flash.
6. Continue taking photographs of the same flower, adding one piece of lens tissue at a time, up to seven sheets. The lens tissue must cover the head of the flash unit to reduce light output effectively. Use rubber bands to secure the lens tissue. Repeat the same procedure with all three flowers.
7. Process film normally.
8. The preferred method for reviewing slides is to lay them on a light box in the order in which they were shot. View them with a 4× magnification loupe. The photographs will appear progressively darker because each layer of lens tissue reduces the light output of the flash. Select the best exposure for each flower. Refer to your chart to determine how many pieces of lens tissue were used for that particular shot.

If you do not have access to a light box, critique your slides by projecting them onto a commercial projection screen or onto a pure white wall. On each slide write down the number of pieces of lens tissue used, and file the slides for future reference.

If the test has been successful, more pieces of lens tissue will be necessary to get the proper exposure for the light flower than for the darker flowers. If this is not the case, something was not done properly, and the test should be repeated.

Once the test has been completed successfully and the best exposure has been selected for each flower, you will be able to replicate your results as long as the magnifications of your subject stay between 1/6 of life-size and life-size. For the most critical exposures, bracket all shots by ½-stop intervals.

COLOR CORRECTION CHART

The chart below shows how to remove a color cast from a photographic subject, so the light records on the film as if it were a white, colorless light. The first column indicates the type of film in the camera. To use this chart, find the description of light that matches the available conditions, outdoors or indoors, and check the possible colors of light that may prevail. Moving horizontally across the chart, locate the suggested color correction filter, and adjust the exposure by the amount listed in the last column. For example, using daylight film at a high mountain elevation on a clear day, the light may have a bluish cast. Correct this with an 81A or 81B filter, and overexpose by ½ of an f-stop.

FILTERS FOR COLOR CORRECTION

Film	Description of Light	Color of Light	Suggested Filter	Exposure Correction
Daylight	Sunrise/sunset	Magenta	82C	+ ½
		Bluish	81A or 81B	+ ½
		Yellow	82A	+ ⅓

Film	Description of Light	Color of Light	Suggested Filter	Exposure Correction
Daylight	Overcast	Bluish gray	81A or 81B	+ ½
Daylight	High mountain, clear	Blue	81A or 81B	+ ½
	High mountain, hazy	Bluish gray	1B	None
Daylight	Midday sunlight	Slightly blue	1A or 1B	None
Daylight	Shade	Blue	81 series	+ ⅓
Daylight	Fluorescent	Greenish	FL-D	None
Tungsten	Fluorescent	Bluish	FL-B	None
Daylight	Tungsten (type B)	Yellowish	80A	+ 2
Daylight	Tungsten (type A)	Yellowish	80B	+ 1½

GLOSSARY

Aperture: The diameter of the lens opening, which affects the amount of light entering the camera. The variable aperture control ring is marked on the lens by a set of f-numbers (2, 4, 5.6, 8, 11, 16, 22). Each f-stop setting changes the amount of light passing through the lens by a factor of 2, with the smaller numbers representing a larger aperture opening and the larger numbers a smaller opening. The larger the aperture opening, the more light enters the camera; closing the lens restricts the amount of light entering the lens.

Aperture priority: The system of exposure control for automatic cameras in which the photographer selects the aperture of his choice, and the computer in the camera then selects the shutter speed that will produce an acceptable exposure.

Averaging meter: An exposure meter built into a camera for through-the-lens metering that measures the light from various areas off the viewfinder screen and then averages the varied exposures to determine an acceptable overall exposure.

Bracketing: Taking a series of slides or negatives that are identical except for their exposure. Bracketing the exposure is done by exposing the film at the meter reading then over- and underexposing the film by 1/2 or 1 full f-stop. Such a series of bracketed shots ensures one excellent exposure.

Cable release: A specially designed wire, of varying lengths, which screws into the shutter release button so that exposures can be taken without touching the camera.

Center weighted meter: A through-the-lens exposure meter calibrated to measure light with greater consideration given to the center of the viewfinder.

Color compensating (CC) filters: Filters designed to compensate for the difference between the color of the film and the color temperature of the available light in order to simulate white light conditions.

Color saturation: The rendering of colors with great intensity and purity, showing no signs of the presence of white, gray, or black.

Depth of field: The zone of sharpness in front of and behind the point of focus. In most instances, this zone ranges from 1/3 the distance in front of the point of focus to 2/3 beyond the point of maximum sharpness.

Diopter: An optical term used to express the focal length and the power of supplementary magnifying lenses. A +1 diopter will focus at 1 meter, a +2 diopter doubles the magnification and will focus at 1/2 the distance 0.5 meters and a +3 diopter will focus at 0.3 meters. A +20 diopter gives a life-size (×1) magnification.

Exposure: Submitting a photosensitive material to light; the combination of aperture size and shutter speed necessary to permit the desirable amount of light to strike the film; gauging light conditions with the use of a meter to determine the appropriate combination of aperture setting and shutter speed.

Exposure compensation dial: A dial present on most automatic cameras that permits manual control of exposure correction in graduated 1/3 f-stop intervals: (−) indicates underexposure, (+) indicates overexposure.

Film speed: The sensitivity of the film to light. There is an international rating system (ISO) that rates the light sensitivity of one film to another. The lower the film speed (i.e., ISO 25, 50, 64), the less sensitive it is to light. The higher the film speed (ISO 200, 400, 800) the more sensitive it is to light. "Slow" films need more light to expose them than "fast" films.

Focal length: An optical term referring to the distance from the rear part of the lens to the plane of focus on the film when the focusing ring of that lens is set at infinity. The focal length is engraved on the front of the lens (e.g., f = 50mm) and should not be confused with the f-stop.

F-stop: See aperture.

Hot shoe: The fitting on top of the camera for an electronic flash unit, which permits it to be fired automatically when the shutter is released.

ISO rating: An acronym for International Standards Organization, an organization that rates the relative sensitivity of films to light. See also Film speed.

Latitude: The degree to which a film can be exposed and maintain detail in the highlights and shadow areas in the emulsion. The latitude varies with the film type. Most transparency films have a latitude of 3 to 4 f-stops while color negative films have a greater exposure range of 6 to 8 f-stops.

Lens shade: A black or dark tube or ring that attaches to the front of the lens to prevent unwanted glaring light from striking the front of the lens.

Light meter: A gauge used to measure the amount of light falling on—or reflected off—a subject. Programmed to the film's ISO rating, the meter reads out a combination of shutter speed and f-stop designations to provide the photographer with information necessary to compute the proper exposure.

Metering: The process of gauging light conditions with a light meter in order to select a combination of f-stop and shutter speed for exposure.

Perspective control (PC) lens: A specialized "shift" lens for the 35mm camera designed to keep lines parallel; primarily used in architectural photography.

Polarizing filter: A filter mounted in front of a camera lens to absorb polarized light in varying degrees as it is rotated. Its effect is to remove glare and reflections from surfaces, to darken the sky, and to lighten clouds.

Pulling film: In color photography, a process used during development to correct accidental overexposure of an entire roll of film (i.e., exposing the film at a lower ISO rating). The film can be saved if processed at a shorter than normal period.

Pushing film: The technique of deliberately underexposing or uprating an entire roll of film (i.e., exposing film at a higher ISO rating) and then processing the film for a longer than normal period of time. The pushing process increases contrast, brings out detail that would have been lost if the film were processed normally, and increases graininess. This technique is commonly used to gain an additional f-stop or to use a faster shutter speed.

Reflector: Any object, such as aluminum foil, a foam board, or a gray card, used to add reflected light onto a subject. Reflectors provide uniform light to illuminate shadow areas and to enable the photographer to use a smaller f-stop or a slightly faster shutter speed than the ambient light permits.

Ring flash: A circular electronic flash unit that mounts around the front of a lens, producing a soft, even, frontal light casting almost no shadows; used primarily for close-up photography.

Selective focus: The lens's capacity to keep some portions of a scene in sharp focus while other parts are blurred through the controlled use of depth of field.

Shutter speed: The amount of time the camera's shutter is left open during exposure of the film. Shutter speeds are imprinted on the shutter speed dial and are listed as reciprocals of fractions of a second (i.e., 60 = 1/60 of a second).

Shutter speed priority: The system of exposure control for automatic cameras in which the photographer selects the shutter speed and the computer in the camera sets the aperture that will produce an acceptable exposure.

Speed of lens: The maximum aperture that a lens can open to, indicated by a number on the front barrel of each lens. Fast lenses with apertures greater than f/2 are most valuable for dim light photography with hand-held equipment.

Split neutral density filter: A filter that is half gray and half clear, with a diffused dividing line in the middle designed to equalize light in scenes that are half bright—e.g., sky or water—and half dark.

Spot meter: A hand-held exposure meter that can measure a very narrow angle of light (1 to 5 degrees) to measure accurately any part of the subject even at great distances.

Supplementary lens: A magnifying lens attached to the front of the camera lens providing magnification through closer focusing; usually sold in sets of three, at various diopters. See also Diopters.

TECHNICAL INFORMATION

Numbers in **bold type** refer to page numbers.

Jacket, front: Kodachrome 64, 200mm macro lens, f/5.6.

Jacket, back: Fujichrome 50, 18mm lens, f/11.

1: Fujichrome 50, 90mm macro lens, f/16.

2–3: Kodachrome 64, 105mm macro lens, f/16.

5: Kodachrome 25, 35mm lens, f/16.

8: Fujichrome 50, 200mm lens, f/4 at 1/125 second.

12–13: Fujichrome 50, 80–200 mm lens at 200 mm, f/5.6.

14: Fujichrome 50, 90mm macro lens, f/8.

15: Fujichrome 50, 90mm macro lens, f/11.

16: Fujichrome 50, 35mm lens f/16.

17, top: Fujichrome 50, 200mm macro lens, f/5.6.

17, bottom: Kodachrome 64, 35mm lens, f/16.

18: Fujichrome 50, 35–70mm zoom lens at 70mm, f/16.

19: Square format, Fujichrome RFP, 80mm lens, f/5.6.

20: Fujichrome 50, 200mm macro, f/5.6.

21: Square format, Fujichrome 50, 35mm lens, f/16.

22, top: Fujichrome 50, 80–200mm zoom lens at 200mm, f/8.

22, bottom: Fujichrome 50, 200mm macro lens, f/5.6.

23, top: Kodachrome 25, 35mm lens, f/8.

23, bottom: Kodachrome 64, 200mm macro lens, f/11.

24–25: Kodachrome 25, 90mm lens with 50mm extension tube, f/8.

27: Fujichrome 50, 180mm lens, f/8.

28: Fujichrome 50, 105mm macro lens, f/8.

29: Kodachrome 25, 200mm macro lens, f/5.6.

30: Fujichrome 50, 180mm lens, f/16.

31, left: Fujichrome 50, 24mm lens, f/16.

31, right: Kodachrome 25, 100mm lens, f/8.

32, top: Fujichrome 1600, 180mm lens with a 2X extender, f/16.

32, bottom: Ektachrome 400, 200mm lens with +1 diopter, f/11.

33: Fujichrome 50, 90mm macro lens, f/16.

34: Fujichrome 100, 90mm macro lens, f/16.

35: Kodachrome 25, 55mm macro lens, f/16.

36, top: Kodachrome 64m, 50mm lens, f/16.

36, bottom: Kodachrome 64, 105mm lens, f/16.

37: Fujichrome 50, 100mm lens, f/16.

38, left: Square format, Fujichrome RFP, 80mm lens, f/11.

38, right top: Kodachrome 64, 105mm lens, f/11.

38, right bottom: Kodachrome 64, 105mm lens, f/8.

39, top: Kodachrome 64, 105mm lens, f/16.

39, bottom: Kodachrome 25, 105mm lens, f/16.

40: Kodachrome 25, 200mm macro lens, f/5.6.

41: Kodachrome 25, 80mm macro lens with 100mm extension

tube, f/22, multiple flash.

42–43: Kodachrome 25, 105mm macro lens, f/5.6.

45: Fujichrome 50, 35–70mm zoom lens at 35mm, f/16.

47: Kodachrome 64, 300mm lens, f/5.6.

48: Fujichrome 50, 50mm lens, f/16.

49, top: Kodachrome 64, 50mm lens, f/16.2

49, center: Fujichrome 50, 50mm lens, f/16.

49, bottom: Kodachrome 64, 50mm lens, f/16.

50, left: Fujichrome 50, 16mm lens, f/11.

50, right: Square format, Fujichrome RFP, 50mm lens, f/16.

51: Kodachrome 64, 35mm lens, f/16.

52, top: Fujichrome 50, 200mm lens, f/8.

52, bottom: Kodachrome 64, 200mm lens, f/4.

53: Fujichrome 50, lens, f/5.6.

54, left: Kodachrome 25, f/32.

54, right: Kodachrome 25, f/16.

55: Kodachrome 25, f/22.

56–57: Kodachrome 25, f/11.

58: Fujichrome 50 pushed to ISO 100, 200mm macro lens, f/16.

59: Kodachrome 25, 200mm lens, f/22.

60: Fujichrome 50, 35mm lens, f/16.

61: Fujichrome 50, f/5.6.

62, left: Fujichrome 50, 90mm macro lens, f/22.

62, right: Kodachrome 25, 90mm lens with 100mm extension tube, f/22.

63, top: Kodachrome 25, 200mm macro lens, f/8.

63, bottom: Kodachrome 64, 90mm macro lens, f/16.

64–65: Kodachrome 64, 200mm lens, f/8.

66: Square format, Kodachrome PKR, 150mm lens, f/11.

67: Kodachrome 25, 24mm lens, f/16.

68: Kodachrome 25, 105mm macro lens, f/16.

69: Kodachrome 64, 200mm lens, f/16.

70, top: Fujichrome 50, 30–70mm zoom lens at 70mm, f/16.

70, bottom: Fujichrome 50, 35mm lens, f/16.

71: Fujichrome 50, 105mm macro lens, f/16.

72, top: Kodachrome 64, 200mm lens at f/11.

72, bottom: Kodachrome 25, 35–70mm zoom lens at 70mm, f/22.

73, left: Kodachrome 64, 200mm lens, f/16.

73, right: Kodachrome 64, 24mm lens, f/16.

74: Fujichrome 50, 28mm lens, f/16.

75: Fujichrome 50, 200mm macro lens, f/5.6.

76: Fujichrome 50, 105mm macro lens, f/5.6.

77: Fujichrome 50, 24mm lens, f/16.

78: Fujichrome 50, 200mm macro lens, f/8.

79: Fujichrome 50, 35–70mm zoom at 70mm, f/11.

80–81: Fujichrome 50, 50mm lens, f/16.

82, top: Square format, Ektachrome EPN, 50mm lens, f/16.

82, bottom: Square format, Kodachrome PKR, 50mm lens, f/16.

83: Square format, Kodachrome PKR, 150mm lens, f/16.

84: Kodachrome 64, 55mm macro lens, f/5.6.

85: Fujichrome 50, 90mm macro lens, f/8.

86, left: Kodachrome 64, 105mm lens, f/11.

86, top right: Kodachrome 64, 55mm macro lens, f/16.

86, bottom right: Fujichrome 50, 200mm macro lens, f/11.

87: Fujichrome 50, 200mm macro lens, f/4.

88–89: Fujichrome 50, 105mm macro lens, f/22.

90–91: Kodachrome 64, 200mm lens, f/11.

92, left: Fujichrome 50, 90mm lens, f/5.6.

92, right: Kodachrome 64, 90mm macro lens, f/11.

93: Fujichrome 50, 100mm lens, f/5.6.

94: Fujichrome 50, 90mm macro lens, f/16.

95: Kodachrome 25, 90mm macro lens, f/8.

97: Fujichrome 50, 105mm macro lens, f/8.

98: Fujichrome 50, 24mm lens, f/11

100: Kodachrome 25, 35mm lens, f/16.

101, top: Fujichrome 50, 105mm macro lens, f/5.6.

101, bottom: Kodachrome 64, 300mm lens, f/16.

102, left: Fujichrome 50, 35mm lens, f/16.

102, right: Fujichrome 50, 35mm lens, f/13.

103, left: Fujichrome 50, 35mm lens, f/11.

103, right: Fujichrome 50, 35mm lens, f/9.5.

104–105: Fujichrome 50, 35–70mm zoom lens at 35mm, f/16.

106: Fujichrome 50, 105mm lens, f/8.

107: Fujichrome 50, 180mm lens, f/11.

108, left: Kodachrome 25, 90mm macro lens, f/16.

108, right: Kodachrome 25, 24mm lens, f/4.

109: Kodachrome 25, 28mm lens, f/11.

110–111: Kodachrome 64, 105mm macro lens, f/8.

112: Square format, Fujichrome RFP, 150mm lens at f/22.

113: Fujichrome 50, 105mm lens, f/4.

114, top: Fujichrome 50, 90mm macro lens, f/4.

114, bottom: Fujichrome 50, 105mm macro lens, f/32.

115, top: Kodachrome 25, 80–200 mm zoom lens at 200mm, f/8.

115, bottom: Fujichrome 50, 200mm macro lens, f/4.

116, top: Kodachrome 64, 35mm lens, f/16.

116, bottom: Kodachrome 64, 55mm macro lens, f/32.

117: Kodachrome 25, 90mm macro lens, f/8.

118: Kodachrome 64, 105mm macro lens with a +1 diopter, f/8.

119: Kodachrome 64, 200mm macro lens, f/5.6.

120–121: Kodachrome 64, 105mm macro lens, f/11.

122, top: Fujichrome 50, 50mm lens, f/11.

122, bottom: Fujichrome 50, 90mm macro lens, f/11.

123: Kodachrome 64, 55mm macro lens, f/11.

124, top: Kodachrome 64, 24mm lens, f/16.

124, bottom: Fujichrome 50, 300mm lens, f/11.

125, left: Fujichrome 50, 180mm telephoto lens with 25mm extension tube, f/8.

125, right: Fujichrome 50, 90mm lens, f/4.

126: Kodachrome 64, 300mm lens, f/22.

127, top: Kodachrome 25, 28mm lens, f/16.

127, bottom: Kodachrome 25, 180mm lens, f/11.

128: Fujichrome 50, 35–70mm zoom lens at 70mm, f/16.

129: Fujichrome 50, 180mm lens, f/16.

130: Kodachrome 25, 35mm lens, f/22

131: Fujichrome 50, 200mm macro lens, f/22.

132–133: Fujichrome 50, 105mm macro lens, f/22.

134: Fujichrome 50, 200mm lens, f/16.

135: Fujichrome 50, 105mm macro lens, f/22.

136, top: Fujichrome 50, 30–70mm zoom lens at 70mm, f/16.

136, bottom: Fujichrome 50, 105mm macro lens, f/16.

137, top: Kodachrome 25, 30mm lens, f/16.

137, bottom left: Kodachrome 64, 55mm macro lens with 100mm extension tube, f/16.

137, right: Kodachrome 64, 300mm lens, f/11.

138, left: Fujichrome 50, 35mm lens, f/16.

138, right: Fujichrome 50, 28mm lens, f/16.

139, left: Fujichrome 50, 105mm macro lens, f/16.

139, top right: Fujichrome 50, 50mm lens, f/11.

139, bottom right: Kodachrome 64, 55mm macro lens, f/16.

140–141: Fujichrome 50, f/5.6.

142–143: Kodachrome 25, 90mm macro lens with 90mm exten-

sion tube, Olympus T8 Ring Flash 2, f/22.

144: Kodachrome 25, 90mm macro with a 25mm extension tube, f/22

145: Fujichrome 50, 90mm macro lens, f/22.

146, top: Fujichrome 50, 90mm macro lens, f/11.

146, bottom: Fujichrome 50, 90mm macro lens, f/8.

147: Fujichrome 50, 200mm macro lens, f/16.

148: Kodachrome 64, 105mm lens, f/22.

149: Kodachrome 64, 105mm macro lens, f/16.

150–151: Kodachrome 25, 50mm macro lens with 46mm extension tube, f/16.

152: Kodachrome 25, 105mm macro lens, f/16.

153, left: Kodachrome 25, 80mm macro lens with 80mm Telescopic Auto Tube, f/32.

153, top right: Kodachrome 25, 105mm macro lens, f/16.

153, bottom right: Fujichrome 50, 90mm macro lens, f/22.

154–155: Fujichrome 50, 50mm lens, f/16.

156: Kodachrome 64, 80–200mm zoom lens at 200mm, f/5.6.

157, top: Fujichrome 50, 105mm macro lens, f/11.

157, bottom: Fujichrome 50, 24mm lens, f/11.

158, left: Fujichrome 50, 24mm lens, f/16.

158, right: Kodachrome 25, 90mm macro lens, f/5.6 at 1/15 second.

159, top: Kodachrome 64, 200mm lens, f/11.

159, bottom: Kodachrome 25, f/16.

160: Fujichrome 50, 100mm lens, f/11.

161: Kodachrome 25, 100mm lens, f/11.

162, top: Kodachrome 25, 80–200mm lens at 100mm, f/16.

162, **bottom:** Fujichrome 50, 200mm macro lens, f/8.

163: Fujichrome 50, 28mm lens, f/16.

164: Kodachrome 25, 105mm lens, f/8.

165, **top left:** Kodachrome 64, 80–200mm zoom lens at 180mm, f/16.

165, **center left:** Kodachrome 64, 200mm lens, f/5.6.

165, **bottom left:** Kodachrome 64, 55mm macro lens, f/11.

165, **right:** Kodachrome 64, 200mm lens, f/8.

166, **left:** Kodachrome 64, 24mm lens, f/16.

166, **right:** Fujichrome 50, 28mm lens, f/16.

167: Fujichrome 50, 90mm macro lens, f/5.6.

168, **top:** Kodachrome 64, 50mm lens, f/16.

168, **bottom:** Fujichrome 50, f/8.

169: Kodachrome 64, 200mm lens, f/8.

170: Fujichrome 50, 18mm lens, f/11.

171: Kodachrome 64, 300mm lens, f/5.6.

172: Kodachrome 64, 24mm lens, f/5.6.

173, **left:** Fujichrome 50, 35mm lens, f/11.

173, **right:** Fujichrome 50, 35mm lens, f/8.

175: Square format, Fujichrome 50, 50mm lens, f/11.

177: Fujichrome 50, 100mm lens, f/16.

178, **top:** Oga 400 pushed to 1000, 80–200mm zoom lens at 120mm, f/22.

178, **bottom:** Fujichrome 50, 400mm lens, f/11.

179, **left:** Fujichrome 50, 24mm lens, f/16.

179, **right:** Kodachrome 25, 35mm lens, f/16.

180: Kodachrome 64, 105mm lens, f/8.

181, **top:** Fujichrome 50, 35mm lens, f/16.

181, **bottom:** Kodachrome 64, 24mm lens, f/16.

182: Fujichrome 50, 100mm lens, f/16.

183, **top:** Fujichrome 50, 80–200mm zoom lens at 200mm, f/16 at ½ second with a tripod.

183, **bottom:** Kodachrome 64, 200mm lens, f/16.

184: Square format, Fujichrome RDP, 50mm lens, f/22.

185, **top:** Fujichrome 50, 50mm lens, f./22.

185, **bottom:** Kodachrome 64, 50mm lens, f/11.

186, **left:** Fujichrome 50, 100 mm lens, f/11.

186, **right:** Square format, Fujichrome RFP, 80mm lens, f/16.

187, **top:** Square format, Fuji-chrome RFP, 50mm lens, f/16.

187, **bottom:** Square format, Ektachrome EPP, 50mm lens, f/16.

188–189: Kodachrome 25, 80–200mm zoom lens at 200mm, f/11.

190, **top left:** Fujichrome 50, 80–200mm zoom lens at 100mm, f/22.

190, **bottom left:** Fujichrome 50, 35mm lens, f/16.

190, **right:** Fujichrome 50, 35mm lens, f/16.

191, **top:** Fujichrome 50, 35mm lens, f/16.

191, **bottom:** Square format Fujichrome 50, 80mm lens, f/16.

192: Kodachrome 64, 35mm lens, f/16.

193: Fujichrome 50, 200m lens, f/16.

194, **top:** Kodachrome 25, 35mm lens, f/8.

194, **bottom:** Kodachrome 64, 35mm lens, f/22.

195: Kodachrome 25, 200mm tele-photo lens plus 14mm extension tube, f/5.6.

196, **top:** Fujichrome 50, 50mm lens at f/16.

196, **bottom:** Fujichrome 50, 50mm lens, f/16.

196, **bottom right:** Square format, Fujichrome RFP, 150mm lens, f/11.

197, **top:** Kodachrome 64, 24mm lens, f/22.

197, **bottom:** Kodachrome 25, 28mm lens, f/16.

198, **top:** Kodachrome 64, f/5.6.

198, **bottom:** Square format, Ektachrome 6017, 80mm lens, f/11.

199: Square format, Fujichrome RFD, 150mm lens, f/11.

200, **top:** Kodachrome 64, 35mm lens, f/8 at ⅓₀ second with a tripod.

200, **bottom:** Fujichrome 50, 180mm lens, f/11.

201: Kodachrome 64, 28mm lens, f/16, ⅛ second with a tripod.

202: Kodachrome 25, 35–70mm zoom lens at 35mm, f/11 at ¹⁄₁₁₅ second with a tripod.

203: Kodachrome 25, f/11 at ¹⁄₆₀ second with a tripod.

204, **top:** Kodachrome 64, 18mm lens with an 80B filter to color correct the tungsten light, f/11.

204, **bottom:** Fujichrome 50, 35mm lens, f/8 at ⅓₀ second.

205, **left:** Fujichrome 100, 28mm lens, f/5.6 with a tripod.

205, **right:** Ektachrome 50, 100mm lens, f/16 at ¹⁄₁₅ second with a tripod.

206: Kodachrome 64, f/8 at ⅓₀ second with a tripod.

207, **left:** Kodachrome 64, 35mm lens, f/11 at ¹⁄₁₅ second with a tripod.

207, **right:** Kodachrome 64, f/16 at ¹⁄₁₂₅ second.

INDEX

(Page numbers in *italics* refer to illustrations.)

Abstraction, 32, 49, 53, 129, 137, *137*, *140–41*, 162
Aesthetics, 36, *36*, 37
Angle of view, *184*
 frontal perspective, 202
 high, 17, 21, *194*, *197*, 201, 204
 low, *1*, 21, *22*, 40, 125, 158, 197
 rear perspective, 15
Aperture, 49, 54, 66, 69, 87, 94, 100, 102, *110–11*, 113, 114
 depth of field and, 100, 112, 116, 136
 with fill-in flash, 94
 sharpness and, 59, 114, *115*, 116, *116*, *117*, 149
Architecture, gardens and, 186, *186*
Atget, Eugene, 213
Aubry, Charles Hippolyte, 212
Automatic cameras, 36, 44
 exposure with, 69, 100–101, 103
 sharpness with, 113

Background-foreground relationship, 15, 20, 21, *21*, 50–51, 100, 117
Backlight, *8*, 22, 82, *82*, 84, 85, *85*, 94, 97, 98
Ball joint heads, 58
Bracketing, 102–3, *102*, *103*
Braun, Adolphe, 211
Bullaty, Sonja, 96, 219

Cameras
 automatic, 36, 44, 69, 100–101, 103, 113
 seeing with eyes vs., 15–23
 35mm SLR, 44, 221
Close-ups, 32, 33, 39, 85, 87, *123*, 136, 142–45, 145, 168, *190*, 195
 adding light to, 94, 152, 153, *153*
 in diffused light, 70, *71*

equipment for, 42–43, 49, 54–56, *54–57*, 145, 146, 149
 extreme, *2–3*, 142–44, *145*, *148–53*, 149, *159*
 moderate, 49, 51, 54, 145, *146*, *146*, 147, 157, *158*
Coastal areas, 172, *173*, 173
Color
 in composition, 139, *139–41*
 exposure and, 22, 28, 29, 66, 76, *76*, 86, 87, 98, 102, *106–9*, *107*, 109
 film and, 27–31, *28–30*, 76
 light and, 23, 66, 70, 74–78, *74–81*, *107*, 109
 of negative space, 131
 of sky, 61
 telephoto lenses and, 52
Color correction filters, 28, 61, 70, 76, 222
Composition, *18*, 18, *19*, 120–39
 abstraction in, 137, *137*, *140–41*
 color in, 139, *139–41*
 depth in, *18*, 138, *138*
 design and pattern in, 18, *132*, *132–33*
 format in, 128, *128*, 129
 framing in, 16–17, *16*, *17*, 122, *122*, *123*
 lens choice in, 21, 127, *127*
 lines and shapes in, 40, 134, *134*, *135*
 of subject in setting, 124–25, *124–26*
 surface texture in, 136, *136*
Conservatories, 202, *202*, *203*
Converging lines, 18, 21, 50, 134, 138, *138*, *181*, *187*

Depth, *18*, 138, *138*, *183*
Depth of field, 21, *49*, 49, 69, 94, 100, *101*, 114, 117, 118, 125, 149, *158*

aperture and, 100, 112, 116, 136
 lenses and, 50, *50*, 52, 114, 127
Deserts, 164, *164*, 165
Diopters, 49, 61, *61*, 113, *140–41*, 146
Documentation, 38, 39, *39*, 50, *172*, 185

Environments, 156, 157, *157*. *See also* specific environments
Equipment, 44–63. *See also* specific equipment
Exposure, 45, 96–109
 with automatic cameras, 69, 100–101, 103
 with backlight, 85
 bracketing, 102–3, *102*, *103*
 camera settings for, 100–101
 choosing, 104–5, *105*
 color saturation and, 22, 28, 29, 66, 76, *76*, 86, 87, 98, 102, *106–9*, *107*, 109
 with contrasting colors and light, 108, 109, *109*
 with diffused light, 70
 with mixed light, 90–91, 93
 "pushing" film and, 32–33, *32*, 37
 with rain, mist, and snow, *72*
 with sidelight, 86
 with strong daylight, 69
 with uniform color and light, 106, *107*, 107
 See also Aperture; Light meters; Overexposure; Shutter speed; Underexposure
Extension tubes, 49, 56, 145, 146, 149

Fences, *184*, 185, *185*
Fill-in flash, 94, *94*, *95*, 146, 205, 220

Film
 color and, 27–31, *28–30*, 76
 grain and contrast of, 32–33, *32*, *33*, 72
 "pushing," 32–33, *32*, 37
 seeing with eye vs., 26–33
 testing, 26
Filters, 61, 222. *See also* specific filters
Flare, 85
Flash test, 221
Flash units, 34, 54, 62–63, *62*, *63*, 70, 86, 144, 149, 153
 in close-ups, 94, *152*, 153, *153*
 fill-in, 94, *94*, *95*, 146, 205
 macro, *62*, *63*, 145
 for maximum sharpness, 116, 117
 ring, *62*, *63*, 63, *142–43*, 153
Flower shows and markets, 204, *204*, *205*
Focus, 114, *114*, 149
 selective, 21, *110–11*, 118, 131
Food gardens, 197, *197*
Foreground-background relationship, 15, 20, 21, *21*, 50–51, 110, 117
Forests, 158–59, *158–61*
Format, 127, 128, *128*, 129, *165*, *184*
Framing, 16–17, *16*, *17*, 122, *122*, *123*
 of backlit subjects, 85
 choosing right lens in, 127, *127*
 format and, 128, *128*, 129
 of subject in setting, 124–25, *124–26*
Frontal perspective, 202
Frontlight, 82, *82*, 87, *87–89*, 94, 107
F-stop, 46, 100, 220
Fujichrome, 27, 28, *28*, 30, 33, 72, 76

Grain, 32–33, 32, 33, 72
Gray cards, 99
Greenhouses, 202

Haas, Ernst, 11, 23, 42, 46, 217
Hedges, 184, 185, 185
High perspective, 17, 21, 194, 197, 201, 204
Horizontal format, 128, 129

ISO ratings, 26, 28–30, 32, 103, 220, 221

Kertész, André, 215

Latitude, 32
Lenses, 46–56, 114
 choosing, 21, 127, 127
 depth of field and, 50, 50, 52, 114, 127
 sharpness of, 46
 speed of, 46
 See also specific lenses
Lens shades, 58, 85

Light
 adding to close-ups, 94, 152, 153, 153
 analyzing, 15, 22–25, 23
 color and, 23, 66, 70, 74–78, 74–81, 107, 109
 diffused, 5, 66, 66, 70, 70, 71, 76, 106, 107, 107, 108, 109, 154–55, 186, 192, 196
 direct, 76, 76, 78
 direction of, 23, 82–87, 82–89. See also Backlight; Frontlight; Sidelight
 high-contrast, 109, 136, 138
 intensity of, 23, 66–67, 66, 67, 76
 mixed, 90, 90–95, 93, 94, 198
 negative space and, 131
 rain, mist, or snow and, 72, 72, 73
 reflected, 77–81, 78
 shade and, 92, 93, 93
 strong daylight, 23, 66, 68, 69, 69

subject-setting relationship and, 124–25
 surface texture and, 136
Light meters, 69, 76, 85, 87, 97, 98, 99, 103, 105
 in automatic cameras, 69, 100–101
Lines, 40, 134, 134, 135
 abstraction and, 137, 137
 converging, 18, 21, 50, 134, 138, 138, 181, 187
 wide-angle lenses and, 51, 138
Low perspective, 1, 21, 22, 40, 125, 158, 197

Macro flash units, 62, 63, 145
Macro lenses, 42–43, 49, 51, 54–56, 54, 55, 140–41, 145, 146, 149, 159, 168
 telephoto, 20, 56, 56–57, 167
Magnification, 49, 52, 52, 54–57, 145, 146, 168
Magnifying filters, 32, 49, 52, 56, 61, 118
Mapplethorpe, Robert, 215
Meadows, 162, 162, 163
Mist, 23, 32, 66, 72, 73, 188–90
Motion, 63, 95, 100, 101, 102, 115, 118, 146
 image softened by, 31
 shutter speed and, 45, 66, 100, 115, 115, 117, 183
Mountains, 166, 167, 167
Muench, David, 209

Natural gardens, 196, 196
Negative space, 40, 130, 131, 131
Normal lenses, 48, 49, 49, 54, 127

Ornamental structures, 187, 187
Overexposure, 28, 28, 70, 74, 76, 77, 83, 86, 97, 103, 106, 183, 185, 200, 201

Pastel colors, 106, 107
Paths, 51, 175, 180, 181, 181
Pattern, 18, 132, 132–33

lines and shapes in, 134, 134, 135
Perennial gardens, 191, 191–93
Photo essays, 157
Photogenic subjects, 11, 15, 18, 21, 23, 34
Polarizing filters, 58, 60, 61, 66, 98
Porter, Eliot, 216
Positive space, 130, 131, 131
Previsualization, 11, 17, 34, 34, 36, 39, 41
"Pushing" film, 32–33, 32, 37

Rain, 32, 66–67, 70, 72, 72, 200
Raincovers, 58–59
Rear perspective, 15
Reflectors, 58, 78, 86, 93, 117
Ring flash units, 62, 63, 63, 142–43, 153
Rock gardens, 190, 190
"Rule of thirds," 18

Schinz, Marina, 218
Sculpture gardens, 198, 198, 199
Seasons, 74, 178, 178, 179
Setting, relationship between subject and, 124–25, 124–26
Shadow, 138
 light and, 92, 93, 93
 strong daylight and, 66, 68, 69, 69
Shapes, 134, 134, 135
 abstraction and, 137, 137
Sharpness, 33, 54, 59, 62, 66, 94, 100, 102, 112, 113, 113, 114, 149
 aesthetics without, 118, 118, 119
 focusing and, 114, 114
 of lenses, 46
 maximum, 116–17, 116, 117
 subject-setting relationship and, 125
 surface texture and, 136
 See also Depth of field
Shutter speed, 59, 100, 101, 102, 149, 204
 motion and, 45, 66, 100, 115, 115, 117, 182

Sidelight, 22, 23, 63, 82, 83, 86, 86, 90–91, 94, 112, 165, 175
Sky, 61, 70
Snow, 32, 66–67, 72, 72, 73, 179
Soft focus, 52, 118, 118, 119
Space
 compressed by telephoto lenses, 52, 52, 126, 127
 positive and negative, 130, 131, 131
Split image filters, 61
Square format, 128, 184
Stieglitz, Alfred, 214
Subject, relationship between setting and, 124–25, 124–26

Talbot, William Henry Fox, 210
Telephoto lenses, 12–13, 21, 32, 36, 38, 46, 47, 51, 52, 53, 61, 87, 101, 110–11, 113, 124, 137, 159, 180, 190, 206
 macro, 20, 56, 56–57, 167
 space compressed by, 52, 52, 126, 127
Texture, 36, 70, 112, 136, 136, 148
Topiary, 200, 200, 201
Trees, 182, 183, 183
Tripods, 42–43, 52, 56, 58, 59, 115, 115, 146, 149

Ulrich, Larry, 219
Underexposure, 22, 29, 66, 76, 76, 86, 87, 98, 102, 109

Vertical format, 127, 128, 128, 165

Walls, 185
Water gardens, 194, 194, 195
Wetlands, 168, 168–71
Wide-angle lenses, 17, 21, 21, 46, 50–51, 50, 51, 127, 127, 138, 138, 157, 158, 166, 170–71, 184, 204, 207
Window boxes, 206, 207, 207

Zoom lenses, 46, 127